THE ART & DESIGN SERIES

For beginners, students, and professionals in both fine and commercial arts, these books offer practical how-to introductions to a variety of areas in contemporary art and design.

Each illustrated volume is written by a working artist, a specialist in his or her field, and each concentrates on an individual area—from advertising layout or printmaking to interior design, painting, and cartooning, among others. Each contains information that artists will find useful in the studio, in the classroom, and in the marketplace.

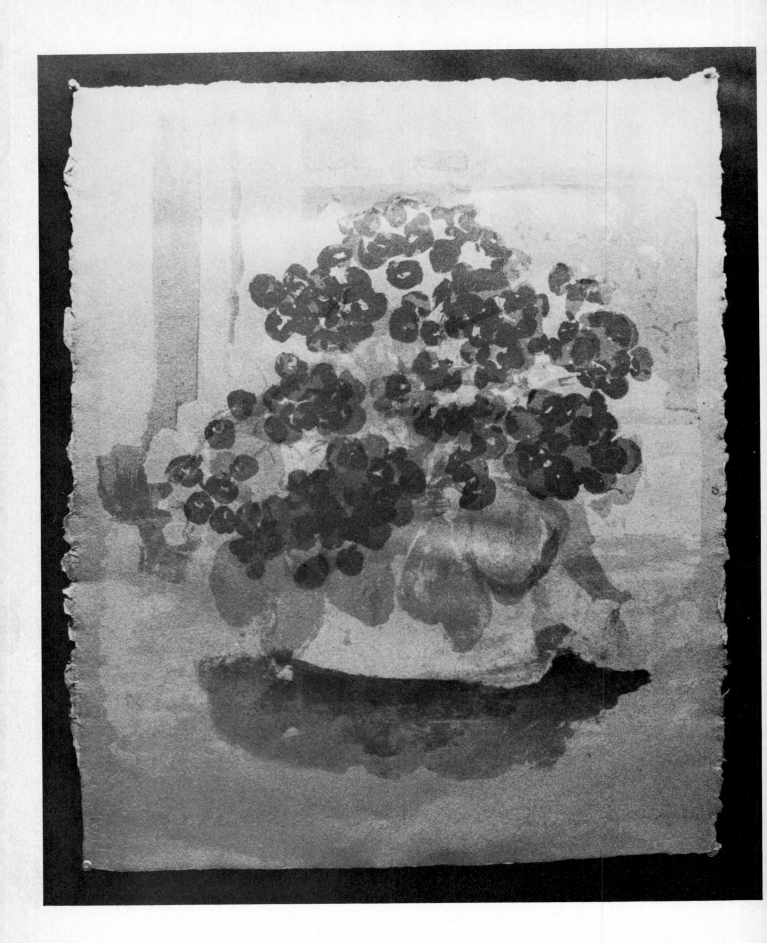

MARY ANN WENNIGER

featuring photographs by Mace Wenniger

LITHOGRAPHY
A Complete Guide

A SPECTRUM BOOK
PRENTICE-HALL, INC., Englewood Cliffs, New Jersey 07632

Library of Congress Cataloging in Publication Data

Wenniger, Mary Ann.
 Lithography: a complete guide.

 (The art & design series)
 "A Spectrum Book."
 Bibliography: p.
 Includes index.
 1. Lithography—Technique. 2. Artists' materials.
I. Title. II. Series
NE2425.W46 1983 763 83-3161
ISBN 0-13-537514-2
ISBN 0-13-537506-1 (pbk.)

This book is available at a special discount when ordered in
bulk quantities. Contact Prentice-Hall, Inc., General
Publishing Division, Special Sales, Englewood Cliffs, N.J. 07632

*The darkness of creativity
with its daily pain and effort
out of which is born
the flower of new life
and light and love.*

*This book is dedicated to Mace,
who steadied me.*

THE ART & DESIGN SERIES.

10 9 8 7 6 5 4 3 2 1

ISBN 0-13-537514-2

ISBN 0-13-537506-1 {PBK.}

EDITORIAL/PRODUCTION SUPERVISION: KIMBERLY MAZUR
PAGE LAYOUT: BRUCE KENSELAAR
COLOR INSERT DESIGN: MARIA CARELLA
MANUFACTURING BUYER: CHRISTINE JOHNSTON

FRONT COVER ART BY MARY ANN WENNIGER

Prentice-Hall International, Inc., *London*
Prentice-Hall of Australia Pty. Limited, *Sydney*
Prentice-Hall Canada Inc., *Toronto*
Prentice-Hall of India Private Limited, *New Delhi*
Prentice-Hall of Japan, Inc., *Tokyo*
Prentice-Hall of Southeast Asia Pte. Ltd., *Singapore*
Whitehall Books Limited, *Wellington, New Zealand*
Editora Prentice-Hall do Brasil Ltda., *Rio de Janeiro*

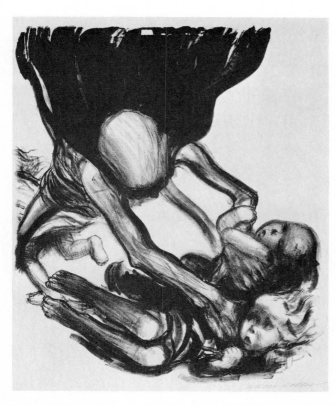

Contents

CHAPTER TWO

Materials

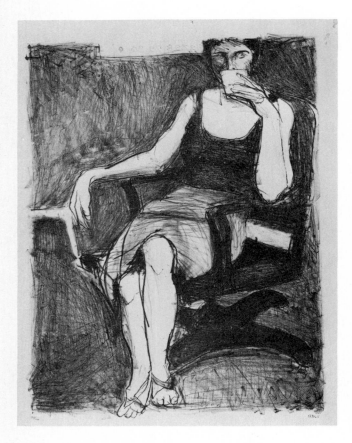

CHAPTER THREE

Imagery

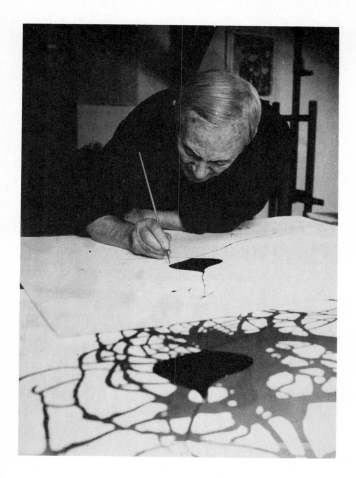

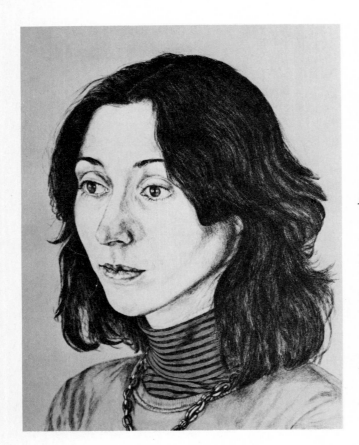

Foreword

This book is written by an enthusiast for enthusiasts.

Over the years, artists have broadened the lithograph's range of pictorial effects. Great artists have pushed lithography in many interesting directions, and, because it is the most versatile of all the print media, it has been able to accommodate them. Senefelder's original intention was to use lithography to print music, so many early lithographs have the qualities of engravings. Today, all the effects of other printmaking media can be put together on the lithographic surface, but basically lithography is a simple process based on the principle that grease repels water. The grease carries ink; water keeps the nonprinting areas—that is, the nongreasy areas—clear of ink.

Mary Ann Wenniger was like the many artists who came into contact with the fascinating process of lithography: She was delighted by the results of her successful efforts and frustrated by the calamities that occurred. She was casually introduced to lithography when the widow of a lithographer sold her some litho stones. Faced with the stones and nothing else, with characteristic determination she decided to sort it out for herself, sending out signals and honing in on any possibilities of widening her knowledge of the lithographic process.

I drifted into the scene three years ago when I visited Mary Ann and her husband, Mace, at their home in Massachusetts. They had sold my lithographs in their galleries for a number of years, and

during my first visit to the U.S. I accepted the invitation to call.

I was immediately brought into this project and tapped for all the technical information I could offer. After twenty years as a painter/lithographer, I have narrowed down my technique to a small area of lithography—chalk work on zinc—to suit my particular artistic direction, which is landscape painting. The prints are, in the traditional way, the graphic side of my work; my goal is to produce original works of art that complement my paintings but still have their own attractive and unique lithographic qualities.

But like so many professional lithographers, I find it difficult to go back to the basic attitude of general instruction. It is a bit like asking a Grand Prix racing driver to write a book on learning to drive. In addition, the classic line "writing about lithography is a trap" sums up my attitude.

Nevertheless, Mary Ann has done it; her general interest in lithography plus the openness of her attitude—to seek and use advice—when faced with technical or other problems has paid off. The intention of this book is to introduce lithography to artists who will use it in their own way.

I admire the book for its practical style and its humility. I am sure it will fill a gap in existing handbooks. It is not a tome on technique, like so many, but a guiding encouragement, like Mary Ann herself.

George Guest

ACKNOWLEDGMENTS

Seated Woman Drinking from Cup by Diebenkorn, page 20, is reprinted courtesy of Brooke Alexander, Inc. Photo by Eric Pollitzer.

The photograph on page 42 courtesy of and copyright by Galerie Maeght. Used by permission of Galerie Maeght. Photo by Claudi Gaspari.

Two Girls by Raphael Soyer, page 58, is reprinted courtesy of Raphael Soyer.

The photographs on pages, 76, 132, 156, and 172 by Mace Wenniger.

Umbra by Deborah Remington, page 100, is reprinted courtesy of Deborah Remington.

Sally after an Eakins Portrait by Oriole Farb, page 150, is reprinted courtesy of Oriole Farb.

The photograph on page 166 is reprinted courtesy George Guest. Photo courtesy Charles Robarts.

Plate 8 copyright © by Michael Knigin.

Plate 10 copyright © 1981 by Deborah Remington.

Kathe Kollowitz, *Death Reaching into a Group of Children*, 1934, lithograph, 19⁹⁄₁₆″ × 16½″ is re-

printed courtesy the Museum of Modern Art. From the collection, Museum of Modern Art, New York.

Figure 4-5a is courtesy Davis Carroll.

Figure 7-2 c Galerie Maeght. Used by permission of Galerie Maeght.

Figure 7-10 courtesy of Barbara Swan.

Table 13.1 is courtesy Alberta Workers' Healthy, Safety, and Compensation, Occupational Health and Safety Division.

Many thanks to Michael and Debbie Michaud for their assistance in preparing the manuscript.

PAUL JENKINS
(untitled)
Courtesy Paul Jenkins

The interweaving washes of color transform this five color mixture into a medley of hues. Jenkins wrote about this image:

"Working through indirection, rather than systematic buildup of one color next to another color, startled me when I first did lithographs, because it was like increasing the percentage of indirection due to the mirror reversal when the stone was printed. Thus it became inadvertently a zen on top of zen experience.

"The lithographic base seemed to grab the granular veils of tusche. No matter how delicate the nuance, or how strong the value, the stone or plate captures it. This is all-important for the interpenetration of the veils, which is for me, structure."

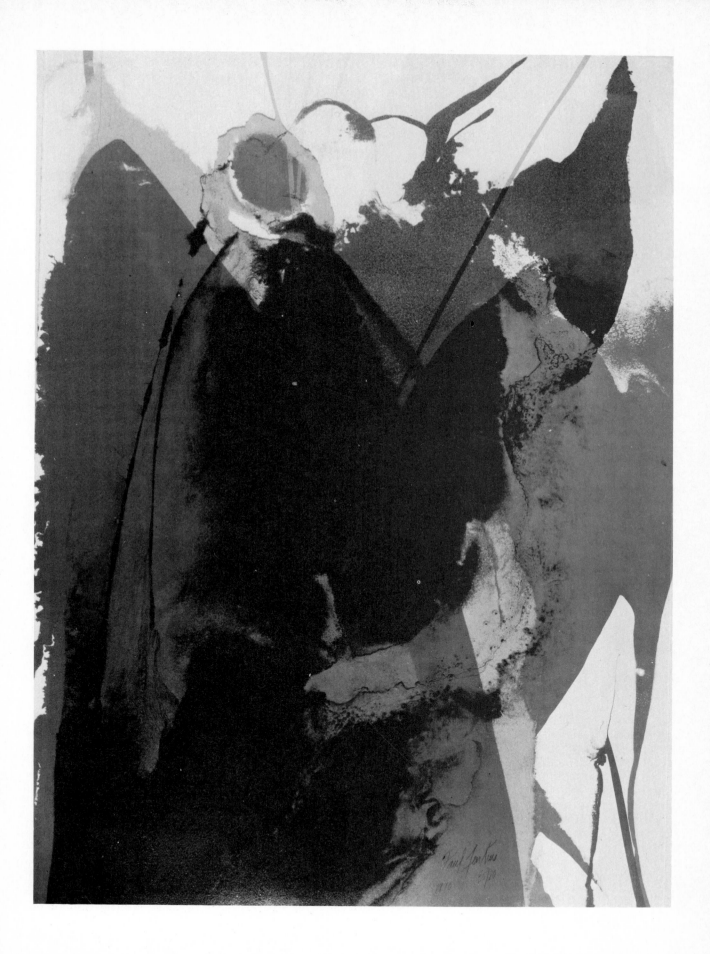

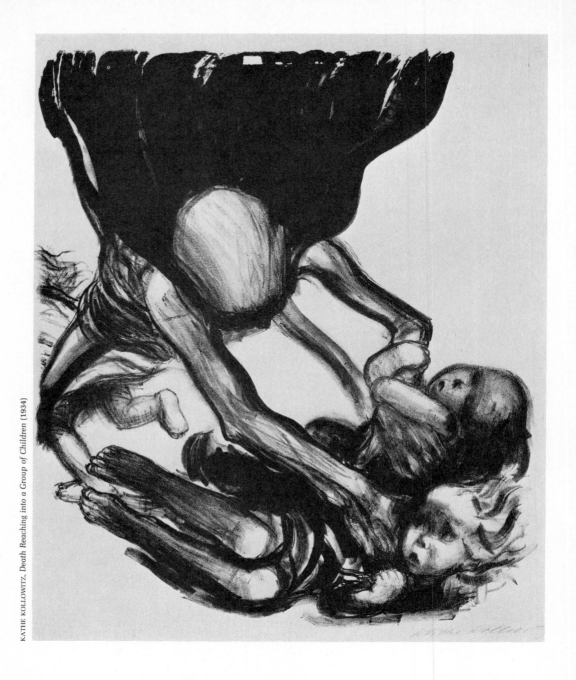

Why learn lithography? Why this persuasion that it is important to make your own lithographs? First, there is a delight involved in using the grainy lithographic surface. Making marks on it always involves an interaction between the medium, its unique surface and tools, and you, the artist. The minute grains on stone or plate transform crayon or pencil strokes into a velvety texture and modify liquid drawing materials in a painterly and rich fashion.

Once a fellow artist asked me why I print my own lithographs. "It's a time of intense quiet," I replied; "I withdraw from everything into the universe of my stone or plate, my sponge, the press bed, and my ink slab. That is my whole world."

During that time frame, I tried to tell him, all my energy is concentrated and flowing to make the print happen. Printing involves a rhythm and a physical effort that shuts out everything else. Suddenly I become so intensely involved that the work becomes play!

There are many reasons why artists print their own lithographs. My bias as a gallery owner as well as an artist is that warmth is generated in a litho-

CHAPTER ONE

Introduction

graph by the total involvement of the printmaker from start to finish, as the work of art is conceived, generated, processed, and printed.

This preference is shared today by print curators of museums who value an artist's "manipulated print," with all its errors, as much as or more than many professionally printed lithographs.

There are other personal and aesthetic reasons why you as an artist-lithographer should print your own lithographs. Although personally working a lithograph through each stage demands a watchful eye and on-the-spot decisions, and sometimes results in mistakes, it is this needed sharpness that contributes to your heightened sense of self as an artist and craftsperson. You are the complete creator, not only creating but also controlling every nuance that suggests changes during the processing and printing stages.

And yet, you, the artist are being created and controlled, too. The work creates the artist as much as the artist creates the work. As the print is being etched, as the drawn image slowly reveals itself under the carefully rolled ink, a symbiotic relationship is established between the artist and the work.

You can change a lithographic stone or plate after you have begun printing, but what happens on the stone or plate can change your ideas as well, so that you might wonder who is in control after all. That is the beauty of lithography. You put down what you want, but what you want changes as you perceive what appears on the paper in front of you. The work works on you as you work.

There is a serenity that comes from resolving and printing your own print. Part of it comes from the simple fluid arm and body motion involved in pushing the inked roller across the face of the stone or plate. Part of it comes from your total concentration on the image as the ink touches the base again and again, layering it.

But remember that there is a great deal of discipline involved in learning lithography. It is not a dilettante's art form. I like to compare it with a serious sport. You have to make a real commitment to lithography. You can experiment and be flexible and creative, but learning each variation will place demands on you analogous to those faced by an athlete in training—it is rigorous, exhausting, and exhilarating.

LITHOGRAPHIC PRINTMAKING AND COLOR LITHOGRAPHY

This book describes, both visually and verbally, how to make a lithograph, in black and white and in color. Since you have to be able to handle a single color, usually black first, before you can print a lithograph composed of several colors, you will begin by learning to work with basic materials to draw, process, and print a lithograph.

Plate and stone lithography are explained, and ways of testing the suggested processing methods are demonstrated to help you find the etching methods and proportions that work best for your lithographs. Both processing and printing procedures are simplified so that after finishing the text you should be grounded in the basic principles of lithography and be capable of printing color and black-and-white lithographs.

The book's two basic premises are addressed to the needs of the beginning lithographer. First, lithography is a fairly simple procedure when it is reduced to the essentials that you must understand in order to use the medium at all. After these basic principles are understood and integrated into your work habits, endless embellishments and experimental approaches are available; I shall refer to only a few of these.

Second, color lithography can be approached aesthetically in a few readily comprehensible ways. These strategies are presented step by step by several lithographic artists who have used them consistently and successfully. Although the artists happen to live in New England for the most part, the methods are not at all regional. These artists also help explain the mechanical aspects of color lithography, registration possibilities, and editioning procedures.

Color lithography has always been considered too hard for the beginning lithographer. In fact, the feeling that printing lithographs of any kind requires special knowledge has been part of the mystique surrounding the technique ever since fine artists adopted it for commercial printing during the middle nineteenth century in Europe and in America.

By custom, both black-and-white and color lithographs have been printed by master printers working in close collaboration with artists. Multiple color lithographs like those in this book's color gallery will show you just how successful this working interdependence can be. But such a collaboration is usually beyond the scope or wishes of the student of lithography who wants to explore the medium and master the mechanics and the aesthetics of the medium on his own in order to become what is known as a hand lithographer, that is, one who prints his own work on a hand-operated lithographic press.

However, there is another collaborative printing arrangement presented in this book which represents a viable alternative for more and more hand lithographers. It is printing on an offset press with the help of a press operator instead of having lithographs printed by a master printer. This arrangement offers speed and ease of registration to the printmaker who has such facilities available and can afford to use them, while still enabling him to work on each color lithograph from start to finish.

WHAT IS LITHOGRAPHY?

A lithograph is a drawing or design made with greasy materials on a limestone block or on a plate and then transferred onto paper. The greasy particles rest on small hillocks made by the grain of the stone or plate. These hillocks have been chemically treated to be water-resistant and permanently attracted to grease. The surfaces surrounding the hillocks have been chemically treated to be grease-resistant and water-receptive.

Figure 1.1

The grains on the two lithographic bases differ: On the stone (top) the hillocks formed by the grain are irregular and vary in size and shape; on a plate (bottom) the hillocks are evenly distributed because the grain is mechanically made.

During the process of printing a lithograph, the stone or plate is kept damp while ink is applied with a roller. The ink is retained by the grease-attractive parts of the stone or plate and repelled by the water-receptive areas. Damp or dry paper is placed over the inked plate or stone, and the image is transferred to the paper by pressure as the stone or plate is passed under the scraper bar of the lithographic press. When the printing paper is slowly lifted from the lithographic base, revealing the inked image on the underside of the paper, the process is called *pulling a proof* (a tentative image) or *pulling a print* (image okayed for editioning by the artist). If it is a proof, it is judged for its artistic merit and corrected, and the printing process is begun again. If it is a print, it is put aside or hung up for the ink to dry; then another piece of paper is readied and the inking and printing steps are resumed and continued until the planned number of prints for an edition are pulled.

Lithography is *planographic*, or even-surfaced printmaking. It differs from relief printing, for example woodcuts, in which ink is rolled up onto the top surfaces of an irregularly surfaced plate and never touches the lower planes that the roller cannot reach. It differs also from the intaglio printing of engravings and etchings which employs many planes to hold varying concentrations of ink, according to the texture and depth of the plate surface, the way the ink is worked into its areas and lines, and the way it is wiped in preparation for printing.

Because the lithographer's artistic work is executed and printed from a flat surface, or plane (hence the term planographic), and is not eaten into by tools or acids, a lithograph retains the immediacy of drawing as well as a spontaneous quality not found in the other printmaking mediums.

HISTORY OF LITHOGRAPHY

The lithographic artist has been the last of the printmakers to become autonomous. As etchings, engravings, woodcuts, and silkscreens became viable artistic forms, artists learned how to print their own images with these methods. This process took longer for lithographers because traditionally lithographic printmaking has been divided into two segments performed independently: imagery and printing. There have almost always been two people involved: an artist and a printer.

A look at the history of lithography highlights the dichotomy that has existed. Since the end of the eighteenth century, when Alois Senefelder invented the lithographic press to print his plays and sheet music on slabs of Bavarian limestone, three printing traditions have emerged:

1. The lithographic printer who prints commercial products in unlimited editions, that is, the job printer
2. The lithographic printer who prints limited editions of the work of a fine artist on a hand-operated press or on an offset press
3. The artist/printmaker who creates and prints his own limited edition lithographs on a hand-operated lithographic press.

During the early nineteenth century lithography flourished as a popular new art form in Europe, and it was used in the United States primarily as a printing process for commercial purposes—calendars, maps, cigar boxes, theater posters, and illustrations in books, newspapers, and magazines. In Eu-

An 1835 American songsheet printed from a lithographic stone shortly after the English publication in 1819 of Alois Senefelder's lithographic instructional manual, *A Complete Course in Lithography.*

This poster, circa 1850, was printed in color and distributed popularly in France.

rope as well as in the United States, the work of the professional printing company was separate from that of the artist.

In Europe, the work of the artist remained paramount even when commercially applied, as in Toulouse-Lautrec's or Daumier's posters, which have since become valued art objects. In the United States, however, the primacy of the commercial lithographic printing firm was unquestioned during the nineteenth century—in fact, the majority of prints mass-produced by Currier and Ives, lithographic printers, contained no mention of the artists' names.

This commercialization of lithography resulted from a new process for color printing called chromolithography, a term coined by French printer Godefroy Engelmann in a patent of 1837. A technically complex and sophisticated process in which the image is composed of at least three colors, each applied to the print from a separate stone, chromolithography provided a means of creating inexpensive copies of original oil paintings and watercolors.

A big business in America, chromolithography was decried by nineteenth-century artists and intellectuals for debasing art by destroying the uniqueness of an original painting and by employing cheap merchandising techniques like that of Louis Prang, who categorized pictures by the room in the house where their subjects were appropriate, for example, fruit, fish and game were "dining room" pictures. More recently, however, critics have begun to credit the role chromolithography played in patronizing artists, in popularizing art collecting, and in perpetuating the craft of lithographic printmaking in America.

In the late nineteenth and early twentieth century, lithography underwent a revival in France, Germany, and Scandanavia, especially among the impressionist painters. Manet, Degas, Redon, Renoir,

Figure 1.4
EDWARD GAY after A. T. Bricher
An Old Man's Reminiscenses
Courtesy The Museum of Our National Heritage, Lexington, MA. Photo courtesy the Print Department of The Boston Public Library.

This chromolithograph was printed in 1871 by L. Prang & Co., Boston. Chromolithography was an early form of lithography used to produce nineteenth-century calendars and inexpensive art for the home. Chromolithos were printed from separated color images (see Ch. 7, Fig. 7.7) drawn on lithographic stones and printed first by hand and later by offset methods.

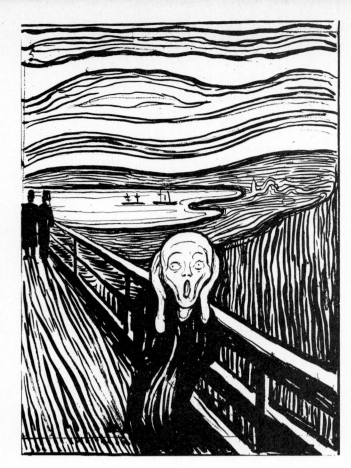

Figure 1.5
EDVARD MUNCH
The Scream
Courtesy the National Gallery of Art, Washington, DC.

The Scream, executed and printed in Europe in 1895, exemplifies tusche worked in a painterly fashion typical of the European lithographic tradition, which used tusche rather than the lithographic crayon then popular in America.

Figure 1.6
THOMAS HART BENTON
Self Portrait
Courtesy National Museum of American Art (formerly National Collection of Fine Arts), Smithsonian Institution museum purchase.

This is a carefully articulated crayon-drawn image, worked on the lithostone, typical of the earliest tradition in American lithography. This image was printed in the first print workshop established in America for printing fine art lithography—that of George Miller in New York, still operated today by his son, Burr Miller. A complete collection of the lithographs printed by George Miller can be seen in the Smithsonian, National Collection of Fine Arts, Washington, DC.

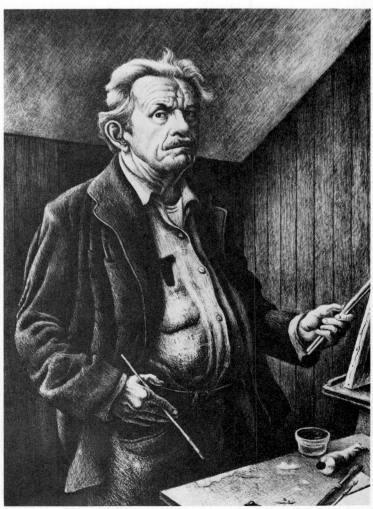

8

Figure 1.7
MARY CASSATT
Woman Seated in a Loge
Courtesy Museum of Fine Arts, Boston, MA.

One of the few lithographs created by Mary Cassatt, drawn in the American classical crayon-drawn tradition and printed in Europe.

Cezanne, Bonnard, and Vuillard, as well as Munch, and later Picasso and Miro, all used commercial printers.

The production of hand-drawn and printed lithographs in strongly graded black-and-white pencil or crayon-drawn images became popular a little later in the United States under the leadership of John LaFarge, Winslow Homer, Thomas Hart Benton, George Bellows, Mary Cassatt, and especially James McNeill Whistler. However great an attraction lithography held for these artists, few considered printing their own work.

Unlike etchers, engravers, and serigraphers, who mastered the printing process as part of their art, lithographers of the twenties and thirties, such as Raphael Soyer, depended in large part on lithographic workshops, like those of Mourlot in Paris and George Miller in New York.

The carefully articulated, crayon-drawn lithographs done by Stow Wengenroth from 1931–1978 are typical of American work during this period. The stones were sent to him grained and ready for drawing from Miller's workshop in New York, and Wengenroth returned them there for processing and printing.

Influence of Daumier on American Lithographers

The true-to-life, expressive lithographic style of Honoré Daumier mirrored, criticized, and satirized social conditions of mid-nineteenth-century France. His approach has had a profound influence on American lithographers since the beginning of the twentieth century, when the famous teacher Robert Henri discovered Daumier's work in Paris and shared his passion for it with his students. Among them were John Sloan, William Glackens, George Luks, and George Bellows, all of whose social-realist lithographs later reflected Daumier's extensive imprint.

When the New Deal began to create work for artists through the Works Progress Administration in 1935, lithographers such as Philip Evergood, Gropper, and Ben Shahn were among those who responded to the times in the same realistic social terms that had marked Daumier's view of the conditions in France.

Several of John Sloan's artist friends, including the well-known lithographers Boardman Robinson, Guy Pène de Bois, Rollin Kirby, and Robert Minor,

became known as New York realists, and they shared Daumier's interest in contemporary city life, which they pictured in the same honest, often satirical fashion.

Other noted twentieth-century American lithographers who dealt and often still deal with subject matter closely related to Daumier's include Howard Cook, Mabel Dwight, Fritz Eichenberg, Mervin Jules, Kuniyoshi, Martin Lewis, Louis Lozowich, Elizabeth Olds, Raphael Soyer, Grant Wood, and Allen Crane.

Will Barnet, popular contemporary American artist and teacher of lithography, has written: "I was 14 when Daumier became my first great inspiration. His sense of form in portraying humanity appealed to my emotions and touched me deeply." (Will Barnet to Ben Goldstein, 1979, *Print Review*, Pratt Graphics, 1980.)

AMERICAN LITHOGRAPHY TODAY

Increased public notice of lithography in America began in 1959 after Tanya Grosman established Universal Limited Editions on Long Island, where she printed the work of such leading contemporary artists as Jasper Johns, Robert Rauschenberg, Larry Rivers, and James Rosenquist. The importance of the Tamarind Lithography Workshop, founded in 1960 in Los Angeles under the leadership of June Wayne and Garo Antresian and later moved to New Mexico, should be underlined. A whole new generation of lithographic artists and teachers was developed there, along with master printers who opened their own workshops and now produce some of the highest quality, most innovative work currently being done in lithography.

Figure 1.8
WILL BARNET
Idle Hands (1936, edition of 10)
© 1936 by Will Barnet. Photo by Styria Studio.

The artist, who was teaching how to print lithographs during the 1930s under the auspices of the WPA, drew this moving study on a litho stone, building the tones with crayons that he scratched and scraped in order to design the cast light in and around his subject, thus building the emotional intensity that continues to distinguish his work.

In recent years, however, many independent lithographers have created a range of highly personal alternatives; like my friend who grains her stones in her bathtub, draws on them in her studio, and then prints the image on a workshop press or pays a master printer to print them for her. Some artists use their own presses to proof their images and get them ready for a master printer. Some printmakers are using their etching presses to print lithographs drawn on plates. Still others are taking advantage, as I have, of the new combination presses, which can be switched from intaglio to lithography fairly easily. And increasingly today printmakers are taking their hand-drawn plates, as well as their drawings made on Mylar for transfer to plates, to offset workshops where the print is a collaborative project between artist and press operator. Many other lithographers have made the major commitment of purchasing, either alone or in collaboration with others, a lithographic press.

The artist interested in lithography today can approach this medium with the anticipation of printing his own work in his own workshop. Lithographic materials are available today by mail order. In the next chapter, and, more completely in Chapter Thirteen, I list and explain the materials necessary for starting lithography on your own, along with their sources, and suggest ways in which a lithographic workshop can conveniently be set up and arranged.

The illustrations and work methods of lithographers presented in succeeding chapters will quickly familiarize you with the fundamentals of lithography and the basic principles of color lithography: the materials involved; how to create an image on a lithographic base; how to test procedures without damaging your imagery; how to process stones and plates; how to print in black and colored inks; and how to use other creative techniques now available, such as photography and the Mylar method.

Although there are as many ways to work as there are lithographers, the formulas and directions included here have been most reliable.

It is important to keep in mind that becoming a lithographer entails some paradoxes, such as drawing an image in reverse, removing an image in order to achieve an image, and printing while using a water film—as well as ink—on a roller. One must suspend judgments as well as make judgments; be patient as well as impatient.

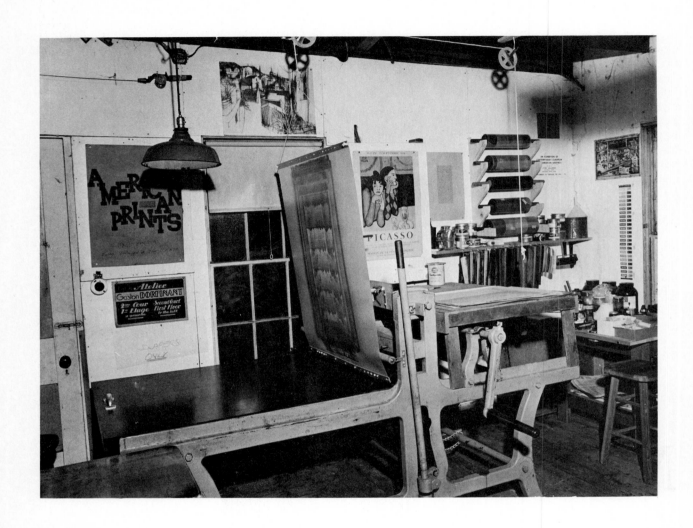

A certain amount of supplies are listed here and described in order to get you started in lithographic printmaking.

Lithographic printmaking is something you can get into gradually. There is no need to go out and buy a four thousand dollar press to see if you like making lithographs when you can join a class or workshop where other artists are working. If you are a visual person, you will learn from observing others as well as from reading a book.

Start by purchasing some of the lithographic drawing and printing materials listed here. You will also need to acquire some printing accessories; the quantity will depend on the set-up where you plan to print. I list essential litho workshop equipment.

When you reach the point of being ready to set up your own workshop, the last chapter will provide detailed information about lithographic materials and how they are used, and a survey of lithographic supplies and the sources for them.

At this point you will also need to round up lithographic processing and printing accessories, such as water bowls and sponges, from hardware and photography stores and order any chemicals

CHAPTER TWO

Materials

needed from a nearby chemical company, which should be canvassed by telephone first.

When I became interested in lithography, I started out with two stones given to me by the widow of a lithographer, and nothing else. It soon became imperative for me to round up supplies; I found that some were hard to find since they were not exclusively lithographic in nature and usage and were not in lithographic catalogues. Most were found with the help of the Yellow Pages. Dropper bottles for acid, finely woven cheesecloth for buffing etched stones and plates, photographic sponges,

enamel water bowls, battleship linoleum for covering the bed of the press—these were a few of the items found by some sleuthing.

I hope that the explanatory remarks appended to each of the following list of supplies will serve as preliminary road maps. They are not intended to be as complete as the explanations given in Chapter Twelve.

The list is set out in a logical order of use as one gets into lithography, starting with making an image and proceeding through printing in black ink and using colored inks. The supplies for more exotic pro-

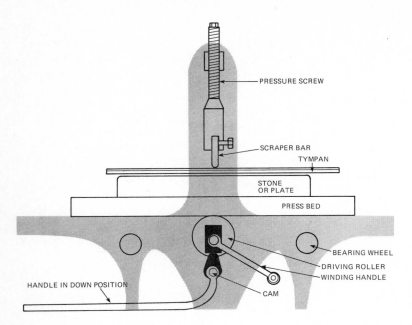

Figure 2.1

Schematic drawing of a lithographic press.

cesses like photolithography are listed and explained in Chapter Thirteen. Major sources of the materials listed below are:

Graphic Chemical and Ink Company
P.O. Box 27
Villa Park, Illinois 60181

New York Central Supply Co.
62 Third Avenue
New, York, New York 10003

Rembrandt Graphic Arts
Rosemont, New Jersey 08556

DRAWING MATERIALS

Lithographic Pencils

Lithographic pencils come in a variety of densities ranging from #0, soft, to #5, hard. About seven inches long and pointed, they are made from a combination of greasy materials, pigment, wax, soap, and shellac. To lengthen the point, the artist unravels the paper wrapped around it. The point can then be sharpened by cutting toward it with a razor blade.

Figure 2.2
Photo by Robin Sherin. Courtesy Steve Steinberg, New York Central Supply Company.

Basic materials of lithograph image-making: pencils and crayons of varying hardness; liquid crayon called tusche, which can be diluted with water or solvents; and autographic ink, which prints as a solid line or tone.

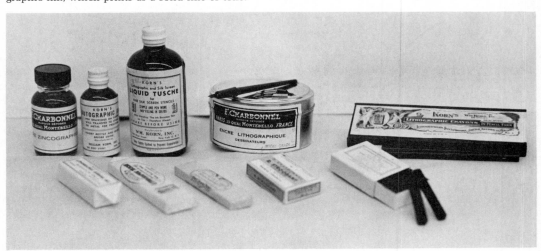

Lithographic Crayons

Lithographic crayons range from soft to hard, and numbered from #0 to #5, these crayons, chalks, or tablets, as they also are called, are about two inches long and one quarter inch square. Both tips and sides of lithographic crayons can be used. For broad strokes break them and use them on the edge or a flat side. The lithographic crayon can also be used with a sharp point made by shaving it with a knife.

Stabilo Pencils. Greasy pencils which work well on Mylar.

China or Glass Marking Pencils. Inexpensive, readily available grease pencils that can be sharpened to a long fine point.

Rubbing Crayons. These come in three grades: soft, medium, and hard.

Tusche Products. Greasy litho drawing material that is worked wet, comes in a stick or as paste in a can, usually dissolved in water or solvent.

Airbrush Inks, Drawing Inks, Acrylics, Opaques, Graphite, and Markers. Materials used to produce an image when used on Mylar with the Mylar method.

Conte Crayons. Grease-free chalks to use when making preliminary drawings or transferring inked images onto a new plate or stone.

Trichlorethylene. A solvent that removes part or all of a drawn image from plates but leaves the lithographic surface reusable for redrawing.

Additional Drawing Tools

Other useful implements are X-Acto knife, sandpaper block, air brush, chamois cloth, red opaque, and a Griffold knife #112 with square blade recommended for sharpening lithographic pencils and crayons.

LITHOGRAPHIC BASES

- *Stone*, limestone gray or tan in color, which is abraded with carborundum powder in a process known as graining to produce minute, evenly spaced hillocks that retain grease with lithographic drawing materials.
- *Plates*, ballgrained aluminum or zinc non porous metal plates grained to form a surface approximately like that of a stone, with coarse, medium, or fine texture.
- *Mylar*, a transparent or translucent plastic film which can be drawn on with any opaque drawing or painting material to produce a design which can be transferred photographically to an aluminum lithograph plate.
- *Transfer Papers*, paper coated with glycerine and gelatine or gelatine only. Used for direct drawings to transfer plate or stone by the pressure applied from going through the press.

Figure 2.3
Photo by Mace Wenniger.

Lithographic bases are (left to right) aluminum, zinc, and paper lithographic plates and lithographic stone (in process). Note the differences in color and texture of these drawing surfaces. The aluminum plate is lighter in color and smoother in texture than zinc, which is darker, coarser, and similar in texture to a grained stone. Stones vary in color from tan to dark gray and can be textured with a smooth or grainy surface according to the wishes of the artist. Lithographers often form preferences regarding the lithographic base they want to work on.

GRAINING SUPPLIES

Carborundum powders, available in a range of textures, coarse to fine, from #50 grit to #100 grit, to #180 grit, to #240 grit and #320 grit.

- Block pumice stone
- File, medium
- File, fine
- Stone piece for graining
- Levigator for graining
- Rubber squeegee with handle, 12″

Carborundum powder is an abrasive made from silicon carbide, sand and carbon. Rubbing with carborundum brings out the soft grain of the limestone and prepares it to receive a new image. Carborundum comes in different densities or grains. The coarser densities with lower numbers are used to grain off old images, while the progressively finer, higher numbered densities refine the surface.

IMAGE PROCESSING MATERIALS

- Rosin x-1522 (fine powdered)
- French chalk or talc

Rosin and talc are powders that do specific tasks when applied to the grease image on the stone or plate. Rosin, used mostly on stones but sometimes on plates, is dusted on before the talc. It isolates each

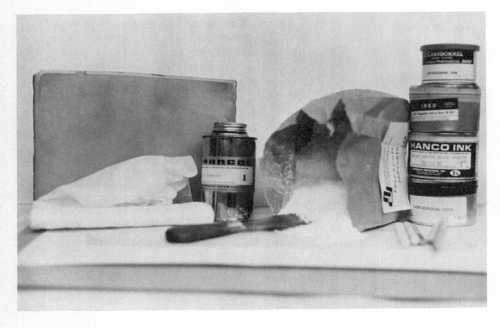

Figure 2.4
Photo by Robin Sherin. Courtesy Steve Steinberg, New York Central Supply Company

Lithographic materials: litho stone, cheesecloth, Hanco varnish, magnesium carbonate, Charbonnel retransfer ink. Graphic Chemical roll up black ink, Hanco crayon black ink, carborundum grits, spatula, snake slip (round and square), scotch hone, retouch transfer stick, litho needle.

Figure 2.5
Photo by Robin Sherin. Courtesy Steve Steinberg, New York Central Supply Company.

Lithographic processing materials: Hanco plate etch, Hanco gum arabic, litho Kem-Ko lacquer C, Hanco lacquer V, litho Kem-Ko lacquer C solvent, Baldwin turp, lacquer thinner, Hanco lithotine.

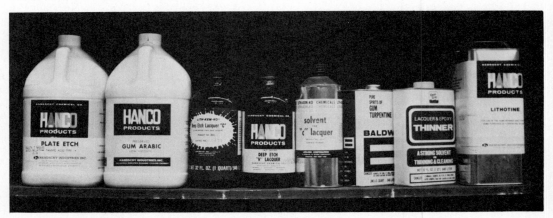

grease-laden particle, enabling the gum arabic used in the etching process to separate nongrease areas from the greasy drawn image. It also acts as an acid resistant to protect the greasy image from the corrosive action of the acid used in the etch. Talc is dusted onto both stone and plate after drawing is complete. Talc absorbs extra grease on the image. It also coats the image so the gum arabic will adhere to the greasy drawing in an even film.

Gum Arabic 14 Baume. Gum arabic is the key to lithography, for it is the main ingredient used to etch stones and plates. Initially a pebbly material, it is dissolved in water to form the syrupy solution that coats the plate or stone with a thin, tightly bonded film during the etch process. It stays on the negative part of the image during the printing of a lithograph, acting as a grease-repellent but water-attractive stencil.

Fine-Holed Cheesecloth. This is used to buff down gum arabic on the surface of plate or stone after processing images.

CHEMICALS

These are essential chemicals and processing materials which are used to sensitize, desensitize, and resensitize lithographic plates and stones. For further reference see Chapter Six on printing.

- Nitric acid, 70% USP
- Phosphoric acid, 85% NF
- Tannic acid, NF, powdered
- Citric acid, USP monohydrat granular
- Glycerin, C3H5 (OH) 3
- Vinyl lacquer, (RBP)
- Cellulose gum, MS448
- Hydrogum, 14 baume
- Red iron oxide or lumberman's chalk or aniline dye
- Phenol (carbolic acid), 88%
- Pro Sol fountain solution #54
- Soda ash
- Hanco tannic acid plate etch, MS214
- Deep etch "C" lacquer, 3001-C

Solvents

These are used in combinations with drawing materials as well as to dissolve and remove images, and to clean up after printing.

- Asphaltum, MS897
- Alcohol Anhydrous (Solox)
- "C" Lacquer Solvent, #3010
- Kerosene
- Lithotine
- Lacquer thinner
- Neat's-foot oil
- Distilled water

PRINTING MATERIALS AND SUPPLIES

Printing Equipment

Lithographic Press. The lithographic press, which can be used with either plate or stone, is a fairly simple structure composed of a bed or horizontal surface made of steel or benelux mounted on a movable roller beneath the bed. It is available from

Vermillion Press
400 First Avenue North
Minneapolis, Minnesota

Takach-Garfield Press Company, Inc.
3207 Morningside, N.E.
Albuquerque, New Mexico 87110

Charles Brand Press
84 East 10th Street
New York, New York 10003

Rembrandt Graphic Arts Company, Inc.
Rosemont, New Jersey 08556

Tympan. The tympan, a flat one-eighth inch thick rigid plastic or pressed board sheet covers the press bed. A manually or electrically operated roller sends the press bed back and forth under the scraper bar, which scrapes along the well-greased tympan and slowly presses down on the tympan, blotter, printing paper, and inked plate or stone. In this fashion the image is transferred from the inked plate or stone onto the printing paper.

Linoleum Sheet or Phenolic Slab. This flat sheet, preferably of G10 Epoxy, is cut to the size of the press bed and acts as a cushion for the pressure of the press upon the stone or plate during printing.

Safety and Comfort Features. Important in every workshop are such staples as a steel cabinet or locker for solvents, stools, a radio, and a respirator mask.

Inking Rollers and Related Supplies. Printing rollers are used for lithography. Leather is used for printing with black ink, rubber for printing in color.

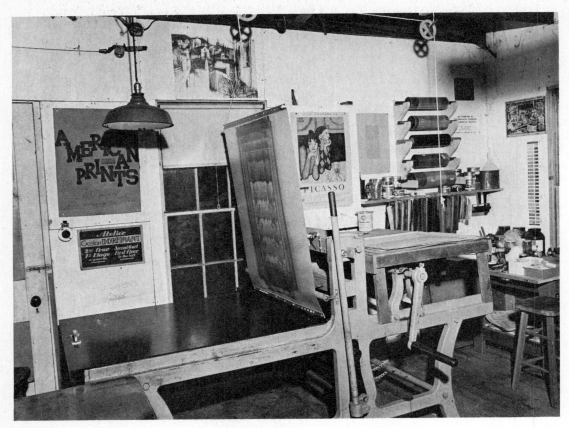

Figure 2.6
Photo by Mace Wenniger.

A lithographic press with tympan attached to a weighted pulley is shown in the studio of a lithographer, John Muench, with a compact, systematic arrangement of materials: drawing materials on the table; rollers in a rack; scraper bars hanging up; chemicals and inks on a shelf; printing paper stacked on a box built at the end of the press; arranged so the artist can print without any wasted steps.

- Rubber rollers, 4″ × 12″, 14″, 16″, or 18″
- Small rubber rollers ½″ to 3″ long
- Fibrous rubber rollers 4″ × 12″ to 18″
- Grained leather roller 4″ × 12″ to 18″
- Mutton tallow for leather rollers
- GPI varnish #8 for conditioning rollers
- 1 each 5″ × 16″ and 4″ × 12″, 40 durometer small rubber brayers

Varnishes and Modifiers. Most inks need some additives before they can be used for printing. Magnesium, varnishes, sets well, and oils increase or decrease viscosity or tackiness. Anti-skinning spray is used inside ink cans to keep a film from forming on ink. Also, spray it on left over inks that you want to use at a later date. Putty knives are used for mixing inks.

- Magnesium carbonate
- CPI lithographic varnish #00
- Reducing oil, 300-95

- Hanco sets well compound, MS679
- Ink anti-skinning (aerosol can)
- S & V cobalt drier, 42-B
- Gloss overprint varnish
- 3″ and 4″ putty knives

Image-Correcting Tools. These include flat snake slips, scotch hones, ³⁄₁₆″ or ½″, and polychrome image remover.

Inks. Use inks without driers, unless you are printing on an offset press. Start color printing with three primary colors specified from which all other colors can be mixed. Add white, black and transparent medium for other effects.

GRAPHIC CHEMICAL INKS
- #1900 red
- #1901 perm process yellow
- #1906 perm process blue

- #1928 opaque white
- #1910 lactine transparent medium

Black inks are divided into inks used for proofing (roll-up inks) and those used for editioning.

- #1921 roll-up black
- crayon black

Printing Papers. A good image deserves to be printed on a good quality rag paper. Be aware of paper content and color when selecting your printing papers.

- Newsprint, 24″ × 30″
- Basing werk, cream, 29″ × 40″
- Arches cover, white, 22″ × 30″
- Arches cover, buff, 22″ × 30″
- Italia, cool white, 42″ × 30″
- Arches cover, 24″ × 41″
- Rives, white, gray or tan, 42″ × 30″

HANDMADE PAPERS
- Richard DeBas
- Moulin duVerger
- Duchene
- HMP

SMALL ACCESSORIES FOR PRINTING
- Mylar, frosted or plain
- Tracing paper, 28″ × 38″
- Lab apron
- Axle grease
- Contact paper, roll 18″ × 25″

- Hanco hand cleaner, can
- Cheesecloth, bolt, densely woven
- PH test papers
- Acid drop bottles, hooded
- Safety cans for solvents
- #2 spring pressure clamps
- Measuring cup or photographic graduated ounce measurers
- Paper roll dispenser and cutting bar
- Aluminum straight edge, 48″
- Steel straight edge, true edge, 48″
- Glass funnel, lab type, small neck
- Graduate, 16 ounce polyethylene
- Polyethylene stir rod, #F-37767
- White enamel pans—water bowls
- Etch bowls, 3¼″ diameter
- Putty knives, 2″ wide
- Putty knives, 3″ wide
- Brass register pins, ¼″

PERMANENT WORKSHOP EQUIPMENT
- Tables with glass top/ink slab
- Sink, stools
- Storage cabinet for solvents
- Drying rack for prints
- Roller rack
- Horizontal paper and plate-storage shelves
- Ink shelves
- Trash cans with lids attached
- Rubber floor mat in front of inking station
- Radio or cassette deck
- Ventilating fan

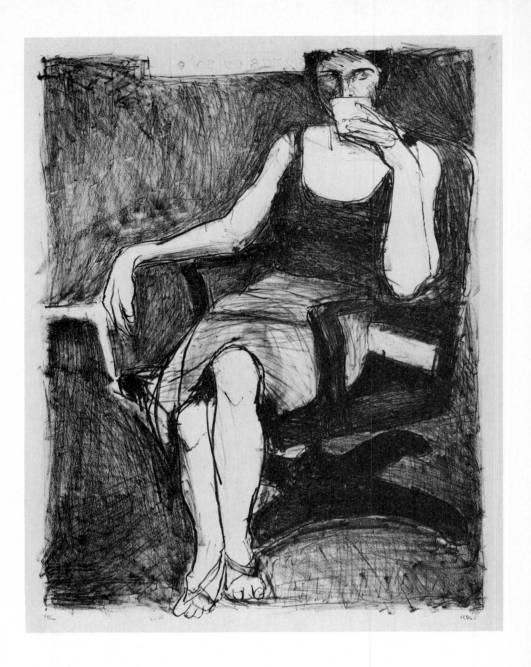

The lithographic process begins with the image. Because the nature of the lithographic base affects your work, the first step is to learn how to use the lithographic surface with the drawing materials designed for it.

The craftsmanship of your drawing lies in how well your drawing materials adhere to each hillock on the lithographic base, and this will influence the success of each subsequent step of processing and printing. A carelessly made image can lose its character during processing; the same image constructed with the correct application of drawing materials can become an artistic success.

The lithographic surface is unique. Feel the grain on your stone or plate. Notice the refined, soft velvety texture. Stow Wengenroth, one of America's greatest lithographic draftsmen, commented that his interest was in "taking advantage of that surface." He added that the elegance and beauty of the grainy quality of the litho surface justifies making just one print.

Wengenroth's artistic philosophy reflected a deep, immutable respect for the lithographic surface, which yielded tones that cannot be made by drawing alone.

A look at Wengenroth's careful rendering illus-

CHAPTER THREE

Imagery

trates the point that lithography can be an extension of basic and advanced drawing techniques. In his work, he used the lithographic surface to emphasize the strong lights and shadows characteristic of New England. The lithographic grain allowed his drawings to go beyond the limits of rendering in a delicate blending of tones that no other medium facilitates to the same extent.

There is a distinctive pleasure involved in using the lithographic surface. Slowly drawing on it is such a pleasurable, centering experience that it might be likened to meditating. The relationship between material and creation, between lithographic stone and lithographic image, is perhaps best stated by artist Barnett Newman in the introduction to his portfolio of lithographs, *18 Cantos,* printed in 1964: "Lithography is an instrument. It is not a medium. It is not a poor man's substitute for painting or for drawing. Nor do I consider it a kind of translation from one medium to another. For me it is an instrument that one plays. It is like a piano or orchestra and as with an instrument it interprets. . . ."

The creative work you do in lithography will usually involve *dry* lithographic materials, such as pencils and crayons, and *wet* painterly materials such as tusches. Renderings created with litho-

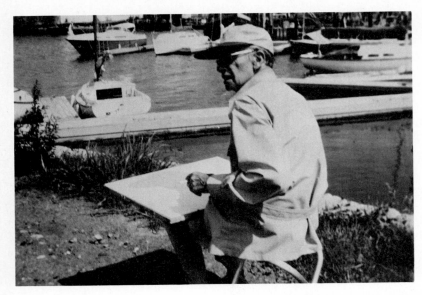

Figure 3.1a
Photo by Mace Wenniger.

Stow Wengenroth drawing on location in East Gloucester where he drew the preliminary sketch for the lithograph *Gloucester Evening*, which he created to illustrate lithographic drawing techniques for this chapter.

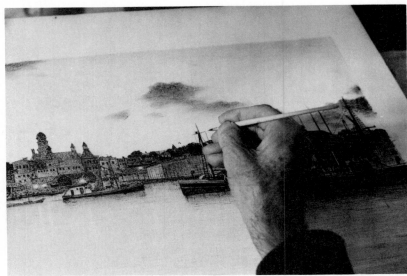

Figure 3.1b
Photo by Mace Wenniger.

Stow Wengenroth demonstrates the dry brush technique.

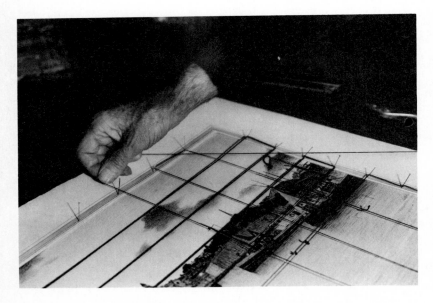

Figure 3.1c
Photo by Mace Wenniger.

Since Wengenroth made his drawings almost a third larger than his finished lithographs, he reduced them later by sectioning his drawing and reducing it faithfully onto tracing paper, which would then be reversed onto his stone.

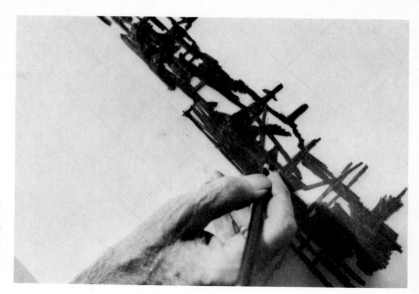

Figure 3.1d
Photo by Mace Wenniger.

Wengenroth blackens the right side of the paper, working over his drawing, which still remains clear. He did this in order to put graphite on the image so it could be traced from the reverse side.

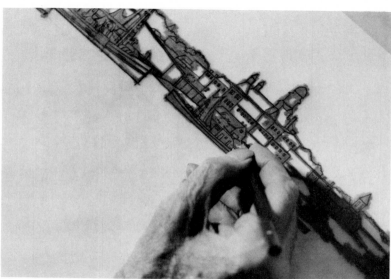

Figure 3.1e
Photo by Mace Wenniger.

With his tracing paper reversed, the harder pencil lines of the image stand out as a guide for the transfer. Wengenroth transfers his outlined shapes to his stone. The graphite tracings on the stone are strengthened later by going over them lightly using a #4 or #5 graphite pencil with a sharp point.

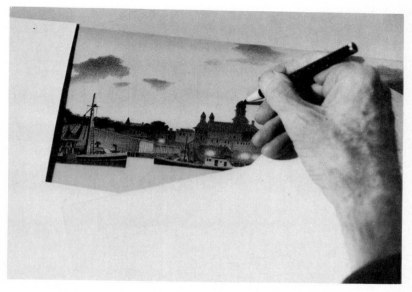

Figure 3.1f
Photo by Mace Wenniger.

In this piece, *Gloucester Evening*, by Stow Wengenroth, the stone is shown when the image was nearly completed. We see Wengenroth "tickling up" his image. He turns his stone and works over the same places from other directions, with his #2 pencils, to ensure even coverage of the grains of the stone. Note how the paper placed beneath his hands protects his image from any unintentional grease deposits.

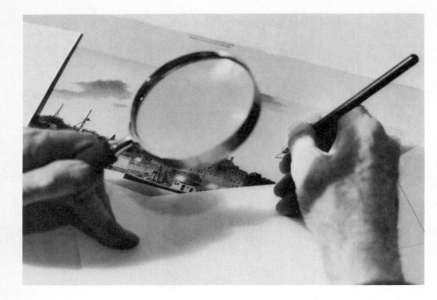

Figure 3.1g
Photo by Mace Wenniger.

After the image has been refined and values harmonized, an etching needle is used to pick out sick dots (an elongated dot made by pencil or crayon worked in one direction only) and point up the texture of the stone. Sandpaper, razor blades, or a sharp knife can also be used. Wengenroth checks the complete surface with his magnifying glass.

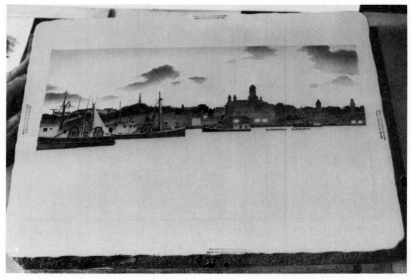

Figure 3.1h
STOW WENGENROTH
Gloucester Evening
Photo by Mace Wenniger.

Wengenroth's complete drawing of *Gloucester Evening* (now a rare print) shown on the lithographic stone, ready to be processed and printed.

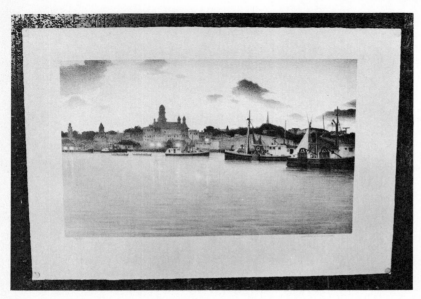

Figure 3.1i
Photo by Mace Wenniger

The finished print of *Gloucester Evening*. Wengenroth suggested working on one part of the stone at a time in order to achieve complete control. But at certain intervals it is important to check the way the complete image works. Make sure that all parts of your image harmonize as this one surely does.

graphic pencils and crayons on a lithographic base resemble classic drawings, but go far beyond in tonal richness and variations, as illustrated by George Guest, who uses lithographic crayon on zinc plates. As you explore image-making with lithographic rendering materials, remember to exploit the hillocks on the lithographic surfaces. See what the interaction between these special pencils and crayons and the stone or plate will produce for you.

Making lithographic wash drawings with tusche products on stones and plates requires an understanding of how tusche products act. You will be excited by the drama of a brush stroke pulling across and then drying on the surface of the stone or plate; tusche worked into water dries with a delicate range of gray tones and crenulated shapes as the water evaporates on the lithographic base.

You should adapt the suggestions in this chapter for using these drawing materials to your own particular style. Many artists mix both crayon and tusche work on one image. The main idea is to exploit the versatility of lithographic materials.

Your first step should be to make a test plate or stone as suggested in Chapter Eight. Besides working with the lithographic crayons, pencils, and tusches, you can create images with anything greasy, including soap, lipstick, fingerprints, or transfers of natural materials and photographs.

Another popular approach used to create a lithographic image involves drawing with lead pencils or opaque materials such as acrylic paint or gouache with Mylar as the drawing base instead of stone or plate. The drawing is then transferred photographically to a lithographic base.

Although you will probably begin by working on litho plates, try to use a lithographic stone as your base as soon as you can, so you can experience the classic approach to lithography. The warm soft texture of the stone invites a drawing; the porosity of the smooth but grainy surface invites a wash.

Creating a lithographic image can run the gamut from the modern method of transforming a Mylar-based drawing into multicolored lithographs to a classic drawing with a hard lithographic pencil or crayon worked on the lithographic base over and over again to produce delicately toned images. There are many ways you can make your image; the most important thing is to understand what is possible and then to begin. The worst thing is to become frightened by the clean stone or plate and to postpone beginning.

This chapter presents some of the different ways to make your first lithograph. I hope that the assorted array of options will interest you so much that you will start several plates at once.

STARTING YOUR IMAGE

Making your lithographic image involves choices. You can work directly with lithographic tools on your lithographic base, or you can work indirectly by first starting your image-making on another surface, such as transfer paper, or within other mediums, such as photography, and then apply it to your lithographic surface to be worked up to a final image. There are advantages to both approaches.

DIRECT LITHOGRAPHIC IMAGE-MAKING

Working directly means that you take a freshly grained stone or counteretched plate (see Chapter Four), with no grease marks on it, sharpen your lithographic pencil or crayon, liquify your tusche and simply begin to make marks on your lithographic surface without the preliminaries of transferring or reversing a preliminary drawing.

Working directly on stones and plates encourages experimentation.

Start by using plates because they are more easily obtained. Arrange several small plates on a working surface. As you draw on the plates, you should become more at ease with the lithographic drawing materials and using the lithographic plate as a drawing surface. You will find that creating your image directly on the plate or stone enables you to relax within this new medium and to no longer be intimidated by it.

Since the thrust of this book is to encourage you to make color lithographs as well as black and white, I encourage you to try this approach: Make several plates at the same time to be parts of the same multicolor image, on the assumption that a few might work and some might be discarded. This will enable you to have all the plates ready for printing simultaneously so you can try them out in several color combinations before printing your edition.

The advantage of not using a preliminary drawing is a certain freedom and energy evident in a work drawn directly on the plate or stone. You will start to experience the unique surface of the lithographic base; working on this slightly grainy surface will stimulate your creativity.

There are several ways to work directly on your base. You can start by making thumbnail sketches on paper, and then select one for development. You can

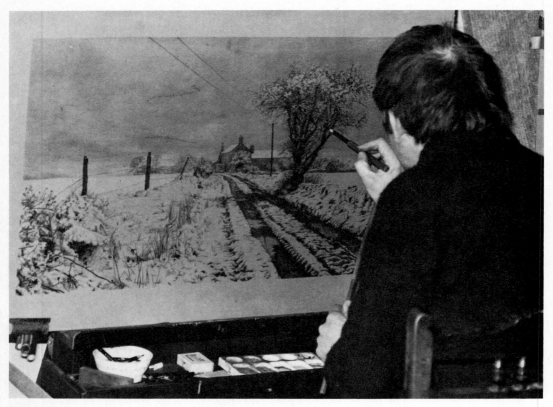

Figure 3.2
Courtesy George Guest. Photo by Charles Robarts.

George Guest works continuously for one week, drawing his main or "key" image on a
zinc plate as the first step in making his color lithographs. After this image is printed
in black ink, color is added by plates carrying tints.

cut up your plate into half- or quarter-plates and take
small plates and lithographic materials with you to
work directly from nature. You can draw with conte
crayons to begin with and then work into it with
lithographic drawing materials.

LITHOGRAPHIC
RENDERING TECHNIQUES

Rendering space with light and dark tones that re-
veal forms; using lines, textures, and masses to help
define an image—these are the concerns of the
lithographic artist.

Lithography can enhance these artistic goals.
Because of the interplay of the lithographic grain or
hillock and crayon and pencil, a lithograph can be
created with sensitively modelled lights, gradually
building up to more and more powerful dark tones.
And working with liquid drawing materials, a

lithographer can create textures and tones made in
no other print medium.

Creating with Litho Pencils
and Crayons

Lithographic pencils and crayons can be used with
great spontaneity or with control. A crayon can be
broken or used flat on its side. A pencil can be dip-
ped in solvent and dragged lightly across the
lithographic surface.

These crayons and pencils have been devel-
oped in seven degrees of softness or hardness which
correspond to the effects they produce on the image
rendered, ranging from rich velvety darks to light
delicate tones. The hardest crayons and pencils (#5)
produce crisp, firm light strokes; the softest, (#0 and
#00) produce dark strokes. Learning how to use all
of the crayons and pencils together properly is the
challenge of lithographic rendering.

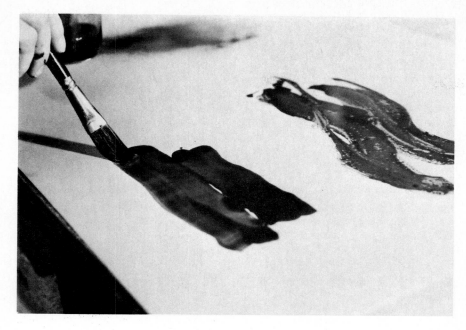

Figure 3.3
Photo by Mace Wenniger.

Artist pulls a flat wide brush fully loaded with tusche solution across zinc plate in two short decisive brush strokes. This treatment dries as a solid tone. Above are strokes made with diluted tusche solution.

Lithographic rendering with pencils and crayons involves two concepts:

1. Layering the drawing materials
2. Tickling the image

LAYERING

Layering means gradually building up the drawing materials on the base. It is the classic way to maintain control while drawing lithographically, and it enables you to take full advantage of the grainy character of the lithographic surface while preserving its minute hillocks.

The range of soft and hard lithographic pencils and crayons was developed so that a firm dot of grease made with hard crayons or pencils could be the lithographic artist's starting point. If only a soft crayon or pencil (#0,1) is used, the hillocks are soon completely covered with grease, lose clarity, and the image coarsens. Starting with a hard crayon, adding to it with medium-soft crayon marks; and then finishing with a soft crayon keeps each grease-laden hillock crisp and separate and results in well articulated image readily recognisable as a drawing made on a lithographic base.

The opposite approach—to attack an image randomly using the softest pencils and crayons hap-

Figure 3.4
Photo by Mace Wenniger.

Here is a sketch of the lithographic surface as drawn by Wengenroth to illustrate the importance of using an extremely well-sharpened point on your pencil or crayon. The larger mass represents a blunt pencil which only hits the tops of some of the grains. Sharp points hit the sides of the peaks as well when the pencil point is moved.

hazardly—usually results in a drawing that is not only smeary and blurred but also is difficult to maintain through each subsequent printing step. The blacks that seem so beautiful and spontaneous might lift during processing or thicken during printing. Careful layering, on the other hand, produces a stable image which rarely lifts during processing and printing.

Layering with a #3 Pencil or Crayon. A beginning lithographer will find it easiest to layer with a middle-range crayon or pencil. Plan to use only the #3. First, draw with a light pressure so the grease-covered hillocks are still distinct. Gradually increase the amount of grease deposited, but be careful not to press the crayon randomly across the plate or stone. Gently build up your light and dark tones until your image is finished.

Classic Layering Method. This way of drawing is an integral part of the lithographic tradition. Lithographers usually layer with their crayons and pencils, starting their drawing with a hard pencil or crayon and gradually intensifying values with the softer ones.

Working this way is more difficult for the beginner, but you should try it after you become more comfortable with lithography. Begin to draw with a hard pencil or crayon (#5 Korn). Work it on a plate or stone; notice that using a #5 produces a pale gray tone. Adding softer crayons or pencils will produce gradually darkening values. Add layers with progressively softer drawing tools. Use #4, then a #3. Then make the richest blacks by working over drawn areas with #2 and #1 crayons and/or pencils. Turn your stone or plate as you work.

While you draw, cover your stone or plate with a piece of cardboard or a bridge, a slightly elevated piece of wood that sits about one-quarter inch above your drawing surface. Rest your arm on one of these devices so no moisture or grease from your arm or wrist will get on your base.

Work at first with a crayon rather than a pencil. Most students find the crayon easier because it is thicker and therefore quicker. With a litho pencil, on the other hand, you can produce incredibly delicate drawings.

TICKLING THE IMAGE

The classic approach to lithographic drawing involves the slow buildup of beautifully controlled tones. This is known as *tickling the image*.

To do this, it is necessary to come to a clear understanding of the way the drawing tool is worked on the stone or plate. You should work with a sharp pencil or crayon from all directions, going every which-way on the grains of the stone or plate until a

tone is gradually built up to the intensity sought. A pencil or crayon without a sharp point, used heavily, lays down too much grease on each grain.

The pencil should be held far from the point, so your arm can move freely. Some lithographers put a crayon in a pencil holder. The objective is to work for a firm, round dot by slowly caressing the plate or stone surface with your drawing tools. Build up your image gradually.

Draw lightly over the part of the image on which you are working. Work up to full value slowly in terms of light and dark. End by going over the image and harmonizing the values.

Turn the plate or stone as you work so that the dots are built up from all sides by the crayon, which you move in turn onto the grainy surface from all directions. Again you must be careful not to rest your hand or arm on the base, as any grease from the hand or fingers may print. Cover all but the area on which you are working with some kind of protective material, such as a piece of mat board or a felt blanket.

Avoid the *sick dot*, a dot elongated by working in one direction only. This dot has a small tail that is a false dot. This is important to note, because it wears away in printing or is accidentally etched away, leaving the image reduced in intensity.

This kind of careful drawing on the stone takes many hours to execute, but the effects can be so unique and beautiful that the drawn lithograph becomes an artistic work.

Other Ways to Work with Crayon and Pencil

There are other materials and methods that lithographers find effective. Different effects can be created by working through a stencil with crayon or by using rubbing crayon.

Rubbing Crayons. Short, thick bars are used to create soft, smoky effects. Rubbing crayons come in hard, soft, and medium grades. All rubbing crayons are equally greasy (unlike pencils or crayons) but vary in firmness to produce different drawing possibilities: a hard stick produces a lighter, crisp tone; the softer sticks, a dense, darker tone. Rub the crayon with a piece of nylon, silk stocking, or chamois. When the material is charged with crayon, rub it on the stone or plate sparingly, slowly build up tones. The husky, soft character produced lends itself to atmospheric effects.

Crayon Through a Stencil. Use stencil paper as a mask. Work over it with ordinary litho crayons or rubbing crayons. Build up tones gradually as described earlier. Working this way produces crisp edges.

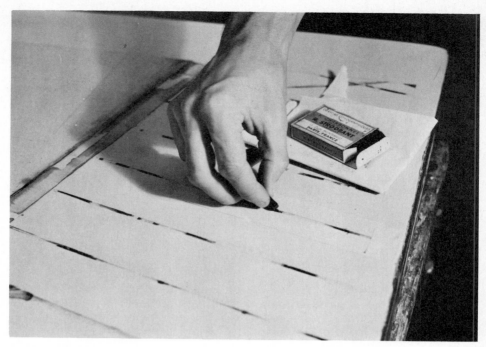

Figure 3.5a
Photo by Mace Wenniger.

Lithographic crayons are worked onto base through masking tape stencil, which is later lifted off. This makes crisp lines and adds variety to a lithographic drawing.

Figure 3.5b
Photo by Mace Wenniger.

Listo lead holders with many small well-sharpened Listo leads are used by David Thomas to enhance his drawings of faces and plants on aluminum lithographic plates. In order to build up a sensitive crayon drawing like this one, Thomas often works on a piece almost continuously for 35 hours. He used 60 Listo leads for this drawing alone. By the time his image is complete, there are no noticeable directional pencil strokes.

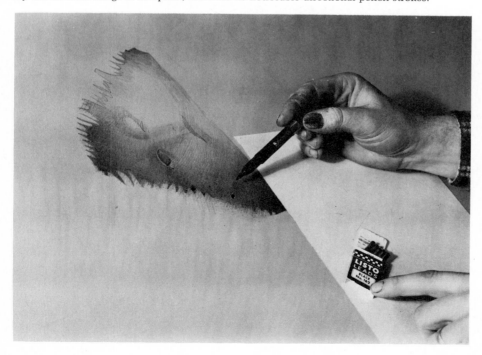

Listo Leads. China marking pencils are utilized almost exclusively by artist C. D. Thomas, who draws for as many as sixty hours on a single image, and thus uses many pencil points. The china marking pencil is composed of essentially the same materials as the lithographic pencil, but its form is different; small inexpensive leads are inserted in the plastic china marking pencil holder. For Thomas, this has proven to be a much more economical method of working, as he would otherwise go through many expensive pencils for one image.

Creating with Lithographic Tusches

Working in a painterly manner on a lithographic stone or plate means familiarizing yourself with the greasy solution called *tusche,* a black liquid composed of wax, tallow, shellac, soap, and lampblack. It comes in bar form, as a paste in a can, or as a liquid in a bottle, and is used as a paint-like substance.

Since spontaneity always adds sparkle to a work of art, the fresh quality of tusche work can encourage creative activity by the lithographic artist. Accidents and transformations that happen in spite of attempts at control can stimulate new ideas and lead to interesting innovations.

All tusche products can be diluted with either distilled water or solvents to act as a wash. Reserve one can of tusche for use with water and another for use with solvents; the effect of either will be diminished if they are mixed.

Tusches are used in solution form to produce gradations of tones as well as solid black lines or areas. Tusche solutions arrange themselves in delicate linear ring formations and sometimes in broken dotted arrangements when dropped onto a wet litho stone and left to dry naturally. The more water and/or solvent in the tusche solution, the more the tusche will form rings, especially on stone. These rings are called *reticulations;* the fineness of such a pattern when stabilized and printed is one of the attractions of good lithography.

If you find you enjoy using tusche in lithography, the most suitable product for delicate to heavy washes is a canned tusche, Encre Lithographique, by Charbonnel. It is favored by lithographers because it breaks into beautiful forms as it dries.

Use bar tusche by preparing it in the following manner: Melt the tusche by rubbing the bar on a plate which is being moved over boiling water. Add either distilled water or turpentine to the tusche and mix it with a brush, making a thick or thin wash, then use it in washes of varying intensities like a water color.

TUSCHE WATER WASHES

Tusche water washes might be compared to watercolor in transparency and delicacy and in possibilities they offer for different brush effects. How fully the brush or sponge is charged with pigment and water will determine the lightness or darkness of the strokes when they dry on the stone or plate. Undiluted liquid tusche used from a bottle and tusche from a bar or can with just enough liquid added to make it useable will print as a solid.

The appearance of a dried tusche wash can be deceptive, however, when one tries to determine how it should be processed. In tusche work the

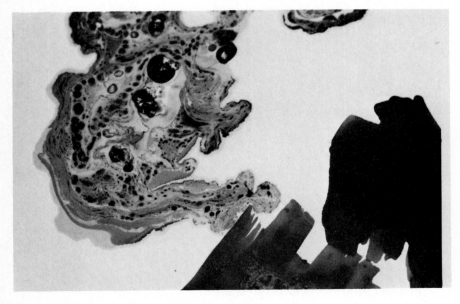

Figure 3.6
Photo by Mace Wenniger.

Charbonnel paste tusche puddled in water on the stone creates peau de crapeau or frog skin effect as it dries.

amount of grease that dries on the lithographic base is often greater than the amount of black pigment that appears. There is usually more grease than the pigment presents to the eye.

The best way to become familiar with tusche products and how to dilute them with water to make varying strength washes is to prepare a tusche scale. First use the full-strength tusche, and then add more and more water. Brush sample strokes of each mixture on a sheet of printing paper, making a chart that ranges from black to light gray. This will act as a guide when you are doing washes on your image. Make a notation on your chart regarding how much water has been added each time.

To prepare trial solutions with bar tusche follow this procedure: First, to make a stock solution that will produce opaque black, combine two ounces of distilled water with bar tusche until paste consistency is reached. Take six small discarded bottles with lids and put an equal amount of the paste you have made in each bottle. Then add an equal amount of water to the first bottle, and keep doubling the water in the rest of the bottles. Mark the bottles and make test strokes on stone or plate, using a clean brush each time, to see what shade of gray each contains. Remember that here also a diluted solution holds more grease than the intensity of the wash would indicate, and that all strokes will print darker than the marks on the stone or plate.

TUSCHE-SOLVENT WASHES

Mixing solvents such as turpentine, lithotine, or acetone with tusche products produces a solvent tusche which is distinguished, when printed, by increased viscosity, density, and dark tones. Solvent tusche penetrates the surface of a lithographic plate or stone much more deeply than water tusche. Hence, it is harder to etch and often prints darker than the original drawing.

Solvent tusche is often applied with the aid of a gum stop-out. If gum arabic (water-soluble) blocks out an area selected to remain white on your plate or stone, you can go over the gummed-out area with a brush loaded with solvent tusche without worrying about coloring the gummed passages.

Other solvent tusches are made when

1. Solvents are mixed into water tusche puddles on the lithographic base or, conversely
2. When water is mixed into solvent tusches, or
3. When water tusche is mixed into solvent tusche. This combination causes tusche to separate into dots, producing a mottled appearance.

SPECIAL EFFECTS

Play with tusche in various ways to create a variety of effects, such as the following:

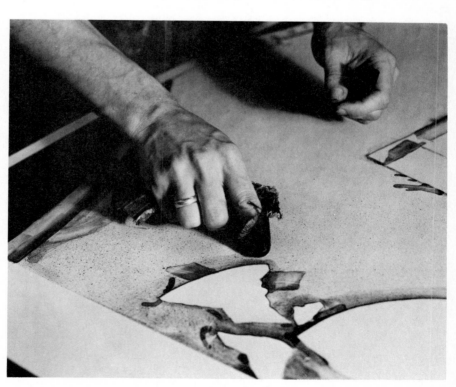

Figure 3.7a
Photo by Mace Wenniger.

Rubbing crayon in artist Ripley Albright's left hand. Albright rubs this soft substance onto his stone using a cloth. This soft stick, a crayon waxy substance, is often used on a piece of chamois or small cloth, as pictured. Here a contact paper stencil was used so that the artist would get a hard edge on his softly rubbed marks.

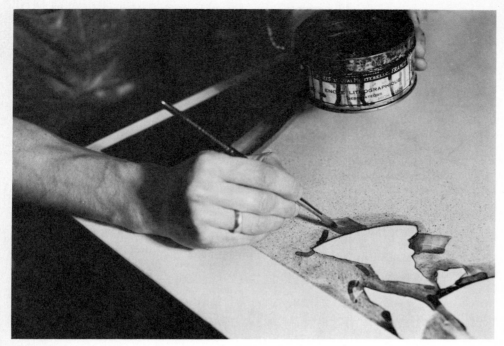

Figure 3.7b
Photo by Mace Wenniger.

A popular tusche is "Encre Lithographique," a French product produced by Charbonnel. It is a paste tusche, packaged in a can: it can be diluted for use either with water or solvents or a combination of both in order to produce transparent washes or mottled effects.

Figure 3.7c
Photo by Mace Wenniger.

This artist, Albright, uses an atomizer, dipping the thick, short end into Korn's liquid tusche and blowing through it. Autographic ink or tusche solution made from a stock can be used. Mask out white areas with masking tape or contact paper. Spray the stone or plate from three to five feet away. You will get a finer dot if the spray shoots above the stone and filters down; working from an angle close to the stone produces a thicker dot or splatter.

1. *Broken-dot effect.* Brush solvent tusche into water or water tusche into solvents. This will dry with an interesting dotted or mottled pattern.
2. *Peau de crapeau.* A tusche-and-water or tusche, solvent and water solution dropped into water on any plate or stone tends to oxidize as it dries. The peau de crapeau, "frog's skin," effect occurs when water tusche solution dropped into water on a zinc plate breaks down into a strange formation of globular shapes and rough circular lines.
3. *Spattering.* Tusche can be used with a spatter technique by blowing it through an atomizer or stippling it from a toothbrush. Stippling or spattering can produce a scintillating effect in a lithograph, especially when several colors are to be combined in a color print.
4. *Manière noire.* Here, layers of tusche are put on a stone. When it is all dry, it is worked into with a tool to expose the clean surface of the stone and produce tonal gradations. This technique permits working from a dark background to lighter forms.
5. Drop sawdust, salt, sugar or other absorbent items into a wet tusche-wash area. These materials will break up the tusche, causing it to dry in a dotted or pebbled fashion.
6. Put textured materials into tusche, and apply them to your stone or plate to achieve interesting new patterns.

AUTOGRAPHIC INK
(OR ZINCOGRAPHIC INK)

This material is a water-based tusche which comes canned in a liquid form. It produces solid lines and areas; it is not recommended for washes. Although it is a brown liquid and transparent when used, remember that it prints as a solid black.

Work with autographic or zincographic ink to make line drawings in a direct, calligraphic, painterly way. Apply it with crow-quill pen or Japanese or watercolor brushes.

Use autographic ink to spatter or spray. Or if you need a solid area, use two layers of this ink to obtain complete coverage, waiting for each layer to dry before adding more.

INDIRECT LITHOGRAPHIC IMAGE-MAKING

Working indirectly means making preliminary images, resolving a final sketch, and then transferring it to a lithographic base. This method enables you to perfect your image first, to correct your composition, to try out what will be dark and what will be light in your image.

If your image is resolved by the time it is transferred to your lithographic base, you are free to concentrate on the subtleties of the new medium, to realize fully what the lithographic tools, drawing pencils, and tusches will do for you.

Figure 3.8
Photo by Mace Wenniger.

Mezzotint or *Manière Noire*—Scraping off tusche with a razor blade creates a unique lithographic drawing effect. A solid black image has been formed with tusche (possible only on stone), dried and then scraped, scratched, and picked until a rich, smoky effect is realized. The scraping in this "*manière noire*" test stone lightens the image but grease is still left in the pores of the stone. This technique needs a strong etch so it won't fill in during printing.

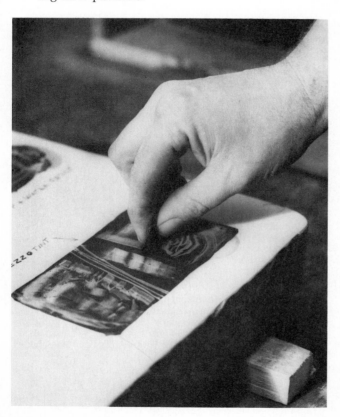

Working indirectly also enables you to take advantage of contemporary image-making possibilities. You can incorporate photographs, transfers of photographs, and textured materials into your work and create on Mylar with non-lithographic drawing tools.

Preliminary Image-making with Drawings and Photographs

You can begin by using a photograph as a guide and translate an image from the photograph onto the lithographic base.

Another way to begin is to work out your ideas in thumbnail sketches and then enlarge your favorite sketch into a full-size drawing. This acts as a fairly exact guide for the lithographic drawing—or as a color key for a multicolor print.

Tracing an Image onto the Lithographic Base

There are several ways of tracing a preliminary drawing to a stone or plate. The easiest way is to draw it on tracing paper. Because of its transparency, tracing paper enables you to use the image either as you draw it or in reverse. When you transfer a reversed image, to a lithographic base, it will print as it appeared in the original drawing.

TRANSFER METHODS

There are several methods you can use to facilitate getting the image from the tracing paper to the litho base. Place a transfer sheet made with either red conte chalk or pastel or lead or graphite on the drawn side of the tracing paper. Then, using a sharp pencil, trace the image onto the lithographic base through this transfer layer.

Use Red Conte Chalk. A popular method of transferring an image involves the use of a red conte chalk transfer sheet, which can be saved and used again. Making one is easy. Saturate a cotton swab with alcohol and dip it into a cup containing ground-up red conte chalk or red iron oxide powder, which is known as carpenter's chalk. Spread the substance on newsprint or tracing paper, and let it dry. When dry, it is like carbon paper. Lay it chalk side down on the stone or plate, and place the tracing paper on top. Use a *hard* pencil to draw over the image on the tracing paper and transfer the image.

Pastel Chalk Sheet. Another transfer material is pastel chalk. Use it to make a transfer sheet in the same way you crafted the red conte chalk sheet.

Chalk Offsets. Chalk offset is an image-transfer method which is often used in creating a sequence of color plates or stones.

Sprinkle a fine powder of ground-up conte or carpenter's chalk on a recently inked, still tacky proof. Transfer a ghost image onto a clean plate or stone by putting the chalk-covered proof through the press, face down on the plate or stone.

Graphite. Some lithographers, such as Stow Wengenroth, prefer rubbing with a soft (6B) lead pencil or graphite on the tracing-paper image because they dislike the red haze that chalk leaves on the clean stone or plate. Once the original image is drawn with a hard lead, softer lead is used to rub over the lines of the drawing. The difference in lead

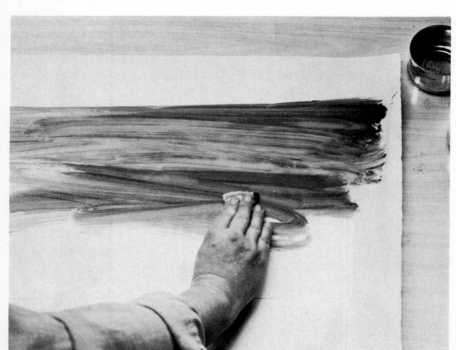

Figure 3.9a
Photo by Mace Wenniger.

Jan Hueras rubs newsprint with a cotton swab soaked in alcohol and dipped into powdered conte chalk. The alcohol makes the conte stick to the paper. When it evaporates, it leaves a dry film of the red powder. Later the conte sheet is turned face down on the aluminum plate, where it will be used to transfer guide lines and details from her master drawing.

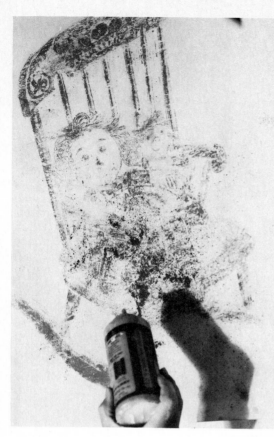

Figure 3.9b
Photo by Mace Wenniger.

Using a proof still tacky with black proofing ink to transfer is fairly simple. Sprinkle powder (lumberman's chalk or conte chalk) as illustrated over the entire proof, and then shake the proofing paper to distribute the powder and release it from the nonimage areas. This chalk-covered proof is laid face down onto a clean plate or stone which is waiting on the press bed. They are both covered with the tympan, and the transfer "package" goes through the press with moderate pressure.

Figure 3.9c
Photo by Mace Wenniger.

As the chalk-covered image is put through the press on a clean plate, the transfer occurs. Here the author points to the red chalked image which will guide her as she works up her next drawing for a multicolor print. The transfer sheet can be used again, but it will give a yet fainter impression.

hardness makes the image visible when the paper is reversed so that the image can be carefully retraced on the reverse side, which transmits the lead or graphite onto the litho base, leaving a distinct impression on the stone or plate.

The one problem with graphite is that it is difficult to distinguish from lithographic pencil. Therefore, when you are drawing the image, you may find it hard to differentiate between what you have drawn and what has been transferred, especially when you are dealing with subtle lines. This is an important consideration because it influences how strong or weak an etch should be applied to the image; a less strong etch is always applied to transferred imagery.

CREATING WITH TRANSFERS

Ever since lithography was invented transfers of images from surfaces other than a lithographic base have been effectively made by lithographers. In fact, Senefelder, the inventor of lithography, initiated the use of lithographic transfer paper to transcribe and print his musical notations. Transfer lithography has been especially popular since Robert Rauschenberg incorporated both photographic images and newspaper transfers into his work during the 1960s.

The use of transfers adds a tremendous sense of immediacy to your lithographic imagery. The sources of this type of imagery can be:

1. Drawings made on specially prepared lithographic transfer paper or with transfer ink
2. Photographic images transferred from magazines and newspapers
3. Photographic images enlarged on negative or positive film
4. Materials found in the environment

This part of the drawing chapter explains how to transfer drawings, materials, and photographs onto a stone or plate, as well as how to use transfer ink. The transferred images can be processed as completed lithographs or become the starting point for further work added at a later time.

Transfer Paper And Transfer Ink

Senefelder developed transfer paper, noting in his "Treatise on Lithography" that transfer lithography was probably the most useful part of his discovery. He invented a coated paper that could deposit a drawn image on the surface of the clean plate or stone, ready to be added to with further marks or processed for the next printing step. The transfer paper I recommend is called Coté Colle, which is produced in France. Its shiny drawing surface makes it resemble white shelf paper; it must be used soon after purchase to ensure success.

Transfer ink, greasier than other inks, is used to transfer images readily from one surface to another. It can be used for creating an image directly on transfer paper or to ink up an image on a plate or stone in order to transfer it or the offset of it to transfer paper or to a prepared lithographic base, glass, or a metal surface so that an impression of this monoprint can be picked up on transfer paper. Transfer ink also facilitates transferring an interesting texture, either directly on plate or stone or onto transfer paper.

As a beginning lithographer, you will find that the use of transfer paper and transfer inks can be tremendously helpful. Here are a few of their advantages:

1. Transfer paper and transfer ink enable the artist to make several different drawings before one is chosen as the image that he will print as a lithograph.

2. Transfer ink encourages quick, spontaneous creative work which counteracts the tightness of other lithographic drawing tools.
3. Transfer paper can do away with the inhibitions associated with the unmarred surface of a clean stone or plate. One feels much less hesitant about making marks on paper.
4. Transfer paper eliminates the need to work in reverse. This is a distinct advantage for a figurative artist or for an artist who cares about directional placement in a work. An added advantage is that words can be used in your image.
5. Transfer paper can be taken with you to life drawing classes or outdoors to make direct nature drawings. The white transfer paper makes it easier for a lithographer to judge how the printed piece will look on white printing paper. This is particularly important for the beginner, since the gray surface of the stone or plate often adds a unifying middle tone to a drawing, a tone that is later eliminated and missed when the drawing is printed.

To make a transfer drawing, use either lithographic crayons, tusche, transfer ink, or other grease-holding substances to create an image on your lithographic surface.

Transfer Procedure

To do a transfer, you must begin with a clean plate or stone (allow for one-inch edges) and an image that fits the space, created on the shiny side of the transfer paper with lithographic crayons, tusche, transfer ink, or other greasy substances. In the photographic demonstration following, Thom O'Connor, creates rapidly and spontaneously with a mixture of transfer ink, turpentine, and asphaltum to which he later adds marks with lithographic pencils.

Values should be intensified when drawing on transfer paper because some of the more subtle tones can be lost during the transfer process.

To release the image from the transfer paper, place the paper image face-down on a dampened stone or plate on the press bed. The back of the paper is dampened with warm water and passed through the press a number of times inside a printing sandwich until the picture drops off the paper and adheres to the lithographic base. The paper is then lifted off, and the image is processed, inked, and printed.

The transferring of images from paper to base is a tricky process which must be undertaken with an

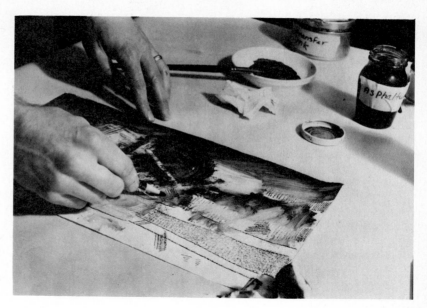

Figure 3.10
Photo by Mace Wenniger.

Artist works over the dried transfer ink with a number two lithographic pencil. The greasier crayons and pencils are recommended for transfer processes.

attitude of suspended judgment. Transfers are not always successful; the procedures must usually be learned by trial and error.

Here are a few recommendations to help you accomplish a successful transfer.

1. Once you begin to transfer a drawing, plan to work rapidly and without any pauses.

2. Because delays can cause air bubbles to form under the transfer paper and prevent the image from bonding completely to the plate or stone, it is extremely important to have on hand all the materials needed for each step when you begin. These materials are: chalk; two clean sponges, one of which has been dampened; a bowl of warm water; aluminum foil; several sheets of newsprint slightly larger than the plate or stone; the press tympan; a scraper bar that is slightly smaller than the stone or plate; and a putty knife.

3. It is important not to wet the transfer sheet too much, as the transfer paper gets *over-ripe*, or too soft, and tends to slip and buckle as it goes through the press.

4. Each time the transfer is put through the press, it is necessary to lift the edge of the tympan to check exactly what has happened.

Gasoline Transfer Method

Printed images gathered from newspapers, magazines, family albums, posters, and other sources can be incorporated into your lithographs by this method of photo transfer. First, take your photographs or magazine cutouts to an instant copy service or copy them on a copier set on "dark." Have the work reproduced as strongly as possible.

After the piece is reproduced so that it is dark enough, the second step is to attach this paper with tape, image down, to a clean stone or plate. Brush

Figure 3.11
Photo by Mace Wenniger.

Photo copy and image transferred to the stone. Working in this way the student was able to write on her collage directly, not in reverse, because by transferring the photo copy to the stone it became reversed and was printed in readable order. Note how clearly the transfer was made.

gasoline sparingly on the back of the paper; if gasoline goes on the stone, the image is likely to run. Immediately rub the back of the image with a rag, then work over it slowly with a flat tool, such as a burnisher or paintbrush handle.

Another way to make magazine or photo transfers is to spray or brush lacquer thinner directly on the plate or stone. Place the printed material (not photocopies) on the wet surface and put through the press with four layers of newsprint over the printing "sandwich" to help intensify the pressure of the press on the transfer materials.

Lift the edge at intervals and check to see how the transfer is working. Burnish with a flat tool to the press until the image is transferred. Rosin and talc the plate before etching it with plain gum. Then wash it out, rub it up with asphaltum, roll it up as usual, and etch with a very mild etch.

Photo Transfer

Printmakers often include a photographic step in their imagery. This is especially interesting in a multicolored image or in a complex black-and-white lithograph. While a photo can be rather dull in itself, it can be distorted, modified, or used in a way that creates tension, extends a given subject, and adds impact to your work.

Photographic lithography involves transferring a photographic image onto the lithographic base and then processing and printing it as a lithograph.

If you are not familiar with photographic processing, you should have a firm specializing in photo reproduction work prepare your photograph by enlarging it to the size desired and printing it as a halftone negative on a sheet of clear film called *ortho film*. You can also have your photograph put directly on a presensitized plate by a commercial printing firm.

You can do the photographic process yourself. Your first step is to print a negative in the size needed on the transparent ortho film. If the photographic image you are using is a high contrast, black-and-white shot of the right size, the negative is simply contacted from the original. If the photograph selected has a range of dark, light, and intermediate tones, to capture these tonal varieties it must be photographed again with a halftone screen placed between it and the sheet of film. The screen can vary according to your wishes from a coarse screen of 80 crossed lines per inch to a very fine screen. The screen separates the image into a series of fine dots, producing half the tonal value of the original image. The halftone negative resulting from this pho-

tographic step will be placed over the light-sensitive emulsion on the stone or plate to make a positive image when light shines through it.

Plates coated with a light-sensitive emulsion can be purchased from a commercial supply house, such as Polychrome Corp. or the others listed in Chapter Two. These plates are inexpensive and work well. However, since it is possible to work photographically on any lithographic plate or stone (with the attendant possibilities of working into the stone, scratching, or scraping it and adding to it), working steps are outlined below.

The second step in photo lithography, is to cover your stone or plate with a wash of light-sensitive coating. This commercial product is chemically formulated to receive a photographic image when it is activated by a strong light directed through the image on a film negative. Concentrated light acts on the light-sensitive emulsion and hardens it; this isolates the positive image and makes it printable after it is processed, and the unexposed negative areas are dissolved and washed away.

Assemble the three commercially available ingredients necessary for photolithography: the emulsion, which is prepared prior to use by mixing a powder with a liquid base solution; the developer, a black, ink-like substance; and the finishing solution, known as *AGE*, which provides a final gum-etch for the plate. The wipe-on solution and developer are used on the stone as well as on the plate; the stone, however, is finished with a mild etch of nitric acid and gum arabic.

Mix your light-sensitive wipe-on solution in a semidark room. (Use a darkroom light or yellow fluorescent bulbs in your work area.) Then apply the solution with a cotton swab in a thin layer, taking care to avoid streaks.

The third step: Ready your photo flood light, assemble your negative over it and the lithographic base, and expose it to light. In semidarkness, position the sensitized plate or stone on a table protected by newsprint if you are using a photo flood. Place the negative in close contact with the printing base; cover it with a sheet of clear glass the same size as the negative or larger. Expose the photographic sandwich to the floodlight for approximately five to ten minutes, holding the photo flood about eighteen inches above the table.

The light used on the negative film goes through the transparent parts of the film and activates or exposes them. The dark parts of the film will stop the light. Only the exposed parts of the image will respond to the lithographic developing solution applied as the next step in the photolithography process.

Figure 3.12a
Photo by Mace Wenniger.

Photographic negative is laid in reverse on a photo-sensitive plate and covered with glass. The work is positioned in semi-darkness so the light-sensitive plate will not be exposed. In this case margins might have been covered by pre-cut strips of black cardboard to eliminate the formation of a black frame around the picture by the margins' exposure to the light.

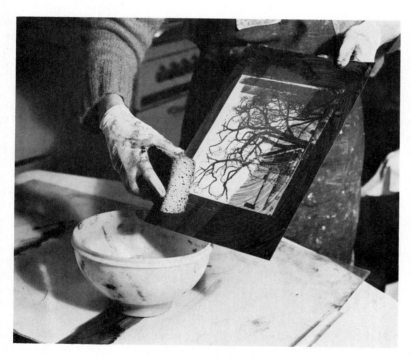

Figure 3.12b
Photo by Mace Wenniger.

Wash excess developer and finisher from the plate or stone with running water, using clean sponge or cotton. As both the developer and finisher stain the hands, it is wise to wear gloves. Process plate or stone with usual steps (see Chapters Four and Five) of etching wash out, gumming rub up and rolling up with ink.

If the right-left orientation of the picture means something to you, be sure to turn your negative over so your plate image will be a reversal of the way you want your final print to look.

Variables such as the density of the halftone dots on the negative film and the thickness of the surface coating demand different exposures in order to secure a crisp print.

PHOTOGRAPHIC STEP-TEST PLATE

It is important to set up a test-exposure situation to determine exactly how long a particular image needs to be kept under the strong light to produce a sharp print. Making a test involves placing your negative on an extra pre-sensitized plate and exposing different parts of it to the photo floodlight

for different lengths of time. In other words, take opaque material such as cardboard and move it repeatedly across the negative, exposing separate sections of the image to the light for set intervals of time which increase in arithmetical progression as more sections of the image are exposed.

The test plate must be rubbed up with the developer to show the artist how much exposure is necessary to preserve the details sharply. Too much exposure results in too dark an image and too little produces a washed out, unclear image.

Once the test plate or stone is developed and you have evaluated the correct amount of time required to secure a sharp image with your particular negative, you are ready to apply this knowledge. Expose your image to the light for the time just determined.

The fourth step: developing your image. The developer is a black emulsion which will show if the procedure has been successful when rubbed over plate or stone. When the plate is completely developed, the image will be intense. Rinse off excess developer with water, which also dissolves the unexposed non-image areas of the surface coating. The image areas that have been hardened by light remain on the plate or stone in a delicate state protected by only a thin layer of the developer.

The lithographic stone or plate now must be chemically processed to establish ink-receptive and ink-rejecting areas. This finishing procedure differs for stone and plate.

The finishing procedure is simpler for a photographic image on a lithographic plate where the commercial finisher AGE provides a gum etch as it is rubbed over the plate surface. The finisher is applied and then buffed.

A photographic image developed on a lithographic stone should be talced lightly and then etched with a mild etch of gum arabic and six drops of nitric acid. Use a sponge, and work in the etch with a light motion, taking care not to disturb the still-fragile photographic image. A photo image on a plate should also be etched with a light etch of 1/8 cup Pro Sol to 1 cup gum arabic.

After letting the stone or plate rest for twenty minutes, dissolve the image with solvent, apply an asphaltum rub-up coat, or use a turp-thinned black printer's ink rubbed on with a soft paper towel. Now, wash off excess ink or asphaltum with water, and gradually roll up the image with a roll-up black ink, pulling proofs until the image prints clearly. At this point, plate or stone can be counteretched and worked into with drawing materials.

Dust with rosin and talc, and apply a second etch.

The plate is ready to sponge with water, roll up with black ink, and make a test proof, as we call the first prints outside of the numbered edition. After proofing, the image can be gummed, the black ink can be washed out with turpentine, and the colored ink can be introduced. This rolled-up, fully inked photographic image on the plate can be resensitized, using counteretch procedures outlined for the plate in Chapter Four and drawn into, if you desire.

TRANSFER LITHOGRAPHY USING FOUND MATERIAL

In this section we will consider a method of transfer lithography which contribute a directness and immediacy to your work. A recommended technique for a spontaneous look is to transfer shapes and textures of found objects to a prepared plate or stone. This creates an image quite rapidly, often with unexpected and exciting results.

The lithographer can use this method to ink found materials such as textured fabrics, wallpapers, lace, burlap, rice paper, rusted and corroded metals, bark and flowers. The easiest way to begin is to roll out a soft ink like transfer ink or etching ink. Place the material on a washable surface and, roll the ink onto the material with a small roller.

The next step involves passing a large, clean roller over the inked material. The clean roller will pick up the image of the inked material and deposit it as an offset onto a plate or stone as it is carefully pressed over the surface.

The roller containing the inked image can be rolled repeatedly over the stone or plate in different directions to deposit the image, fainter with each roll, in an overlapping, delicate composition. Remember to keep the offset roller absolutely clean except for the image you are picking up. Be careful to remove all traces of any previous offset; wipe the roller off with turp and a clean rag before rolling it over any new material.

After the transfer of found materials has been completed, the plate can be drawn on with lithographic drawing tools; then it should be etched, washed out, rubbed with asphaltum, rolled up with ink, and printed following the procedures for processing and printing.

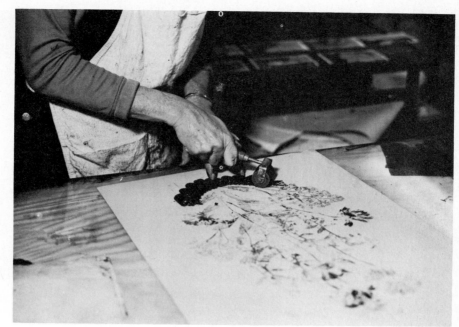

Figure 3.13a
Photo by Mace Wenniger.

Small rollers can also be used, as pictured, with other materials. This transfer plate is now ready for talcing and etching. In etching a transfer plate, since parts of the image are lighter or darker than other parts, the proportion of the Pro Sol to gum in the etch should be sensitively adjusted with less Pro Sol for the fainter image and more for the stronger.

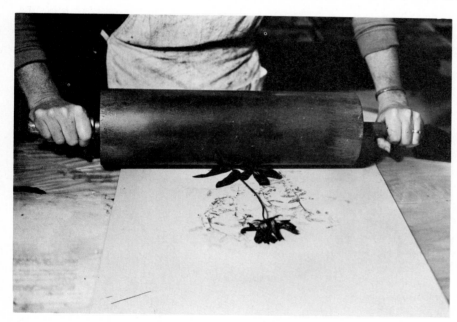

Figure 3.13b
Photo by Mace Wenniger.

A clean roller presses an inked blossom directly onto the plate. In this direct method of application the image may be darker than that resulting from an offset process, another alternative in which a clean roller first picks up an offset of the inked image, then deposits it on plate or stone.

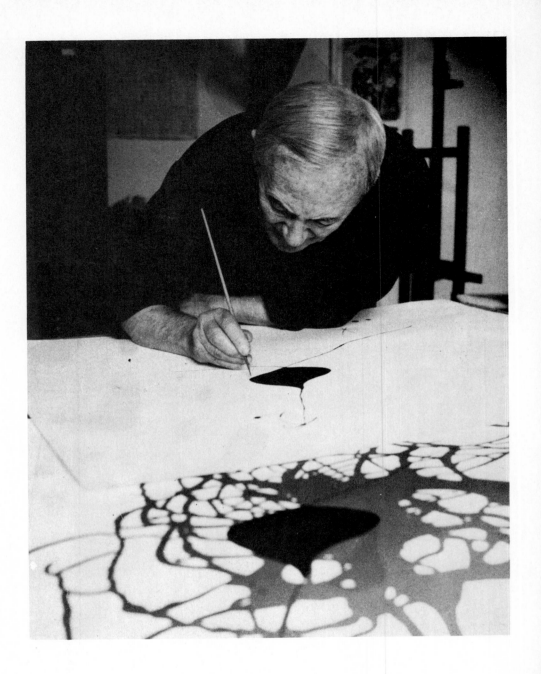

Metal lithographic plates have helped bring hand lithography to the fore as an artistic medium. Today every print-maker can do lithographic prints. Indeed, the availability, convenience, portability, and economy of litho plates of aluminum and zinc—which are manufactured with a granular surface approximating that of a stone—have helped create the surge of interest in lithography.

HISTORY

Metal plates were used as bases quite early in lithographic history. Because Senefelder worked on zinc plates and wrote about them in his book on lithography, artists and printers in Europe have worked extensively on zinc plates since the nineteenth century to exploit the advantages that plate lithography offers.

Plate lithography did not achieve the popularity of stone lithography, however, while the hand press was the principal means of printing a lithograph. It was during the early part of the twentieth century, when the motorized offset press was developed, that metal plates began to supplant stone lithography, first for commercial use and later for artistic uses. Although zinc plates continued to be used in European print workshops, aluminum plates

CHAPTER FOUR

The plate

were soon introduced in America, and since then they have been used for lithographic purposes by both printers and artists.

ADVANTAGES

Plates have obvious advantages over stones for the beginning lithographer: availability, inexpensiveness, portability, lightness, and manipulability. They can be readily used as an extension of a sketchbook. They can be cut into different sizes, large as your press scraper bar or small enough to fit under an arm or in a portfolio or a knapsack.

Plates enable you to capitalize on one of the advantages of lithography. Spontaneous drawings can be transformed into multiple impressions and then printed, just as drawn. You can take a plate to drawing class, to a life-drawing group, on an outing with you, or wherever you feel free to create. The drawing materials as well as the plates are lightweight and easy to carry.

Plates are also reusable (although this is not recommended for aluminum plates since the quality of the element deteriorates with each etch or counteretch) and require little storage space. They do not require the graining steps of stone, and they can be used without any preparatory steps if they are stored

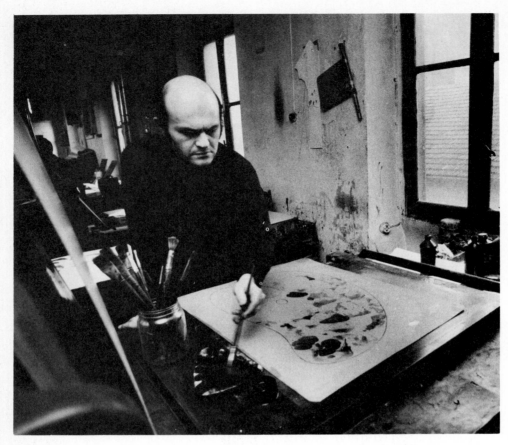

Figure 4.1
Photo by Ugo Mulas.

Jim Dine creating with tusche on a zinc
plate in a European studio.

Figure 4.2
Photo by Mace Wenniger.

To prepare the aluminum plate, the artist
uses a straight edge and a mat knife to cut
it to a size that will include at least two-
inch margins as well as the designated
image area.

in a protected state. They thus promote an immediate follow-up between inspiration and execution. They are quickly and easily processed, and they can be printed on an etching press in a pinch which makes lithography possible in most high school and college art rooms.

LIMITATIONS

Some of the limitations of plates should, however, be noted. First of all, the grain on a metal plate cannot be modified. Metal plates come with either coarse, medium, or finely grained surfaces. Once you select a plate with a certain grain, it cannot be made finer or coarser by the individual artist as a stone can.

Moreover, although metal plates can be reused after the greasy image has been dissolved and a strong counteretch solution has resensitized the granular surface, they do not have the reworkability of stones. They cannot take the scratching, scraping, cross-grain cutting that produces a striking halftone or a gleaming white accent in a stone drawn lithograph.

More important, aluminum plates do not "remember"—as old-time lithographers say the stone does. If the artist, during processing, forgets the greasy rub-up step on a stone, the image can still be recalled. It cannot be recalled on a plate if grease is not rubbed through the gum after a drawn image is dissolved with solvents on a metal plate, you can forget about that image; it will completely disappear once the wetting sponge goes over the plate surface. Aluminum plates do not "forgive," but making sure that this rub-up step takes place is a discipline that quickly becomes a habit when you work with plates constantly. If carefully washed out with solvents, zinc plates are a little more retentive, holding the image as stone does.

In spite of these limitations metal plates are wonderful to work with. They give far fewer problems than the stone to the beginning printmaker. But when a printing problem does occur, it's hard to cope with on a plate! To sum up: Plates are matter-of-fact to process, easily replaceable if a drawing goes badly, and adaptable to experimentation. Since there is no laborious graining involved in plate preparation, artists can work on several images simultaneously, with the intent of processing and printing those they like, and abandoning any that do not work.

Alternative Uses of Plates

Because of their availability and low cost, the option of creating several color plates at the same time becomes increasingly attractive to the artist. Several plates can be drawn simultaneously as color parts of the same image, then processed and proofed at one fell swoop, with an eye toward making sure that all the colors and drawings work perfectly together before starting to print the edition.

Flat color washes and photo montages on metal plates are often used in combination with drawings on stone to make a lithographic print. In Robert Rauschenberg's *Banner*, a four-color image, the stone adds scraped areas and tusche and water washes as accents to a dramatic photolithograph executed on aluminum plates.

After you become familiar with creating on and processing a plate, I suggest that you plan to work on two or three plates at once. Experiment with using extra plates to add background and accent colors to an image drawn on another plate; flat washes of background color from a plate printed on the paper before the fully delineated image immeasurably enriches work, or try printing your image on gray or tan Rives BFK or Arches buff paper. In fact, coloring the paper with a tint suggesting the color of the plate (or stone) itself is a step that every beginning lithographer should try because it helps sidestep the shock of seeing your image on white paper instead of on the gray (or tan) of the lithographic base you may be drawing. This look can also be accomplished by printing on hand-made paper which you might make yourself or purchase.

Start by making two plates: one with a carefully articulated crayon drawing and one, a tint plate made in the following way:

1. Measure the perimeters of your crayon drawing.
2. Outline this shape on your plate with gum arabic thinly laid on with brush or sponge. Etch this border by adding 6 drops of Pro Sol or TAPEM to your arabic solution first.
3. When the gum arabic is dry, spread with vinyl lacquer or asphaltum inside and overlapping the inside edge of the gum border.
4. Proceed to rubbing-up steps with blank ink. Talc and apply a moderate etch. Wash out and ink using any color. Although you can roll up a lacquer flat without this intermediate step, you will note that the pink lacquer can discolor your hues.
5. If any ink stays in the negative or border areas after printing, you should apply a light etch to the whole plate before printing further.

Print this plate using a background color under your pencil- or crayon-drawn image. Many artists use lacquer flats for roll ups of beautiful blended colors or rainbow rolls.

Before you begin, however, read the following sections on the characteristics of aluminum and zinc plates and exact directions for processing each of them, so they can be successfully printed as multiples.

TYPES OF METAL PLATES

Aluminum Plates

Aluminum plates are the most popular and the most available lithographic plates in this country. They can be ordered in a variety of large sizes and can easily be trimmed down to smaller sizes. They come with various granular surfaces approximating the effects of carborundums on the stone, although a coarse grain (117-140 grain) is generally recommended. Plates used for offset printing are made with a much finer grain, which makes them harder to handprint.

ADVANTAGES

The light gray surface of aluminum plates is attractive to draw on because a drawing will show up on it more clearly than on a zinc plate, which is darker in color.

Another important characteristic of aluminum plates is that they are hydrophilic, that is, more receptive to water than to grease. Aluminum plates are predictable and fairly easy to print without "scumming," a problem which occurs when non-image areas begin to break down and hold traces of ink. Since aluminum is water-loving, water stays tight on the non-image areas, which prevents scumming. If your aluminum plates are old and have oxidized, watch out for scumming. Be sure to counteretch older plates.

LIMITATIONS

Because of this hydrophilic property, washes and drawings on aluminum plates tend to break down or lift unless the etch strength and duration is exactly adjusted to each part of a drawing. Before working on aluminum plates, take the time to test out your particular drawing style in relation to various etch strengths and duration of application, as suggested in Chapter Eight, Test Stones and Plates.

PREPARATION FOR USE

Aluminum plates oxidize easily, especially when stored under damp conditions. Kept tightly wrapped and stored so that dampness will not affect the surface, they can be used without any prelimi-

nary sensitizing step. If rings or spots do result from oxidation, the plates must be counteretched before they are drawn upon. (See the section on counteretching later in this chapter.)

Zinc Plates

While zinc plates are similar to aluminum plates in their properties, there are textural and chemical differences as well as aesthetic attributes that printmakers should be familiar with. Every beginning lithographer should work on at least one zinc plate, even though they are less readily available than aluminum in this country.

Create on zinc plates with the hardest crayons and pencils, with autographic inks, transfer inks, and experimental tusche washes. Try all the methods of using tusche taught in the preceding chapter, including solvent and water and tusche combinations.

ADVANTAGES

Zinc plates are dark gray in color, oleophilic or grease-attractive in nature, and have longer, sharper grains, resembling the texture of a coarsely ground stone. As a result, a crayon drawing done on zinc has a more pronounced look, with each grain distinguishable, as compared to the smoother look of the same drawing executed on an aluminum plate.

Because of zinc's oleophilic nature, it is suggested that the rub-up step in printing preparation be eliminated. After dissolving the image with solvent, you can proceed directly to sponge it with water and roll up your image with ink. The image will not be lost if you skip the rub-up step, and eliminating the addition of grease at this time will help avoid scumming problems you might otherwise have with a zinc plate.

Zinc plates are the most popular metal lithographic plates in Europe, where there are more facilities available for regraining them than in America. They are used there primarily for crayon and tusche lithographic work. American lithographers often send for zinc plates from Europe because of the growing interest in the tusche-and-water wash effect of "peau de crapeau," which is unique to zinc-plate lithography.

These tusche-and-water washes on zinc plates often attract the artist lithographer to zinc plates. Tusche used alone or mixed with any solvents will, when dropped into or mixed with water, dry in a special fashion on a zinc plate, because of its oleophilic nature. As a water-and-tusche wash dries on an oxidizing zinc plate, grease from the tusche will shrink into the spontaneous, slightly curdled

and contorted shapes that have become known as peau de crapeau or "frog's skin," a much sought-after and classically lithographic look. Zinc plates can be reused. Their surfaces can be regrained so that a completely fresh drawing surface is recreated (see Chapter Twelve for regraining company's address).

LIMITATIONS

Because zinc plates are oleophilic or grease loving (not water-loving as aluminum plates are) there are attendant problems. Combining the grease attractiveness with the sharp character of the zinc plate grains sometimes causes scumming and filling in. The protective wall of gum arabic is quickly worn away in minute spots around each drawn-on hillock as inking proceeds. This causes a buildup of ink, and a thickening of the image results. Grease also is more likely to stick on parts of the non-image areas. This results in scumming problems. (See Chapter Eleven, Printing Problems).

PAPER PLATES

You can print small editions of simple lithographic drawings quickly and inexpensively using the specially prepared paper lithographic plates now on the market. Sold generally in kits consisting of a variety of drawing materials, processing liquid, printing inks, and a composition ink roller as well as carefully explained directions, the twelve-inch crisp white paper plates have a slick surface easy to draw upon and cut easily into smaller sizes.

ADVANTAGES

Paper plate lithography offers an excellent introduction to lithography as a planographic process. It also offers advantages to the beginning illustrator. Gradations of value ranging from light gray to strong black can be achieved with tusche-type washes and particularly with crayon drawings. In addition, tremendous experimental possibilities exist because any greasy materials like lipstick, magic marker, soap flakes, carbon paper, and vaseline can be used on paper plates, then processed and printed, quickly and easily.

To facilitate the creation of a multicolor lithograph on a stone or metal plate, large paper plates can be specially ordered and used to create color backgrounds. In fact, their greatest value, in my opinion, comes from their capacity to lay down large areas of color and patches of different colors quickly and easily. They are not recommended for the really fine classic lithographic drawings that one might put on metal plates or stones.

LIMITATIONS

Paper plate lithography has its limitations and problems. Paper surfaces do not have the granular texture that is so appealing in other lithographic bases. Paper plates bend and crack; unwanted ink is often deposited on the plate in a sort of scumming action; if the coated paper plate cracks or bends it holds ink during printing; small flecks of ink may appear with no explainable cause during inking. To help solve these problems, extra ink in dots and cracks or scum may be removed by wiping the plate with diluted plate solution during inking and while printing. Because the paper plate is so lightweight, it is difficult to keep in place during inking, and the edges tend to curl when dabbed with solution. To counteract this problem, the plate can be made to adhere to a larger piece of mat board by coating both the back of the paper plate and the mat board with rubber cement and pressing the two surfaces together.

PREPARING METAL PLATES FOR AN IMAGE

Unless the plate comes directly from the manufacturer, most lithographers remove any oxidization stains which might have occurred during storage or grease marks created by handling the plates before drawing on an aluminum or zinc plate. In this process, known as counteretching, a diluted acid-and-water solution is gently worked over the plate with a cotton ball saturated in the solution and rinsed off in water. The process should be repeated several times, with a water rinse in between, until the cotton ball shows no gray after use on the plate. At this point, the plate will be lighter in color, showing no stains, and ready to be used by the artist. To prevent the water from oxidizing on the plate, blot excess water and fan the plate dry.

COUNTERETCH SOLUTIONS
FOR ALUMINUM PLATES

1. ½ gallon water (distilled)
 2 ounces of glacial acetic acid—photo grade
 1 ounce of phosphoric acid

2. 2 ounces hydrochloric acid to 1 gallon distilled water is a good counteretch for cleaning

3. For counteretching after roll-up and for additions, try a commercial solution (Richgraphic 108 or Sinclair & Valentine counteretch)

4. Also good (and gentle) is ¼ teaspoon citric acid crystals in 10 ounces of water. This is inexpensive and not so dangerous. Always use *distilled* water in counteretch.

5. An alternative, simpler, counteretch combines white vinegar (acetic acid) and water. Add a few drops of vinegar to warm water, soak the cotton ball, work it over the plate, then rinse the plate and repeat the process until the cotton appears clean.

COUNTERETCH SOLUTIONS FOR ZINC PLATES
1. 1 gallon water (distilled)
 1 ounce hydrochloric acid
2. 1 gallon water (distilled)
 10 drops nitric acid
 alum added until the mixture is saturated
3. Richgraphic Counter Etch (#108)

Since zinc plates are so receptive to grease, the effect of the counteretching becomes more dramatic. The dark gray zinc plate turns a much lighter color as the grease residue is removed.

PROCESSING METAL PLATES

Once the drawing is complete, sprinkle talc or French chalk over the image to absorb excess grease, and buff it with cheesecloth. Talc allows gum arabic to lie more tightly around image dots. Fine rosin gently dusted on the image can be used first. This forms a strong acid resistance on the grease image. Being finer, talc reinforces this. Rosin used carelessly does scratch an image on a plate, so most beginners just use talc.

How to Etch Aluminum and Zinc Plates

First, assemble the proper etch materials. For aluminum plates use Pro Sol, tannic or phosphoric acid, and gum arabic mixture. Work with rubber gloves because the etches are carcinogenic, and gum arabic can cause skin allergies.

The etching procedure for both aluminum and zinc plates involves two steps:

1. Applying a solution of gum arabic mixture with a commercial etching product over the whole plate
2. Applying a second layer of a clear gum over the whole plate if you have used a Pro Sol etch previously. This moves the Pro Sol etch, with its acid content, off the plate.

NOTE: Step Two is extremely important when working with Pro Sol etching. If the plain gum application is omitted, the drawn and undrawn areas will not stay separated when the image is inked, and the whole plate will turn into a field of black ink.

It is possible to go ahead and print after the plate rests for half an hour after gumming, although some lithographers prefer to let the plate stand overnight to permit the gum to harden further.

METAL PLATE ETCH CHARTS
When determining the proper etch for a drawing, many variables must be considered. Foremost among these factors is the manner in which the artist applies his drawing materials and the etching solutions. For this reason an etch chart can only be a starting point and general guide. Any time a new material is tried, one or several small tests should be executed as needed, etched, and rolled up, to assure a familiarity with the technique before attempting a major project. What I present below is one cohesive system for successful lithograph, to use as a base from which each printmaker must diversify to suit his or her own art work as created.

Table 4.1. STRENGTH OF ETCH TABLE

Etch Formula # 1—Pro Sol and Gum Arabic. (Always wear gloves when working with Pro Sol)

Aluminum Plate Etches

All crayon and dark washes	60% of gum arabic solution
Water or solvent and tusche washes	40% Pro Sol Solution #54
Light drawings	75% gum arabic solution
	25% Pro Sol Solution #54

Zinc Plate Etches

#3, #4, #5 crayon	40% gum arabic solution
	60% cellulose gum solution (acidified)
#00, #1, #2 crayon, and rubbing stick	75% cellulose gum solution
	25% cellulose gum solution (acidified)
tusche/autographic ink	90% cellulose gum solution
solids and lines	10% cellulose gum solution (acidified)

How to Vary Etches. Weaker or stronger etches may be used, depending on the image. If an entire drawing is light or dark, the etch solution can be varied accordingly. For example, for a lightly drawn image, use one ounce Pro Sol and three ounces of gum; for a dark image, use one ounce of Pro Sol and one ounce of gum.

Obviously, the ratio of Pro Sol to gum arabic need not be perfectly exact. The duration of the etch adds a compensating variable to the strength or weakness of the etch solution. Experiment with various etch solutions to see how they work on your drawings. Modify the etch according to the strength of the image and the materials used. In general, once again, the stronger the image, the stronger the etch—meaning the greater the amount of Pro Sol in the solution. As long as you remember that a stronger image is generally a greasier image, and that more Pro Sol is needed to cut through the grease, you will have little trouble. One exception, however, should be noted. The grease content of various tusche solutions can be deceptive; a tusche wash that looks light might in fact need a stronger etch. Try various etches on light tusche washes and see what works best for you.

Duration-of-Etch Table. Remember that there is another factor besides the strength-of-etch solution that interacts with your drawing when you process a lithograph: duration of etch.

The duration-of-etch charts below are offered as guidelines for successfully processing tusche washes (always a challenge) and for crayon work. After working on plates for a while, you will develop a second sense about the duration of the etch and the strength of the etch solution. Meanwhile, try varying the etch proportions and the duration of the processing for your tusche or crayon work on metal plates.

ETCH FORMULA #3:
PHOSPHORIC ACID
AND GUM ARABIC

For delicate tusche-and-water washes on aluminum plates, besides the Pro Sol and gum arabic etch, use the following stock solution in a diluted state. However, on all delicate tusche work, you can start by applying straight gum arabic over your talced image, then proceed with the etch chosen.

- Stock Solution: Combine one part gum arabic with one part phosphoric acid.

Make the stock solution *first*, and then mix it with additional gum arabic. TAPEM etch is just an improved phosphoric acid etch. The H_3PO_4 (phosphoric acid) is the basic plate etch, but it is not as

Table 4.2. DURATION OF ETCH TABLE

Drawing	PROPORTIONS		Duration of Processing
	Pro Sol	Gum Arabic	
Dark washes with water or	1	1	2 minutes
solvent tusche	1	1	2 minutes
Full-strength tusche	1	1	1 minute
Medium washes with solvent	1	1	45 seconds
Medium washes with water	1	3	30 seconds
Light washes with solvent	1	7	30 seconds
Light washes with water	1	15	30 seconds

Table 4.3. STRENGTH-OF-ETCH TABLE

Etch Formula #2: Tannic Acid, Phosphoric Acid, and Gum Arabic (TAPEM)*

40 oz. Hanco tannic acid plate etch (MS-214)

75 oz. gum arabic

1 oz. phosphoric acid (85% acid)

The pH (acidity) is adjusted to 2.4 by addition of more acid or gum as needed.

If the Hanco product is unavailable, another tannic phosphoric etch may be mixed:

Tannic acid crystals to saturation

12 oz. gum arabic

1 tsp. phosphoric acid to pH 2.4

*Courtesy Russell Hamilton, Albuquerque, New Mexico.

gentle as the TAPEM etch and it does not desensitize the element as effectively. Use phosphoric etch on plates just as nictric acid is used on a stone.

STOCK SOLUTION USES
- Delicate tusche work: mix 2 or 3 parts of gum arabic to 1 part stock solution.
- Medium tusche work: mix one part of this stock solution with one part gum arabic.
- Dark tusche work: mix 2 parts stock solution with one part gum arabic.

To familiarize yourself with metal plate etch solutions and the way they work, fill two trial plates with your marks. Use the tusche solutions listed in the tables as well as lithographic crayons and pencils. Also use soap, magic marker, rubbing crayon, lipstick, and whatever else you can think of in an experimental fashion. Try the different strengths of etches for varying amounts of time, and print them to determine what is best for the various marks. (See Chapter Eight, Test Stones and Plates, for more information on this important procedure.)

Table 4.4.

GA = Gum arabic
TAPEM = Available plate etch @ pH 2.4
The etch given is for the first etch only, second etches will be roughly the same.
Fractions refer to the portion of TAPEM to gum arabic.
Crayon (traditional application)

	Med. Rubbing Crayon	1,2	3	4/5
Light	¼–⅓ TAPEM	⅓ TAPEM	GA ⅓ TAPEM	GA
Medium	½ TAPEM	½ TAPEM	⅓ TAPEM	GA
Heavy	TAPEM	½–⅔ TAPEM	½ TAPEM	⅓ TAPEM

TUSCHE

Water	Light	Medium	Dark
Korns stick	GA ⅓	½ TAPEM	TAPEM pH 1.7
Charbonnel stick	GA ⅓	½–⅔ TAPEM	TAPEM pH 2.0
Charbonnel paste	GA ⅓	½–⅔ TAPEM	TAPEM pH 2.0

Solvent			
Korns stick	⅓ TAPEM	⅔ TAPEM	TAPEM pH 1.0
Charbonnel stick	GA ⅓ TAPEM	⅔ TAPEM	TAPEM pH 1.5
Charbonnel paste	GA ⅓ TAPEM	⅔ TAPEM	TAPEM pH 1.5

This etch should be applied in five minutes or less, buffed down, and allowed to dry for a minimum of thirty minutes.

There are a few points to consider relative to the TAPEM etch:

1. The TAPEM etch provides an adsorbed gum film superior to either of the other etches.
2. TAPEM is easy to work with, as a gallon of stock may be mixed.
3. TAPEM provides a gentler etch which maintains a wider range of gray tones.
4. H_3PO_4 is easily available, any chemical supply house should have tannic crystals.

Step-by-Step
Processing of Aluminum
and Zinc Plates

1. Assess the drawing and determine the etch strengths needed.
2. Carefully apply rosin.
3. Talc image.
4. Combine gum arabic with etch; use amounts directed according to the chart above. Generally, it is better not to mix more than a few ounces of solution at a time, as the mixture will go bad quickly. Three ounces of etch solution is sufficient for a 24″ × 36″ surface.
5. Pour the etch solution onto the plate, but not directly on the image. For delicate tones, coat with pure gum arabic first, to buffer etches to be used. With a soft brush or sponge, first surround the image with the etch, then work it onto the image area for 2 to 5 minutes on zinc plates using a cellulose gum etch and adjusting time according to the strength of the etch and the complexity and delicacy of the tonal range within the imagery; 30 seconds to 5 minutes with Pro Sol solution on crayon and 15 minutes for dark tusche on aluminum; add five minutes to these times for TAPEM etch. Apply etch to the edges of the plate so that the plate does not pick up ink later on.
6. Beginning with the darkest parts, work the etch back and forth over the image for several minutes. The darker parts are etched longer and on the lighter parts apply pure gum arabic to stop acidic action. Wipe delicate areas gently with a sponge and pour pure gum arabic on these areas. Watch the image closely while you are etching. Stop the etch process on any areas that seem to be weakening. To stop the etch process blot plate or areas on the plate with newsprint.
7. Sponge the etch down to a thin film with a damp, small-pored sponge. To make sure the etch is evenly distributed, it is best to buff lightly with cheesecloth for smoother film.
8. Let the plate dry—5 minutes on zinc, 20 minutes on aluminum plates.
9. Apply clear gum solution with a clean sponge over the whole plate. Take pains to move the first etch and gum mixture in the process. It is important to be sure the plate is regummed before the washout with a solvent, so the washout will not activate any residual acid.
10. Buff the gum coat to a shiny surface. Use several wads of clean cheesecloth previously placed nearby for this purpose. Polish the plate with a light, sweeping motion, discarding each cheesecloth as it becomes gummy. Let the plate rest for at least half an hour, preferably overnight, to make sure the gum has hardened before proceeding to the washout step before rolling up your image.
11. Regum a plate after any storage time before washing out to ensure against anything that might happen to a plate. Buff tight and smooth.

These remaining printing steps are explained in detail in Chapter Six, Printing, but are outlined here as well because they are an integral part of the second etch procedure.

Figure 4.3

Thomas uses the bottle cap to measure the two-to-one gum-Pro Sol etch solution he uses on his plates. If parts of his drawing are extremely delicate, he covers them first with gum and uses a weaker etch solution.

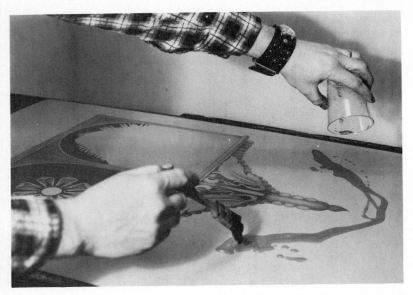

Figure 4.4a
Photo by Mace Wenniger.

The etching mixture is poured on the plate, but not directly on the image, in case the etch is too strong. A soft brush is then used to surround the image with the solution before actually brushing it on the image.

Figure 4.4b
Photo by Mace Wenniger.

The etch is worked back and forth over the image for approximately fifteen minutes, the "duration of the etch" factor judged appropriate, since this drawing is quite dark.

Figure 4.4c
Photo by Mace Wenniger.

The artist applies etch to the edges of the plate. Borders must be etched or they will pick up ink later during printing.

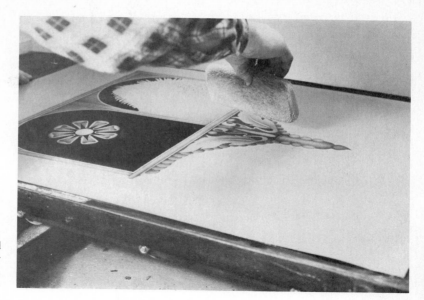

Figure 4.4d
Photo by Mace Wenniger.

Using a damp, small-pored sponge, Thomas lifts excess etch from plate.

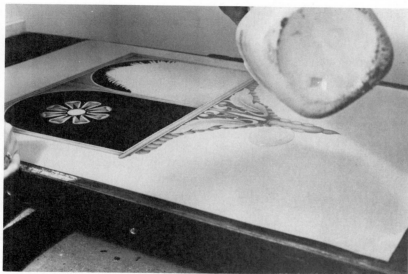

Figure 4.4e
Photo by Mace Wenniger.

Thomas pours gum arabic on the plate to move the etch and replace it with fresh gum.

Figure 4.4f
Photo by Mace Wenniger.

Using cheesecloth, Thomas buffs the gum lightly in all directions until the surface looks shiny and slick. The plate is then left to rest at least a half hour before the wash out, rub up, and roll up, so that the gum hardens around each drawn dot before the image is printed.

Figure 4.5a
Photo by Mace Wenniger.

This zinc plate drawn by Davis Carroll holds an extremely well-articulated image full of controlled crayon and pencil work. Carroll chose a zinc plate because of the slightly larger grain on the plate surface, which accentuates and emphasizes his use of lithographic drawing tools.

Figure 4.5b
Photo by Mace Wenniger.

Zinc plate processed by Carroll is much darker in appearance when wet then an aluminum plate. Carroll works a generous amount of his etch, equal parts of cellulose gum solution and cellulose gum etch over the entire surface of the zinc plate for three minutes. After bringing the etch to a thin layer, he will cover the entire plate with pure gum arabic and buff it. Another etch used for zinc plates is Pro Sol and gum arabic, in a formula of three parts Pro Sol and one part gum.

12. Prior to rolling ink onto the plate, the image is removed in a step known as the washout. Be sure the image is regummed first and buffed tightly, then apply solvent or lithotine to dissolve all grease marks through this gum stencil.

13. Apply lacquer coat. Buff it on very quickly and thinly: Do not be afraid to buff it hard.

 Note: be careful that no moisture of any kind touches the plate until asphaltum is applied. Water can result in disastrous, unforgiving streaks.

14. Apply asphaltum to entire plate to act as a grease attractive surface on image areas. Wash off your element (stone or plate) using water on paper towels. The asphaltum will stay on the drawn image.

15. Roll up plate in black ink. Roll ink on to full tonality but do not force ink to overload. On an aluminum plate pull one or two newsprint proofs to firm things and help "bring up" any reluctant areas. On zinc roll up *lean* but full and *do not pull any proofs*.

16. Assess the roll up on your plate, dry it and cover it with talc.

17. Apply moderate etch. This is a *second etch* which serves to stabilize the non image areas. Use etch similar to first etch but etch stronger to weaken dark areas and etch with a light strength etch on those areas that are rolled up light. Buff down tightly. Regum buff. Let dry for thirty minutes before printing.

Second Etching

A second etch acts to stabilize the image after it has been etched, inked, and printed, and to decrease or increase the ink receptivity of an image.

SECOND ETCH PROCEDURE

1. Ink image up to strength.
2. Fan dry and talc image.
3. Mix second etch solution(s):
 For zinc, if image is overreceptive to ink, make the etch stronger by using a slightly larger percentage of etch solution and increasing the time by 30 seconds; if image took an excessive amount of time to come up full, decrease the etch by using larger proportions of plain gum arabic and decreasing the time by 30 seconds.
4. Overinked images on aluminum are helped by simply increasing the percentage of the Pro Sol solution #54 (or trying a solvent washout on the image).
5. Repeat wash-out and rub up prior to rolling up and printing the image.

The plate is now ready for printing.

STORING METAL PLATES

To preserve the image on aluminum plates for future use, roll the image up to full strength with your ink, and cover it with gum and buff until smooth and tight. If your ink is a color, it is best to wash it out through the gum base and replace it with asphaltum.

Colored ink tends to harden and be difficult to remove at a later time. Store aluminum plates horizontally, wrapped in newsprint for protection. Storage of zinc plates: to keep zinc from filling in during storage; roll up with ink, gum and buff tightly, washout with lithotine, then buff talc on to absorb the residual solvent which leaves no grease on the zinc plate. Note that the zinc plate is very vulnerable in this state and should be kept tightly covered with newsprint.

ETCHING PAPER PLATES

Illustrator Elaine Garrett, shown working on a paper plate, used #4 and #5 lithographic pencils for shadings and a crow quill pen dipped in the tusche provided with the kit for outline drawing. Wrestling with the problem of transcribing a hand-lettered text in reverse onto a plate, Garrett discovered that carbon paper transferred and printed well on paper plates.

Processing a paper plate lithograph takes less time and is simpler than processing a metal or stone lithograph. A pre-bottled desensitizing plate solution acts as an etch, a gum, and even as the wetting agent during the inking and printing sequence. It is easily applied in one step with a cotton swab.

To ink a paper plate, simply draw the cotton swab saturated with the plate solution over the drawn plate. Then roll it with a film of ink from the

Figure 4.6a
Photo by Mace Wenniger.

Children's book illustrator, Elaine Garrett, draws with a crow quill pen using tusche to make fine lines on her paper plate.

Figure 4.6b
Photo by Mace Wenniger.

Garrett adds lettering in reverse to her drawing. She has turned over the tracing paper and now is going over the letters so that an impression goes through the carbon paper below, onto the paper plate.

Figure 4.6c
Photo by Mace Wenniger.

Processing a paper plate starts with the application of a plate solution sold with the kit. This solution acts both as a gum and a moistening agent during printing.

Figure 4.6d
Photo by Mace Wenniger.

Using a small roller and the dark blue, oil-based ink provided in the kit, Garrett rolls the paper plate with ink. Paper plates can be printed either on a litho or etching press or by rubbing the back of the printing sandwich with the rounded side of a spoon.

composition roller offered with the kit or any other rubber roller. Paper plates do not need proofing in black. In fact, they can be damaged by this step. It is best to work with the colored inks provided in the kit while the bendable plate is still uncracked and clean.

Because the edges of paper plates tend to hold ink, a jar of diluted plate solution and an eraser for cleaning unwanted ink are kept handy. The cleaning solution is three parts distilled water and one part plate solution.

Use the inks that come with the paper plate kits, or, if you purchase the paper plate and desensitizing fluid separately, use etching ink or lithographic inks. Inking must be done sensitively, with a watchful eye, because overinking is the greatest hazard of paper plate lithography.

Paper plate lithographs may be printed on an etching press, a lithographic press, or, if the image is small and relatively dark in value, simply by rubbing the back of the printing paper with a spoon. This is what makes paper plate lithography so easy to attempt.

After a proof is pulled, any mistakes in drawing can be removed with a pink pearl eraser or an art gum. The image can then be processed with plate solution and put through the press again.

Storing Paper Plates

Drawn and printed paper plates are preserved by first removing all the ink possible by printing without re-inking. Then a thin layer of lith-sketch gum solution is wiped over the plate. When the plate is to be used again, the gum is removed with diluted plate solution, and the plate is rolled up with a new application of ink.

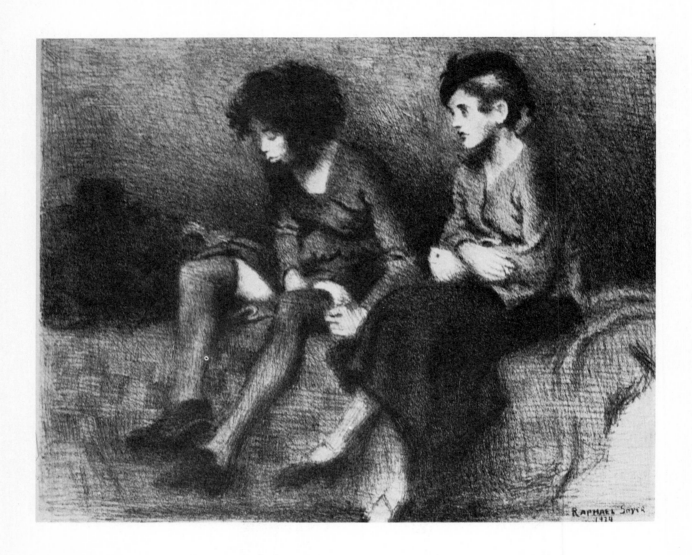

The lithographic stone, made from Bavarian limestone slabs, has a grainy surface made up of pores that are exceptionally even and consistent. Lithographic drawing materials can be manipulated on this granular surface in many ways—scratching, scraping, layering with crayon or pencil, working with tusche pools diluted or oxidized in special configurations. This makes stone lithography a unique pleasure which more than compensates for the effort involved in obtaining a stone and a lithographic press. (The information you need about these and other supplies relating to stone lithography is given in Chapter Two.)

This chapter details, with step-by-step instructions, the procedures for graining and etching the stone. To exploit the unique surface of the stone fully, you must use sensitivity in adapting the processes to each particular stone. Working with the lithographic stone is different from working with a lithographic plate. Each stone is an organic substance with a physical nature and chemical properties that must be respected.

One clue to the nature of a stone is its color. A gray stone has a much harder surface than a yellow stone, which suggests that a finer graining, a more delicate drawing, and a stronger etch should be con-

CHAPTER FIVE

The stone

sidered. Before doing a complete drawing on your stone, make a series of test marks and try out different strength etches. (See Chapter Eight, Test Stones and Plates.) This preliminary procedure will indicate how *your* stone will respond to *your* way of drawing and will help you ascertain what etches are appropriate.

Environmental differences also affect the decisions you make as you process each stone. The temperature of your work space and the level of humidity, as well as the temperature of the stone itself (whether it is hot or cold when you are working on it), have to be considered as you undertake each step.

GRAINING THE STONE

To prepare the stone to receive a drawing, it is necessary to grain it with water and an abrasive called carborundum powder. The water and carborundum are rubbed repeatedly over the stone's surface, using another stone, a piece of stone, or a round, heavy metal instrument with a handle called a levigator. If the stone contains a previous image, it should be grained thoroughly to remove that image and prepare a new drawing surface. This step is equivalent to counteretching a plate before drawing on it.

Figure 5.1
Courtesy Van Nostrand Reinhold Publishing Company.

Vito Acconci in the process of making his print, *Kiss Off*.

Graining serves several purposes: it removes all dirt and any traces of previous images by exposing a new virgin surface of the stone; it makes the limestone surface receptive to new layers of grease marks; it creates the surface grain—ranging from a coarse and granular texture to a smooth and silky one according to the roughness or fineness of the carborundum used—which the artist needs for the lithographic image; and it ensures that the surface of the block is level for even printing. The greatest benefit of graining the stone, however, is the artist's involvement with and commitment to the stone.

It is important to note that when a stone is grained, at least two different densities of carborundum should be used, and each grade must be applied separately from the other.

Carborundums

Coarse grains of carborundum are #100 (coarse) and #180 (less coarse); finer grains include #220 (fine), #240 (finer), and #320 (finest). On most stones in the yellow and yellow-gray color range, it is sufficient to grain only in two or three steps. Coarse

Figure 5.2
Photo by Mace Wenniger.

Equipment assembled for graining the stone: carborundum powders (here stored in ink cans), sponge, squeegee, metal spoon (for applying the carborundum), and graining sink.

grains like 100 are followed by 180 to remove the old image, and then a finer grain, such as 220, can be used to bring the stone to its desired smoothness.

Many lithographic draftsmen, including Stow Wengenroth, work on fine gray stones. They prefer to leave a coarse grain on the stone because this enables them to layer distinctively obvious deposits from hard crayons. As a result, when printed, the minute hillocks on the stone's surface stand slightly separated from each other, crowned with dots of hard crayon.

The finer grades of carborundum are used on the surface of stones as a final step to make the drawing surface particularly fine, preparing it to receive an extremely delicate drawing. Before a new grade of carborundum is applied, all traces of the previous grade must be completely washed off the stone, the levigator or the rubbing stone, the slats of the graining sink, and even the artist's hands. If one or two grains of a coarse carborundum are rotated across the stone along with a finer grade, it can be easily scratched, and a scratch will appear as a white line if the stone is correctly etched.

Before you begin to grain, assemble your equipment: carborundum powder in various grades, car-borundum sponge, squeegee, metal spoon, and graining sink. You will also need water and draining facilities.

TWO METHODS OF GRAINING THE STONE
1. Moving a levigator on top of the stone
2. Moving a stone (or part of one) on top of another to grind down the bottom stone through the rotation of the carborundum powder and water between them

GRAINING PROCEDURE
1. Wet the stone to be refinished.
2. Sprinkle the stone with a spoonful of carborundum (more or less, depending on the size of the stone).
3. Move the graining stone or levigator to the edge of the stone and gradually tilt it onto the stone rather than dropping it on the stone.
4. Begin to make rotations in even patterns across the stone's surface, either in a figure-eight pattern or in circles that more in a combination of horizontal, vertical, and diagonal patterns across the stone's surface.

Figure 5.3
Photo by Mace Wenniger.

The author grinds a stone with a levigator, which is moved in tight circles across the surface of the stone with frequent changes in direction.

Figure 5.4
Photo by Mace Wenniger.

Stone-to-stone grinding. A coarse powder and carborundum and water are being used. The top stone is swung around in a figure-eight or in horizontal, vertical, or diagonal patterns across the surface of the bottom stone, which eliminates the drawn image on the bottom stone.

Continue these graining patterns until the carborundum becomes thick and milky. At this point you should wash off the stone and start the grinding step again. As soon as the levigator or graining stone starts to stick, stop graining or you will destroy the grain on the stone. The grain holds the water on the stone, and if you lose the grain, you will pick up ink. You can begin with 100, proceed to 180, and finish off with 220.

1. #100 carborundum—use three or more times or until most of the ghost image is gone and the stone is flat.
2. #180 carborundum—use three times minimum.
3. #220 carborundum—use three to five times.

The ghost image left on the stone after graining can be quite disconcerting. It is simply the stain from a previous image. Sometimes a ghost image will refuse to leave the stone completely. These traces of the image usually will not hurt the new image which you will draw over the ghost on the stone's surface.

Because you can unwittingly go over one area too much, and create a depression, you should test the evenness of the stone's surface after every pass of the first graining step. This is important (especially for beginners) to be sure your graining pattern is even. Use the coarser grades of carborundum in order to change the levels of the stone's surface.

Testing Levelness of Stone

It is extremely important to test the levelness of the surface of the stone, because an uneven stone might break later under the pressure of the scraper bar. To do this, place a strip of newsprint or a piece of tissue paper at either corner and at the middle point and lay a steel ruler across them. If none of these can be pulled from underneath the heavy ruler, you know that the stone is completely level. This tremendously important detail ensures that the scraper bar will move smoothly and with even pressure over the stone and tympan and that there will be no skips in the image when it is printed.

The stone should be perfectly level after every regraining, using the proper graining procedure. But if, after a stone has been used repeatedly for any length of time, it becomes concave, it can be sent out to a marble or granite works to be planed even. If a stone has just been planed, be sure to grain it two or three times with 100-grade carborundum before going on to the other grades.

At the end of the graining process, the graining stone or levigator should be moved to the stone's edge and tilted off, and the stone should be washed. The edges of the washed stone should then be beveled with a coarse metal file by pushing in the direction away from the drawing surface. This gives the stone a smooth edge that will not retain ink when it is later touched with an inked roller.

62

Figure 5.5
Photo by Mace Wenniger.

The author tests the levelness of the surface of her stone by pulling newsprint strips from underneath a steel ruler.

After the last graining, it is a good idea to work the stone surface with your hand and a small stream of running water to loosen as much sludge as possible from the stone's surface before the final drying step. Some lithographers use a squeegee on the stone to remove excess water; this can leave rubber skid marks and can force stone sludge into the stone's pores.

DRYING THE STONE

To dry the stone, I use a very clean, non crumbly sponge for removing any excess water, blot with clean newsprint, and then fan it dry by turning a "flag" rapidly over the damp stone before the water can dry and leave water marks, which are residue from impurities in the water and unflushed stone dust.

Figure 5.6
Photo by Mace Wenniger.

To dry the stone, a "flag" is made by the author, who attaches a rectangle of foam core board to a thick wooden dowel with masking tape. The flag is waved rapidly over a damp stone to dry it.

MAKING A FLAG

A flag is made with some stiff material such as foam core board, Mylar, or leather attached to a thick wooden dowel. The secret of making an effective flag is to attach the rectangular material to the dowel with a free-floating strip made of leather or two strips of strapping tape attached to each other, face side in.

PLANNING YOUR IMAGE

Planning where your image will be on your grained stone is the next step. Once the stone has been grained and dried, but before you begin to draw on it, you must decide whether your image will be contained within a border on the editioning paper or whether you want your image to extend to the edges of the paper or seemingly beyond, which is known as a bleed print.

Image Within a Border. If you want to contain the image within a border, brush acidulated gum arabic (3 or 4 drops of nitric acid to one ounce of gum) on the outside edges of the stone's surface, to a width of at least two inches. To make the gum border *visible*, also mix some red conte chalk powder into

the gum arabic before using it on the stone. Acidulating the gum with the nitric acid will ensure that the gum border will not hold ink. To determine the exact size of the border, draw it first with conte chalk or hard pencil to mark the boundaries of the image area.

To Do a Bleed Print. The image must be drawn larger than the paper you will print on, but the image still should be contained within gummed borders on the stone, leaving at least 1″ to 1½″ at each end of the stone on the long axis for the scraper bar to start and stop.

PROCESSING THE IMAGE ON THE STONE

Now the stone is ready to receive your personal expression. As discussed previously in Chapter Three, Imagery, the lithographic artist has many options. Selection of technique depends on the artist's intention and inventiveness. The challenge is to hold the image, with fidelity, through subsequent processings and printings, created in response to the uniquely sensuous, granular surface of the stone, and to make

Figure 5.7
Photo by Mace Wenniger.

The edges of the stone are coated with a thin film of lightly acidified gum arabic. If you want to work on the stone just after the edges are gummed, you can use a hair dryer or a flag to accelerate the drying.

sure the drawing materials will become semipermanent marks on the stone.

When your drawing has been completed on the stone, look it over carefully, pick off any smears on the light parts of the image, strengthen the darker values, make sure you have used the special surface of the stone to full advantage, then begin to process these marks with an appropriate etch.

Steps Preparatory To Processing a Stone

CONSIDERATIONS
BEFORE PROCESSING
YOUR STONE

Variables Affect a Stone. Remember that processing a lithograph on a stone is a much more intuitive undertaking than etching an aluminum or zinc lithographic plate, since each stone has its own special chemistry that must be taken into consideration. Remember also that the acid is used in the gum etch as a means of setting or staining the grease particles into the stone. The etch formulas need to be altered according to environmental factors that can and do change constantly.

1. *Type of stone*—The type of stone used will affect the etch: a blue-gray stone, which is hard, requires a stronger etch than a yellow stone, which is softer.

It also is important to realize that the quality of each stone changes as it is used and new strata are reached.

2. *Environmental conditions*—Even if an artist uses the same stone repeatedly, as I do, temperature and humidity changes will demand varying the usual etch. For example, if the stone is cold and damp when the etch is applied, it will take a stronger etch than usual (cold slows down the etch reaction). Warm humid weather, on the other hand, speeds up the etch reaction.

3. *Use of drawing materials*—The amount, type, and quality of the drawing materials on the stone, as well as the type of stone on which they are used, also should be considered as you plan the etch procedure. A drawing with a rull range of values works well if it is given a progressive etch. This etch method allowed artist Allan Gardiner to vary the etch according to the light and dark parts of the image.

4. *Timing*—The amount of time that the etch is manipulated on the stone will affect how the etch works. The average time for an etch to be left on the stone is 3 to 5 minutes. However, time is a very flexible matter in stone etching. I have spent an hour or more on a first etch on a complex set of washes with light and dark tones densely intertwined. Take into consideration the color of the stone and the range of light and darks in the image when planning your first etch step.

Figure 5.8a
Photo by Mace Wenniger.

The author at work finishing a lithographic drawing of a magnolia branch in bloom. She used lithographic pencils to reinforce tusche work and also scratched and scraped on her stone.

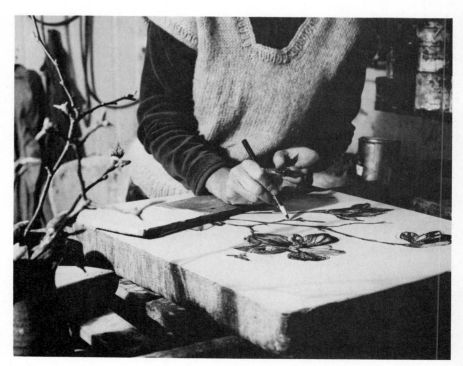

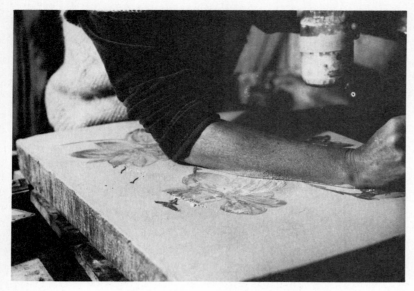

Figure 5.8b
Photo by Mace Wenniger.

To protect the drawn image on the stone talc is applied over rosin and rubbed in lightly with the forearm, as shown, or with a piece of cotton.

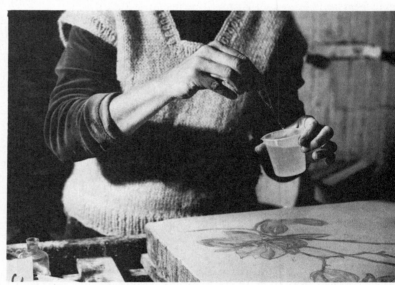

Figure 5.8c
Photo by Mace Wenniger.

Author drops acid into gum arabic solution in measuring cup. Photographic ounce measurers work well as containers for your gum and acid etch solutions.

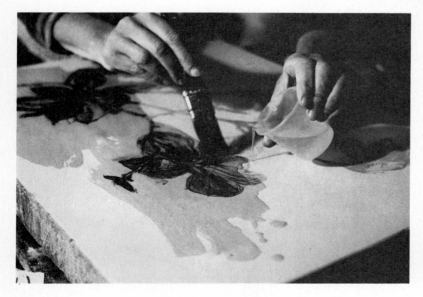

Figure 5.8d
Photo by Mace Wenniger.

Etch is applied to the image and worked over it. A few more drips of nitric acid are added to the remaining gum arabic as a spot etch, which is applied to the darker parts of the image.

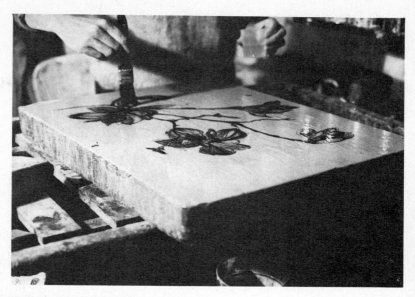

Figure 5.8e
Photo by Mace Wenniger.

An even coat of the etch mixture is worked over the whole stone for three minutes. The following day the gum is carefully washed off the stone. The stone is dried after the gum has been washed off, and a coat of slightly acidulated gum arabic is applied and buffed down to a thin tight coat over the entire surface of the stone. The etched image is washed out in preparation for proofing. The image is rubbed up with turpentine-thinned black ink and is swabbed with wet cotton to push the grease spots closer together and closer to the stone. After the half-strength etch is applied, the excess is removed.

Figure 5.8f
Photo by Mace Wenniger.

Using a flat wad of cheesecloth, the author buffs down tightly the gum arabic and acid solution to a thin light coat over both the image and the entire stone.

PREPARING YOUR IMAGE FOR AN ETCH

After the image is complete, but before you begin to etch it, use rosin powder to dust the stone. The rosin is an acid resist that clings to the image and protects it from the acid in the etch. Lightly brush off excess rosin and buff lightly with a cotton pad or webril wipe. Then dust the image with talc or French chalk, to absorb the excess grease and cover the image so the aqueous gum solution in the etch to follow lies down on it; otherwise the water-based gum will be repelled by the grease of the drawing materials. Again brush off excess talc and buff the stone lightly with a cotton pad or webril wipe.

PREPARE YOUR STUDIO

To prepare for the etching process, assemble the following materials:

- the drawing stone, which is placed on a level surface such as the graining sink or press bed so that the etch will stay on the flat face of the stone without dripping, or, in case of a water etch, so that the water will stay contained in a pool
- gum arabic
- rosin
- talc
- a measuring cup or plastic photographic ounce container for etch mixtures
- nitric acid and an acid dropper on a holder
- sponges and soft brushes for applying and smoothing etches
- three or four wads of cheesecloth (depending on the size of the stone) for buffing the etch on the stone.

67

ETCHING A STONE

There are as many etch formulas as there are lithographers. Through experimentation each lithographer eventually develops his or her own method based on a blend of chemistry, timing, and touch, which combines with one's art work and the particular stone being worked on.

It is important to realize that working with etches has to be done by feel as well as by formula. There is no substitute for sensitivity and there is a great deal to be learned from experience, even from failures. The critical thing at first is to keep trying, not to create a masterpiece, but to get a firm hold on the medium. This is why test stones are so important. (See Chapter Seven.)

Etch Formulas for Stone

Stones offer great versatility in etching, as the printer can control the tonal ranges by the etches selected. The whole "secret" to good etching is a light touch and a good physical sense of each procedure—an intuition for keeping control over each procedure: inking, buffing, and so on.

THE WATER ETCH

The water etch given here is considered an antiquated but useful formula for a beginner to use, because it does not involve the removal of grease or the addition of ink to the image between the etching steps. It works well for crayon or pencil drawings. The water etch involves a lightly acidulated gum etch followed by an acidulated water etch as the second etch, and finally another acid-gum etch as the third step in the process. Prior to the second step in the etch, a line of water is brushed around the image, creating a water wall that will contain the water-acid solution of the second etch in a puddle.

The water etch in this three-step etch isolates every grain on the stone and flushes around it in a deeply penetrating manner. The final gum and acid etch step acts to seal the parts of the stone that have not been drawn on. The acid content in all of the etch steps is light.

The medium and dark values that dominate the image by Jack Coughlin, shown in Figures 5.9a to g, make this lithograph a perfect candidate for the water etch, which he used on it as demonstrated in the accompanying figure. This type of etch might coarsen a more delicate image, but it works well for this strong image, ensuring that it will not fill in as it is inked.

THE WATER ETCH FORMULA

First Etch. *One ounce of gum* is mixed with *two, four, six, or eight drops of nitric acid.* The amount of acid used varies according to the lightness or darkness of the drawing. An eight-drop etch is used on this dark-valued, well-articulated drawing by Jack Coughlin.

Procedure: Pour the gum and acid solution onto the stone, which has been rosined and talced, and then work it gently on to the stone to form a thin film. After you have applied the etch, buff it with a wad of cheesecloth until the image looks slightly shiny. The stone must then rest for at least one hour between the first and second etch steps so that the gum hardens.

Second Etch. This is the water etch step in which eight ounces of water (one cup) are mixed with more drops of nitric acid than were used in the first etch. Use this formula: double the drops—less two drops—of nitric acid used in the first etch. If the drawing on the stone is dark, and eight drops of acid were used in the first etch, the second etch would therefore be formulated as follows: 8 drops × 2 = 16 − 2 = 14 drops of nitric acid to 8 ounces of water.

Procedure: Wash the first gum etch off the stone, using a hose or a pitcher of water. Fan the stone completely dry. Then build a water wall with a brush as shown in Figure 5-9c to hold the second etch in a pool. Slowly pour the water etch inside the area contained by the water wall. Move the water-acid solution gently over the image with a brush for two minutes. The etch creates small bubbles as it works into the stone's grains. If there are any significant variations in tone, you should apply a stronger spot-etch to darker areas after applying the initial overall etch, or apply only half the etch solution initially, then, depending on how dark the image is, add more acid to the remaining solution. The spot etch is applied where necessary for an additional 60 seconds.

Sponge the solution off the stone with a damp, tightly wrung-out sponge, leaving a thin film only. Dry the stone with a fan or flag.

Third Etch. Repeat the first gum-and-acid etch, using the same proportion of acid to gum as you did in the first etch step. (Hence, if eight drops of nitric acid to one ounce of gum were used in the first etch, as Coughlin used on his image, use the same solution.

Procedure: Prepare the stone for the third etch by again applying talc and rosin and buffing the image. This talc and rosin application has a three-fold purpose: it absorbs excess grease on the image, it

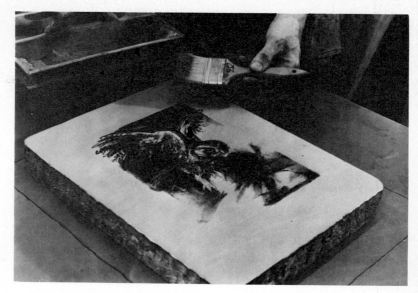

Figure 5.9a
Courtesy Jack Coughlin. Photo by Mace Wenniger.

Before he etches his image, artist Jack Coughlin applies rosin and talc, carrying them from wooden trays to the drawn stone with a soft brush.

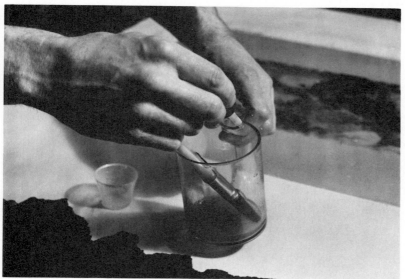

Figure 5.9b
Courtesy Jack Coughlin. Photo by Mace Wenniger.

Adding nitric acid to gum arabic, Jack Coughlin counts the precise number of drops needed for the etch he selects to fit his image. In this case, he uses eight drops nitric acid to one ounce gum for his strongly articulated image with many dark areas. After the first etch is applied to his stone, Coughlin will buff it with a wad of cheesecloth.

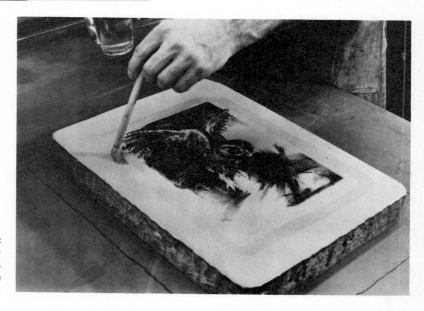

Figure 5.9c
Courtesy Jack Coughlin. Photo by Mace Wenniger.

Before applying the second etch, Coughlin creates a water wall around the image with a pointed brush.

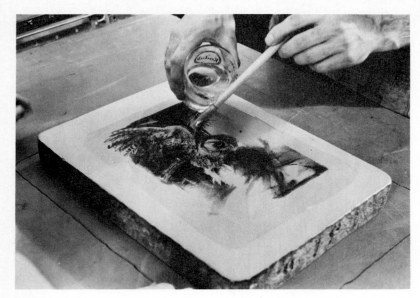

Figure 5.9d
Courtesy Jack Coughlin. Photo by Mace Wenniger.

The second etch is applied to the stone. A solution of eight ounces of water and fourteen drops of nitric acid is gradually poured onto the stone and worked with a brush for two minutes. The amount of acid used varies according to the lightness or darkness of the image.

Figure 5.9e
Courtesy Jack Coughlin. Photo by Mace Wenniger.

This photograph shows the effervescence (foaming) caused by the action of the etch on the stone.

Figure 5.9f
Courtesy Jack Coughlin. Photo by Mace Wenniger.

Talc is shaken onto the dried stone prior to the third etch and wiped close to the image with cheesecloth.

Figure 5.9g
Courtesy Jack Coughlin.

For the third etch, repeat the first etch and sponge down as pictured. Buff with cheesecloth until the gum forms tight, hard film on the stone.

prevents drawing material from smearing when the final etch is buffed, and it makes drawn areas resistant to the acid and gum of the third etch.

Wipe the talc and rosin close to the image with a cheesecloth wad or the inside of your forearm. (The latter method will protect a drawing that might be scratched by using cheesecloth.) Either way be sure to use a light touch to protect your drawing.

Mix the etch solution, pour it on the stone, and sponge it evenly over the stone. Buff it rapidly with cheesecloth, until the gum-acid film is wiped as close to the surface as possible. Change cheesecloth wads several times. Discard each wad when its flat surface becomes tacky, and replace it with a clean one. Finally, with a dry wad of cheesecloth, buff the etch until it is shiny.

This etch will seal the surface of the non-image parts of the stone so they will not attract ink.

Leave the stone to sit overnight, to make certain the gum hardens in preparation for washing out and rolling the image in ink. (See next chapter for processing instructions.)

WATER ETCH MODIFICATION
FOR TUSCHE WORK

The water etch process can be used to etch tusche drawings made on a stone, but it must be modified. In tusche work, there are usually modulations of tone that must be handled with care. These light and medium gray areas often are broken into reticulations. It is these reticulations that challenge the lithographer—both in the processing or etching step, where they can be under- or overetched so easily, and in the inking step, where they can fill in if they are not inked with the proper amount of ink.

It has been found that the best way to stabilize tusche washes is to *strengthen* the acid in the water-etch step. Since tusche penetrates the limestone more deeply than it looks, it needs a stronger water etch to permeate more deeply around each particle of grease.

Use the three-step formula, as already described, *but double the acid used in the water-etch, or second, step.* (Remember the "minus two" component of this step of the formula.) A recommended etch for most tusche work is as follows:

First Etch. Use four to six drops of nitric acid, depending on the strength of the drawing for every ounce of gum.

Procedure: Follow the procedure given for the standard first etch.

Second Etch. The usual formula of doubling the drops of nitric acid minus two is *doubled* again and mixed with the usual eight ounces of water. Therefore, the four-drop etch of the first step (suggested above) doubled to eight must be doubled again. This makes $4 \times 2 \times 2 = 16 - 2 = 14$ drops of nitric acid to 8 ounces of water.

Procedure: Build a water wall as before. Apply the etch to a small area (an edge) in order to test the etch. The foaming reaction should be noticeable but not too strong.

Using the strengthened water etch demands vigilance and sensitivity. The foam reaction depends on the stone, on the weather, and on the way the tusche was applied. For particularly dark areas you may wish to apply a stronger spot etch, but caution is advised.

Dry the stone, apply talc and rosin, buff, and apply the third etch, which is the same as the first etch. Buff it, and let the stone rest overnight before printing (See Chapter Six.)

TRADITIONAL GUM
AND NITRIC ACID ETCH

This is basically a two-step procedure, one etch applied before rolling up with black ink, the second after. It is the multiple-step etch that makes the image fast on the stone. Of particular importance is the duration of application of each step (duration of etch

is crucial in relation to medium and hot etches) and more important is judging the correct strength of the acid to suit your image and stone. Making these judgements for your own work involves getting to know your stone by running tests and then using your experience and intuition to help you judge modifications of Table 5.1.

Etch Procedure: Apply gum and nitric acid etch, apply rosin and talc to the image as a protective coating. Brush on first etch—a mixture of nitric acid and gum arabic; buff; let it rest for at least a half hour; ice gum with plain gum. Wash out and roll up with tight black ink; apply second etch; wash-out and roll up with proofing ink. Print.

AVERAGE ETCH MIXTURE FOR FIRST ETCH
- Crayon drawing—7 drops nitric acid to 1 ounce of gum arabic.
- Tusche washes—10 to 20 drops n.a. (nitric acid) to one ounce gum arabic.
- Autographic lines and solids—15 drops n.a. to 1 ounce gum arabic.
- Rubbing ink stick—10 drops n.a. to 1 ounce of gum arabic.
- Transfer ink—8 drops to 1 ounce of gum arabic.

GUIDELINES
1. If a drawing contains little grease and appears very light, as may be the case when an image is completed with only a number 5 crayon or a very pale wash, the amount of acid to gum arabic must be reduced considerably. It is possible to etch these areas, at least at the first etch stage, with gum arabic on only. If a drawing contains excessive amounts of grease, as would be the case if a drawing was completed totally with a number 00 or 1 crayon, the amount of acid to gum arabic should be increased to a suggested maximum of 35:1. Take note, however, that solid lines and areas drawn with authographic or transfer ink require weak etches to maintain solidity.

2. Images that contain a wide variation in tone and texture should be treated with ultimate caution. Here it is best to start with a weak etch mixture on the lighter parts of the image; apply successively stronger etch mixtures to darker areas. Washes with light and dark areas should be etched gradually and carefully. On a light area start with a weak etch on the first etch, watch the area closely, and increase the etch accordingly at the second etch stage.

Table 5.1. ETCH TABLE: DROPS OF NITRIC ACID PER OUNCE GUM ARABIC

Code: d = drops of nitric acid to one ounce of gum arabic (GA)

Crayon, Pencil, Rubbing Stick

	#1 (Crayon or Pencil)	#2	#3	#4	#5	Med. Rubbing Crayon
Light	5d	4d	3d	2d	GA	5d
Medium	10d	9d	7d	5d	2d	10d
Heavy	20d	15d	10d	7d	5d	20d

Tusche in Distilled Water

	Light	Medium	Heavy
Korns stick	GA	5–10d	12–25d
Charbonnel stick	GA	4–8d	10–20d
Charbonnel paste	GA	5–10d	10–20d

Solvent Tusche

	Light	Medium	Heavy
Korns stick	5–10d	12–16d	20–25d
Charbonnel stick	4–8d	8–15d	15–25d
Charbonnel paste	4–8d	8–15d	15–25d

3. Regum stone with pure gum arabic. Buff till hard and smooth with cheesecloth wad. The stone is ready now for the second etch.

4. Note, drawings containing all or several of the media variations in the extreme, from heavy grease to light, from fragile washes to solids, and so on, should be area etched. This process will be discussed.

If the area you are working in is fairly dry and comfortably warm, it is possible to continue to wash out and roll up and second etch after just a few minutes. If studio is humid, however, the gum arabic should be given much more time to harden. The stone should be covered with newsprint and stored in a safe place.*

Second etch: A stone is not stabilized until after the second etch. A second etch is applied to the stone after the image is dissolved with turpentine in a wash out step, then rolled up with black ink (preferably use roll-up black ink). Rosin and talc the inked image and then proceed to give it a second etch.

Before applying the second etch, protect your image by brushing powdered rosin on it and applying talc. Apply a second etch mixture that repeats your first etch but is slightly weaker, either made up of a little less acid per ounce of gum.

A word of caution: if you find it hard to get a full image when you roll up your image, pull several proofs inking it up to the desired fullness of tone before applying a second etch and *reduce* the nitric acid in the second etch by one third. If, however, the image starts to thicken or fill-in during roll-up, a stronger etch must be used.

FIRST ETCH PROCEDURE

1. Dust image with powdered rosin and talc.
2. Mix etch. Add acid to gum arabic. One ounce of gum is sufficient for most stones.
3. Cover delicate areas with pure gum.
4. Pour a little of the etch on to the stone slowly, moving it constantly over the image with a brush or with the flat of your hands. Add more etch gradually. Work constantly for at least three minutes more or less, depending on the variables cited above.
5. Work etch over the *entire* stone.
6. Remove excess gum etch first with a damp, not wet, sponge, then make at least three cheesecloth wads and start to buff the gum arabic mixture with the first one. Use fresh cheesecloth wads and buff again, continuously, using short, circular motions and medium pressure, until the gummed surface is slick and shiny, and the gum is buffed tight to the stone.

*Maxwell, William, *Printmaking* (Prentice-Hall, Englewood Cliffs, N.J.: 1977).

a. Go across the stone, crisscross, up and down, zigzagging. Pick up the mass of gum arabic. Finish using this cloth by turning it to a dry side and going around the perimeter of the stone, including the corners and edges. This prevents dragging gum into the semidry central surface.

b. Use a new cloth, go back and forth crisscrossing again in a zigzag pattern across the face of the stone.

c. Use a new cloth again to crisscross up and down across the stone.

d. Finish with circular motions; buff it until completely hard and smooth and dry.

7. Dry stone with a flag. Polish it by rubbing it with the flat of your hand. Let it rest for half an hour before proceeding to the wash-out, rub-up, and roll-up steps that preceed the second etch procedure and subsequent printing steps that follow.

Area Etching. If an image has many tonal variations, apply varying etch mixtures. Mix four strengths of etch in separate containers, each with a separate brush for applying etch solutions—strong etch, 25 to 1; medium etch, 18 to 1; medium weak etch, 13 to 1; weak etch, 6 to 1. Apply weakest etch to lightest areas first, follow with medium weak, medium, and strong etch. Keep the brushes moving continuously for about three minutes.

When you do the second etch, be sure to follow the area etch procedures.

Considerations While Etching Your Stone. Check your stone during and after processing. Your stone should be examined repeatedly and minutely for any tiny particles of drawing materials that might have become dislodged and moved randomly or for foreign materials that might have settled. These should be removed because they will show up on your paper when your image is printed.

Buff your stone thoroughly and with care. Keep a light touch and a rapid motion as you buff. Take care to not scratch the image you have made with so much skill. After applying gum solution to the stone, buff the whole stone with cheesecloth folded and wadded so that only a completely flat surface without any ridges is lightly skimmed over the surface. Assemble several such cheesecloth wads before processing your image. Change them frequently. Discard a wad made tacky on the flat bottom surface by the buffing process, and interchange it for a fresh wad.

Buff with the flat of your hand as the final touch after buffing with cheesecloth, or use your hand throughout instead of cheesecloth, if the cloth scratches your image.

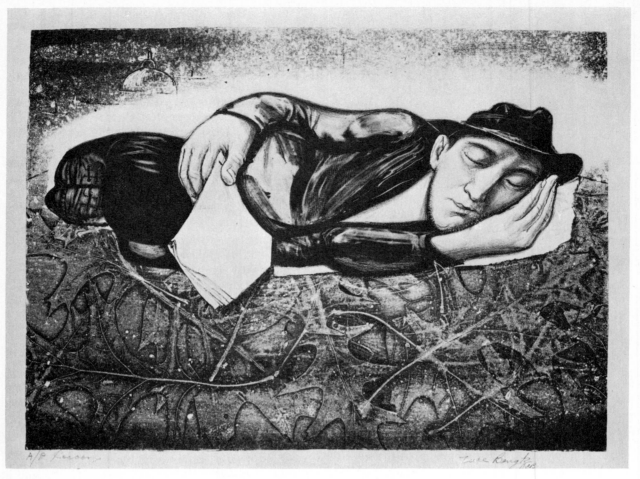

Figure 5.10
Courtesy Lillian and Lance Bengtz. Photo by Mace Wenniger.

The *Cocoon*, which an outstanding teacher of lithography, Ture Bentgz, using a compelling mix of experimental transfers, tusche and crayon work on his image, back in the fifties printed on his stone in his own studio.

Buff until the stone's surface reveals a hard, thin, shiny finish. This step helps ensure that the next step, printing your image, will be successful.

OUTLINE OF STONE PROCESSING STEPS
1. Assess the drawing to determine etch strengths and etch processing.
2. Rosin and talc the image.
3. Apply etches (in many cases you can sponge pure gum arabic onto the entire stone to buffer the bite of a strong etch). The etches application can last minutes or hours depending upon the complexity of the image, since complex images demand many different strengths of etches. Be careful that you do not allow the gum to dry completely dry until you buff it down.
4. *Carefully* remove excess, and buff down the etch to a smooth finish. A little finese is necessary here; keep a light touch, don't smear too much, don't scratch delicate tusche work, and watch out for streaks. Let the etch set for 30 minutes.
5. Regum the stone with pure gum arabic, and buff it to a smooth film.
6. Wash it out with lithotine.
7. Rub with asphaltum or a solvent thinned black ink.
8. Wash off with water and roll up with medium-stiff black ink:
 a. At this point, my preference is to use a stiff printing ink such as Senefelder's crayon black (graphic chemical) thinned with a little #5 varnish.
 b. It is important to wash off asphaltum or black ink and get the stone to matte-damp condition as quickly and smoothly as possible.
9. Roll up image to partial strength using several passes from all directions. Using an ink slab

carrying only a thin veil of ink is usually best so the image builds its ink up slowly with repeated passes of the roller and several trips to the slab. Reassess the image while it is still sponge-damp to determine areas that are light or dark.

10. Fan dry (Note: If proofs are pulled at this point, the image will darken progressively. Proofs need not be pulled except to intentionally darken the tones.

11. Rosin and talc.

12. Apply a second etch, slightly milder than the first etch, with judicial variations according to nuances of dark and light areas in the image.

13. Follow the second etch with an overall etch of four or five drops of nitric acid to one ounce of gum arabic, unless you have some very weak light passages which would require a pure gum film. This adsorbed gum film is a vital element in clean printing.

14. After 30 minutes or more, the stone may go to press for proofing (see Chapter Six).

This procedure will yield a print with superior subtleties and stability. It will print superbly if you are careful about inking and printing procedures.

After you have drawn your image on a stone or plate and etched it, you are ready for the most dramatic stage in the making of a lithograph: printing.

Jim Dine has written: "I like to print not because of reproduction but because of the results. The act of printing is inspiring to me.

"One of the interesting things about printmaking for me has been that every print need not be like coming off a machine. I like the variants possible between impressions."*

Printing a lithograph is not a casual process. It demands attention to the craft involved, much time, and a commitment to learn how to work through the

problems that inevitably arise. The intent of this chapter is to help you avoid at least some of these problems. First, however, you will be introduced to the fundamentals of printing preparation as well as to procedures for making your image ready for inking and printing.

PREPARING TO PRINT

To start with, you must focus on a certain number of steps preliminary to printing, such as mental and physical preparation, press preparation, paper prep-

*Print Review 12, Pratt Graphics.

CHAPTER SIX

Printing

aration, and ink and roller preparation, as well as preparing for necessary tasks such as print storage and clean up after printing. Then you will be taught how to prepare your image and print it: processing, rubbing up, inking, proofing, making corrections, and editioning your lithograph.

To prepare yourself for printing, you must clear your mind of other thoughts and concentrate. Proofing and printing require leaving the work day in order to tune in to the difficult craft of printing a lithograph.

When you are printing, you will occasionally have moments of sheer panic when an image does not work out as conceived. Once again, keep your artistic ideas in mind. Take a deep breath, sit down,

and look at the proof. You can remove parts of the image, make corrections and additions. Every printmaker panics during proofing because it is often frustrating. This is something to be worked through by calling on all the support systems noted below. Remember what you set out to accomplish, and keep going.

Physical Preparation

Since lithography is more physically demanding than any other printmaking medium, it requires special attention to working conditions. It is important to make yourself and your physical environment as comfortable as possible.

COMFORT

Wear shoes that will support your arches. You will be on your feet for many hours. (Tennis shoes do not provide enough support.) Have a sturdy apron, plastic gloves, and lithographic materials laid out. A radio or stereo system can help carry you through tedious phases. Good lights and fresh air are necessities.

TIME

Allow enough time so you can take your time. Many new lithographers try to rush the process of rolling ink onto the image or set a limit on the time it takes to print. To give yourself plenty of time for proofing and editioning, block out several hours of concentrated effort. Include enough time to hesitate when you first begin to print—to think about your image, to try different colors—so that when everything seems right you will be able to print a full edition.

EMOTIONAL SUPPORT

As you begin printing, your most important support will come from other people. It is extremely difficult for beginners to work completely alone. There are many tedious and tenuous aspects of the printing process which can best be surmounted by other people's collaborations and support. If there is no lithographic workshop or class near you, try to work with another person on a regular basis.

It would be ideal to set up your lithography workshop with another student or group, ordering materials together and then printing together on a regular basis. My first two years in lithography were sustained by a small group of artists who were as interested in lithography as I was. We worked together regularly twice a week and helped each other print many editions successfully.

Try to set up a buddy system with a fellow printmaker. Having someone sponge your lithographic base, hand you your printing paper, and hang your print up for you after it goes through the press facilitates and speeds up the printing process. Another person can provide you with a critique of your image and can advise you whether it needs further work before you proceed to print an edition on good paper. It also helps to have another student's (or professional's) ideas when things go wrong. When, for example, an image starts to coarsen or to fade, you and your co-worker can figure out together which one of the variables needs adjusting, and together can find new energies to make the necessary changes.

Apprentices or friends can help you print and readily do monotonous tasks such as tearing paper, planning registration, wetting the stone or plate during printing just for the experience of participating in a lithographic workshop.

It also helps to have an experienced lithographer on tap by telephone to help you figure out what to do if printing problems arise.

Prepare Your Materials and Equipment

You will find it most convenient to work directly on the bed of the press while doing the steps preparatory to printing (the wash-out and rub-up steps), as well as during printing.

The glass inking slab and the printing press nearby will be your *printing station*. Clean them off with turpentine or lithotine to remove any ink residue from previous printings. Then use lacquer thinner to pick up the last vestiges of ink, the unseen tint on the glass slab.

Arrange wash-out, roll-up, inking, and gumming materials (including sponges) near the printing station. Many printmakers use a cart or a shelf near their inking slab for this purpose. Have the following materials on hand:

- two enamel or stainless steel bowls for water
- one small-holed sponge and two large-holed sponges
- three or four wads of tightly woven cheesecloth
- a container of gum arabic
- correcting materials (snake slip for stone, image remover for plates)
- small containers of acid
- a measuring cup
- inexpensive 2″ or 3″ paint brushes
- talc and rosin
- a piece of felt or silk stocking (to rub off extra ink deposits)
- large and small ink rollers
- putty knives for mixing inks
- ink cans
- black and colored inks
- magnesium
- vaseline
- cotton swabs
- Q-tips
- aluminum foil for unused ink
- spatula
- roll of paper towels

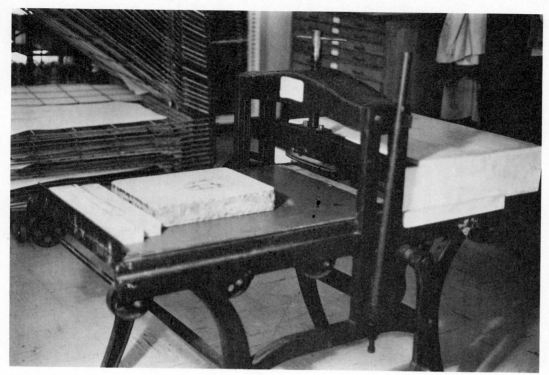

Figure 6.1
Photo by Mace Wenniger.

A lithographic press with the press bed pulled out from under the scraper bar and a stone wedged firmly in position, ready for inking. Note the box built over the end of the press to hold printing papers and accessories. Behind the press to the left is a print drying and a storage rack, to the right are classic print drawers for more permanent storage.

Figure 6.2
Photo by Mace Wenniger.

The author washes the image off a plate in preparation for printing it on the lithographic press.

Paper Preparation

PREPARE TO PRINT MULTIPLES

The printing process is essentially divided into two stages: *proofing* and *editioning.* When you *proof* your image, you will be printing it for the first time in a trial fashion on impermanent paper such as newsprint. When you *edition* your image, you will be printing many impressions of the stabilized image on a fine grade of paper, ideally chosen both to enhance your image and last permanently.

First, you must prepare proofing: at least ten sheets of newsprint torn to the size of your stone or plate. On these you will begin to print your image immediately. These first prints will be less distinct than your image. Keep inking and printing until it prints as clearly as you first created it. This is called *bringing up the image.*

Since you are now working in a printmaking medium, you now start to print your image repeatedly on many pieces of good quality paper and thus create multiples. This is called making an *edition.*

An edition is any number of lithographs printed in a consistent fashion. More than one edition can be printed from the same stone or plate. For an edition of ten to twelve prints, tear fifteen to eighteen pieces of rag paper to the prescribed size. This allows for a few unevenly inked prints on good paper, which will be designated *trial* proofs, and for a few extra prints (usually ten to twenty per cent of the edition) held by the artist for particular, often personal, reasons. These are known as *artist's* proofs.

DETERMINE PAPER SIZE
AND USE

Tear your paper to a predetermined size and mark with registration marks. If you are working only with black ink, you will also dampen your paper and store it between blotters in a plastic bag prior to printing. However, if you plan to print a multicolor lithograph, keep the paper dry because damp paper expands during printing and may or may not shrink as it dries, which will throw off the exact register.

There are several ways to decide paper size. The classic approach is to trim the paper to a size slightly smaller than the stone or plate so that it fits inside the base but remains at least an inch and a half larger than the image on all sides and makes a *border* around the print.

A bleed print, in which the image extends beyond the edges of the paper, requires a different approach. To make an effective bleed print, you must tear the paper slightly smaller than the image on all sides. A fresh sheet of newsprint must be used as a cover sheet before each print goes through the press,

to prevent ink not covered by the edition paper from rubbing off on the plastic tympan sheet, which lies between print sandwich and press scraper bar.

PREPARE EDITION PAPER

It is a good idea to prepare your paper before you begin the printing procedures that will get your hands stained with ink. Plan to make at least a small edition of your lithograph on good paper. Even if something goes wrong, and the image never goes beyond a few newsprint proofs, the paper you have prepared can always be saved for another lithograph.

Do your paper preparation on a clean surface. Since clean surfaces are often rare in a printing room, you can simply cover a surface (a table) with clean blotters or newsprint and do your paper preparation there. Alternatively, you might set up a convenient table, cover it with newsprint, and reserve it for paper preparation (for tearing paper and preparing registration), and for holding your paper apart from, but near, the printing station during printing.

TEAR YOUR PRINTING PAPER

It is traditional in printmaking to *tear* the editioning paper, not to cut it. This provides a slightly ragged edge, or deckle, similar to that left on paper made by hand. To tear editioning paper, hold a heavy metal straightedge or any steel ruler tightly against the back side of the paper (the rough side) and tear the paper up against that edge. This creates a down-sloping ragged edge on the side of the paper on which you will print. Printmakers generally find the deckle edge more pleasing than the edge created by cutting with a knife, a blade, or scissors.

Assemble the torn paper in two piles, newsprint in one, editioning paper in the other. Arrange all your printing paper in the same position with the printing or felt side down; when tearing your editioning paper, you can ascertain the felt, or printing, side because the watermark reads correctly from left to right.

You should also arrange a stack of newsprint sheets to place between each freshly pulled print as a protective sheet.

Wrap each pile of torn printing papers in sheets of newsprint for protection and put them near the press in a clean place. This place should be handy to your inking and printing traffic pattern. Many lithographers build a special box platform arrangement over the end of their presses for this purpose.

Dampening your paper for black-and-white prints makes it easier to pick up the image when printing. Dampening can be done the day or night before printing by any of these methods: lightly sponging every other sheet with a thin film of water; sponging each sheet on both sides; thoroughly wet-

ting every third sheet and making a sandwich of dry and wet sheets. Store the dampened paper in a plastic bag or plastic wrap. The sheets eventually become evenly damp, particularly if they are kept flat and weighted down. Remove each sheet of paper separately when you begin to print.

You should become familiar with the many good quality papers and use them as you learn because they can enhance your prints with their color and surface variations. (See Chapter Two.) To begin, however, we recommend Arches Cover (a warm white with a slight surface roughness) and Italia (a cool white with a smooth surface).

Registration

Marking the editioning paper with registration marks ensures that the image in a black-and-white print will be positioned exactly the same way throughout the edition. In a multicolored print, registration marks designate where the paper must be placed on the stone or plate so that each color will print correctly in relation to the others.

There are several methods of registering, and each artist develops a personal preference. The first method explained here is known as T-registration and is quite simple.

T-REGISTRATION

Spread the edition papers face down on a clean surface. With a straightedge and pencil draw a short line at the midpoint of each short edge of the paper perpendicular to the edge of the paper. Note that you are drawing the register marks on the side of the sheet that will *not* print.

Now center one of the marked sheets of paper on the undrawn stone or plate, and using a ruler and a hard (2H) drawing pencil, extend the registration lines on the paper onto the lithographic base. For the sake of simplicity, call this line the *vertical.* Then draw a perpendicular line through the middle of the line on the bottom edge of the paper, that is, the edge at the foot of the press bed. This line is the horizontal. Now draw a line on the plate or stone parallel to the edge of the paper and the first horizontal. This is your T.

One handy trick used by professionals is to use the smooth, cut, edge of the paper for the T-edge instead of a torn edge. This insures that the line on the stone or plate is perfectly straight.

Thus the stone or plate and the paper will each have two lines, one vertical and one horizontal. The horizontal line on the stone or plate, parallel to the edge of the paper, will enable you to line up the bottom edge of the paper. The vertical lines on the bottom edge will enable you to center the paper on the plate or stone while the horizontal line on the paper will enable you to keep the paper straight. If you register the lines at the bottom of the paper correctly, the vertical lines at the top edge of the paper will line up perfectly.

Using T-registration takes some practice. Always begin with the bottom edge of the paper and set that down first. As you bring down the rest of the sheet, bend over the paper and line up the vertical at the top of the paper with the vertical on the plate or stone, keeping the bottom edge in place with your thumb. Because you have placed the registration marks on the length of the paper, you will have more control when registering to an inked plate or stone; if you were to place the registration marks on the width of the paper, the longer edge could flop down and get smudged.

When using T-registration, you must tear the paper and make the registration marks before you begin the printing process. The lines on the stone or plate are first drawn using a lead pencil with a hard (3 or 4H) sharp point. For editioning they are usually incised with an X-acto knife or similar sharp instrument so they do not disappear or hold ink (as a pencil mark would) during printing.

PINPOINT REGISTRATION

Another registration method, more useful with small prints because small paper is easier to handle, utilizes straight pins or etching needles. This produces a fairly accurate registration, and the pinhole, being as tiny as it is, does not show on the printed work.

Begin by making a registration cross at the top and bottom of the back of each sheet of paper, in exactly the same location. These marks should be outside the print area but within the confines of the stone or plate. Then, take one sheet of paper, center it on the stone or plate, and insert a pin or etching needle through the center of the registration cross to make a small hole. Remove the paper, and make a small circle around the hole with a sharp instrument to help you find it when you need it.

Here are some helpful hints for making your pinpoint registration work: Take a few two-inch darning needles, and insert them in the broken ends of old paintbrushes or similar pieces of wood. This will give you a pinpoint registration tool large enough to handle. Stick the pin tools upright in a sponge to store them.

I find pinpoint registration especially useful when I suddenly realize that an image I am printing might work well with colors added. In this instance your initial print becomes your key image. (See Chapter Seven, Working in Color.)

To make it work follow this procedure:

1. Ink your image in black, and cut the paper with three-inch borders. Tap with a nail or punch two small holes on the key plate, just outside this image area, but within the paper area, about an inch and a half in from the paper's edge. This will make it possible to handle the paper and pins at the same time.

2. Take impressions of the image in black on newsprint or any other cheap paper. A small indentation will appear where the paper has gone over the holes in the plate. Spot this with printing ink.

3. Before the ink on the paper dries, dust with a mixture of aniline dye and magnesium powder (set-off powder) or lumberman's chalk. Make sure the image is covered thoroughly. Get rid of excess powder by tapping the back of the paper.

4. Take a new plate, sensitize it, and dampen the surface.

5. Lay the dusted impression on the damp plate.

6. Put them through the press as you would a print.

7. Peel off the paper, which plainly reveals a non-printing transfer image of the key plate and register dots.

8. Tap with a nail or punch the new register dots.

After you have inked your stone or plate, push the pin or etching needle through your paper and insert the pins or needles into the holes on the stone or plate. Now let your paper slip down onto the base and withdraw the pins or needles. Smooth the paper down onto the lithographic base, making sure not to move it in the process.

Another way to approach pinpoint registration is to make your marks on the key image by hammering minute dents with a nail, then pass your printing paper through the press. The pressure will make dents where the pin should push through.

Pinpoint registration is very useful for multicolor bleed prints. In such instances, two tiny holes are made at significant points on the image, top and bottom, such as the corner of an eye or the edge of a fold of clothing. Thereafter, each stone or plate has a pinhole at these points.

One advantage of pinpoint registration is that you can use it after the fact. If you have printed an edition of an image to which you would like to add other colors, you can use pinpoint registration to add additional colors.

MYLAR REGISTRATION

A popular method of registration is one which involves the use of a transparent sheet of mylar. Holes are punched in the mylar, the litho plate, and printing paper in a manner similar to the pin regis-

tration just explained above. Although Mylar registration can be adapted for use with stone lithography, it is suggested that you use it as explained here, only for plate lithography.

In the Mylar registration method, you penetrate the Mylar, printing papers and your metal printing base with a quarter-inch paper-punch. These are held together during printing by quarter-inch registration pins commercially available from offset printing supply sources. These registration pins are taped down to the bed of the printing press where they hold both the paper and the plate or just the printing paper during printing.

Although you can use far more complicated and sophisticated approaches to the Mylar registration method, here is a basic step-by-step presentation of this technique:

1. Cut a master sheet of clear Mylar to the size of your plate.

2. Position Mylar and litho plate on your press bed with a narrow end of the plate positioned under the scraper bar. Using a magic marker, mark this end of the Mylar "START."

3. Indicate your paper area on the Mylar. Calculate to leave one and a half inches as the border of your paper on the Mylar. Then add two inches on both printing paper and Mylar guide sheet at the end of the paper which will line up with the Mylar position designated "START."

4. Indicate the image area inside paper area.

5. Tear the proofing and edition papers to the correct size, including the extra two inches used for register marks. Mark the "START" end of the paper with an S in pencil to help you position it correctly for each use.

6. Place Mylar and printing paper over the printing plate. Punch holes evenly through Mylar, plate and proofing editioning papers, using a paper punch.

7. Continue to make holes in the paper using the plate and Mylar as a guide.

8. Attach registration pins through the register holes in each plate to position the paper for multicolor printing.

To make sure the holes are positioned in exactly the same places on all three, I use the following procedure: I get the end of a discarded offset plate or a used opaque from my friend's offset print shop. Both of these have four or five quarter-inch holes that have been made by the shops' heavy duty punch. Use them as a guide to position your plate with the holes in exactly the same place each time on each base and printing paper and then punch through the holes with a quarter-inch hand punch.

Another way to make these holes accurately was shown to me by the stripper in the camera room of the same offset shop. He positioned four or five quarter-inch register pins through the prepunched holes in a sheet of yellow opaque plastic. Then he gently rubbed the printing paper over each pin until the paper was indented. Using a knife, he cut and removed a small square around the identation and inserted and taped a small plastic square containing a prepunched hole in its place. These prepunched holes are inexpensive and can be ordered by the hundreds from offset supply houses (see Chapter Thirteen for a supply directory).

PRESS PREPARATION

The lithographic press is a transfer press. It operates on the principle of pushing a straightedge under considerable pressure across the flat surface of the plate or stone. Paper is placed over the plate or stone, covered with a protective sheet of newsprint or a blotter, and topped by the greased plastic sheet known as the tympan. It is the tympan that directly receives the sliding action of the long straightedge piece called the *scraper bar*; as the press bed moves the plate or stone under the bar, the pressure of the scraper bar pushes the paper against the inked surface so that the ink is released onto the porous paper.

The horizontal surface on which you place your plate or stone is the *press bed*. It is usually at least two inches thick and is made of pressed wood or metal. It slowly moves forward under the scraper bar when the roller beneath the bed is activated by an electric starting button or a hand-turned press crank. It is usual practice to place a sheet of battleship linoleum or a Mylar slab on the press bed (underneath the stone or plate) to act as an additional cushion to absorb pressure.

HOW TO OPERATE
THE PRESS

Pressure is exerted on the lithographic base from two sources: a foot-long handle on the side of the press, which can be raised and lowered, and a large center screw mechanism, called the *pressure screw*, which raises or lowers the box holding the scraper bar. As the pressure handle is lowered, the press bed lifts up toward the scraper bar.

Figure 6.3
Photo by Mace Wenniger.

Press tension is increased until tight contact is made between the scraper bar and the press bed by turning the pressure screw to lower the scraper at the same time that the press bed is raised by pushing down the press handle.

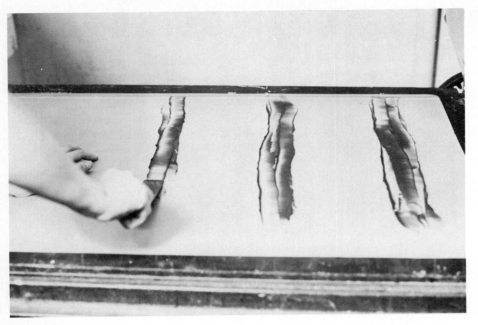

Figure 6.4
Photo by Mace Wenniger.

Strips of the same lubricating grease used for the scraper bar are distributed on the surface of the tympan. It may be mutton, tallow, car lubricant or vaseline.

To set up the press, first spread lubricating grease or vaseline on the leather edge of the scraper bar and on the tympan (on the side that comes in contact with the scraper bar). The tympan must be kept dust- and grease-free when you are not printing.

The tympan should be drawn up over the press or moved to a clean, handy location. With the tympan out of the way, you can use the press bed for inking.

Positioning Stone or Plate on Press Bed

Now you can position your stone or plate in approximately the middle of the press bed. Be sure, however, to wash the press bed with hot water first to remove old gum; use lithotine to remove old ink.

To secure the plate to the press bed, lightly sponge the press bed with water, making sure the

Figure 6.5
Photo by Mace Wenniger.

To secure a plate to the press bed, the author squeezes a small amount of water onto the press bed, where it works as a bond between press bed and plate. The plate is shimmied and slid about until it attaches itself firmly to the bed.

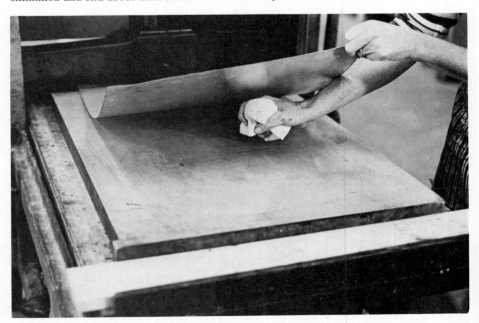

wet area is much smaller than the plate. Then slowly uncurl the plate over the center of the wet area on the press bed and coax it down. This squeezes out any air and creates a suction between the plate and the bed. Take care not to use too much water, or it may ooze out while you are printing and cause smears. Sponge up excess water from around the plate. More water might be squeezed out on your first print, so keep a clean sponge handy to soak it up.

One alternative preferred by some printmakers is to tape the dry plate to a dry press bed. The problem with tape is that it holds ink, so care must be taken to keep ink away from the taped edges.

Care must also be taken in transporting the heavy stone to the press bed. When you lift the stone, be sure to tilt it so as to protect your fingers and make it easier to grasp. If you have a rolling cart, you can use it to make the transfer to the press bed. As you slide the stone onto the cart or directly onto the press bed, do so at an angle to a corner as shown and keep the stone tilted to protect your fingers. Position the stone on the flat surface of the press bed, approximately in the middle, and lock it in place with a wedge of wood.

Adjusting Press Tension

Now that your stone or plate is in position on the press bed, you can adjust and readjust the pressure screw and pressure handle. First, be sure to cover the stone or plate with a sheet of newsprint to protect the surface. Then cover both with the greased tympan.

With the base, blotter, and tympan positioned under the scraper bar, and with the press handle up, turn the pressure screw located in the center of the press frame to the right to lower the scraper bar. Continue slowly until the scraper bar just rests on the tympan surface, barely making contact. Then push down the pressure handle, which will raise the press bed so that the printing sandwich is pressed against the scraper bar. You should feel some tension in the handle as you push it down.

Check tension; adjust it by repeatedly releasing the pressure handle and minutely tightening or loosening the pressure screw. Test the tension you feel as you lower the pressure handle each time. When the scraper bar rests firmly on the tympan, the final step in getting the correct amount of pressure is to release or raise the pressure handle and turn the pressure screw one half of a turn tighter. When the pressure is just right, you will feel an even but definite resistance as you lower the pressure handle. This is your signal. Get to know when it feels like the right pressure.

You can start printing with this moderate to light pressure. As you proof, you will probably want to adjust the pressure by raising the pressure handle and turning the pressure screw to increase the pressure slightly. By the time you are pulling your last proofs, the pressure should be adjusted sufficiently.

Figure 6.6
Photo by Mace Wenniger.

Carrying a stone to the press requires some skill. This stone is transferred to the corner of a cart by carefully tilting and pushing it, while watching out for the fingers of those carrying it.

Starting and Stopping the Press

Since the edges of your stone or plate will be obscured by the tympan, you need to know where to stop and start the press without actually seeing the front and back edges of the stone or plate. This is particularly important in the case of a stone, because if you allow the scraper bar to continue beyond the edge of the stone, you risk breaking the stone.

Move the press bed toward the scraper bar until the edge of the stone or plate is just under the bar. Mark the edge of the press bed with chalk or thin strips of masking tape at the front of the press frame, which houses the scraper bar. This tells you when the scraper bar and stone or plate will first make contact. Move the press bed again until the plate or stone has passed under the frame so that the back edge is just touched by the scraper bar. Mark the edge of the press bed at the back edge of the press frame. This second mark tells you when to stop the press.

Preparing to Proof

Your press is now ready for proofing. First, however, try starting the press without inking. Lower the pressure handle, press the starting button if you have an electrically operated press, and hold it until the first chalk mark or piece of tape lines up with the edge of the press frame. Continue to move the press bed until the second chalk mark (denoting the back edge of the stone or plate) lines up with the edge of the press frame.

If you are using a hand-operated press, turn the wheel that makes the press bed roll slowly under the scraper bar.

Note that lithographs are passed under the scraper bar only once, with the press bed moving in a forward motion.

After the stone or plate has passed under the scraper bar and the press has been stopped, the pressure handle should be raised. If you were actually proofing or editioning, you would then lift off the tympan and blotter and "pull" your proof or print. "Pulling" means that you carefully and slowly lift the paper off the base, starting at the end of the paper farthest from you, and pulling the print toward you. Use tabs to protect the paper if you have ink on your hands.

After your dry run through the press, put the tympan and blotter (and protective newsprint) aside for the moment. You are now ready to ink your stone or plate on the bed of your press.

Roller Preparation

If you are going to use a leather roller, get it ready to receive ink by scraping the old ink off its surface with a long spatula. Remove any residue of old ink

Figure 6.7
Photo by Mace Wenniger.

Chalk marks are made on press bed, to line up with beginning and end of stone or plate. They indicate where to start and stop the press, as the tympan obscures view of stone or plate. It helps to make exact stops and starts if you keep your index finger poised on the bridge of the press as illustrated during printing and then stop the press when the chalk mark meets your finger.

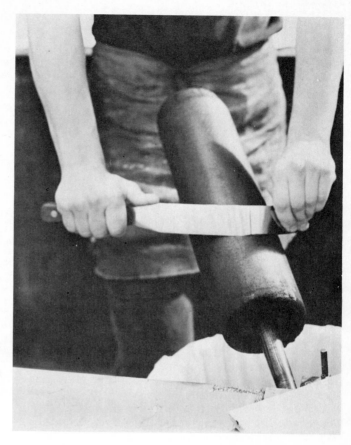

Figure 6.8
Photo by Mace Wenniger.

A leather roller is scraped with a long spatula to remove old ink in preparation for rolling out proofing ink.

from a rubber or composition roller with turpentine or lacquer thinner. You have to be extra careful to remove any ink traces if you are going to print in color, to prevent your ink from being grayed by hidden residues of black ink. This requires going through the cleaning process again, using lacquer thinner on the glass slab and rubber roller.

Ink Preparation

Begin by putting on rubber gloves to protect your hands, having shaken talcum powder into them to make putting them on and removing them easier.

Ink cans are usually difficult to open. Keep a large screwdriver on hand to pry the lid open. Re-

Figure 6.9
Photo by Mace Wenniger.

Ink is scraped out of the can correctly. The putty knife scrapes ink from the surface and does not cut down the ink.

move the tape from previously opened lids (the tape helps prevent the ink from drying out), but be sure to put the tape back on once you have laid out the ink you need.

To remove the ink from the can, *use a putty knife and scrape ink evenly from the surface.* Do not make a dent or gouge in the ink. Following these rules will prevent your ink from drying out quickly.

Black ink is used for proofing, even if the plate or stone will be editioned in color. It is finer and stiffer than colored ink and holds on to each dot or grain separately without oozing and slipping between the grease-laden hillocks, which could result in a not-so-well defined image.

Working the Ink

To work the ink means to push it against the glass slab with a putty knife, folding it over and pressing it on the glass surface.

It is recommended that you work your ink for at least five to ten minutes. This warms it and loosens the molecules, which helps the ink flow on the glass slab under your roller.

The flow required of the ink depends on the image you are printing: carefully delineated drawings need tight, tacky ink, while large flat areas respond best to a loose, juicy ink which contains a drop of varnish or the commercial printing gel sets well (see Supply List, Chapter Two). If the black ink you are using seems loose, add magnesium as you work it against the inking slab. Note that ink is affected by weather conditions, its age, and the heat or humidity in the room.

The ink must have bounce, or tack, so that the image will be crisply transferred or printed on the paper. Take a smear of ink on the slab and bounce your knife up and down on it. If you can pull it away from the inking slab with some snap, not drippiness, it is ready for use. For more information about inks, see Chapter Two.

Inking the Roller

Using a putty knife, lay down a thin flat line of ink slightly longer than the roller across the glass inking slab.

Push and pull the roller across the strip of ink, lifting at the start of each roll. Turn it each time it is lifted, spinning it slightly to make sure that all parts of the roller receive the ink evenly. Elevate your wrist at the end of each roll to release your fingers slightly and to allow the roller to rotate with a rhythm. When the ink appears in a thin even film on the slab and roller, it is ready to be applied to the image on the stone or plate. It is important that the ink be evenly distributed on the entire roller, without any empty spaces, so that the image will receive an even film of ink.

As the ink is rolled across the inking slab, be aware of its feel and sound. If the ink feels slushy and is very slippery, it is *too long.* This may mean

Figure 6.10
Photo by Mace Wenniger.

On a glass slab, black ink is worked with a putty knife to "warm it up" before using it on the roller. Magnesium carbonate is being added to tighten the ink, a step which makes it easier to print crayon drawings faithfully, i.e. without "filling in."

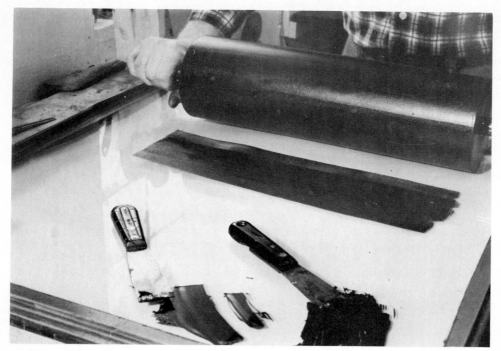

Figure 6.11
Photo by Mace Wenniger.

With a putty knife, a thin strip of ink has been pulled across the inking slab. Here the rubber roller is moved vigorously back and forth across the strip of ink.

that it needs an additive like magnesium to tighten it up or that there is too much ink on the slab. (See Inks in Chapter Two.) The ink should make a slight snapping sound as it is deposited on the image and as it snaps away from the dots. If there is no sound at all, the ink has too much magnesium in it, that is, it has become *too tight* on the roller, and consequently isn't releasing or adhering to the image as it should. In either instance, the ink should be changed before proceeding.

PREPARING YOUR IMAGE

Before you actually begin to print, you must first carefully prepare your processed image. This involves three tasks: the wash out, the rub up, and the roll up.

The various technical steps involved in preparing an image for printing are easy enough to remember. After you have etched the stone or plate, you dissolve the image through the gum stencil; this is known as the *wash out*. You then rub the image with thinned ink or asphaltum, which is called the *rub up*. After washing the surface clean with water, you dampen your stone or plate and roll ink onto the grease-attractive image; this is known as the *roll up*. You will then proceed to print the image.

Wash Out

The wash-out procedure is the same for plate or stone. To wash out the image, use turpentine or lithotine and soft paper towels. Rub the stone or plate in a circular fashion and replace used paper towels with clean ones periodically until all traces of grease are removed from the image. Be sure to remove all drawing materials through the gum; if any are left on the image they will lift during the printing process, thus creating an unstable image for you to print.

Rub Up

Before you can print a lithographic image, the previously dissolved image must be coated with grease-attractive material. This is called the *rub up*. It establishes a stable printing base on your litho stone or plate. Rub thin asphaltum or a solvent-thinned solution of the colored ink you will use across the face of the stone or plate in short circles, using cotton swabs or paper towels. Then buff the rubbed-up stone or plate smooth with a cheesecloth, using light pressure. Remember that asphaltum will discolor inks not in the black brown range. Refer to chapter seven on color lithography.

Rubbing the image with this greasy material is essential. It will adhere to the previously cleaned image and make it grease-attractive. Since the print-

ing ink is greasy and grease-loving, it will stick to these grease-laden dots during printing. But when preparing a zinc plate for inking it is important to *skip* the rub up step which would add too much grease causing fill-in and scumming problems to a plate that is oleophilic, or oil-loving by nature.

If you are going to ink and print immediately, wash off the stone or plate with water to remove the asphaltum or solvent-thinned ink from nonprinting areas. Use a coarse sponge that will not be used during proofing or printing, because the rub materials clog the sponge. Wet it with cool water and pull thin, even strokes over the stone or plate. You can substitute wet paper towels, to keep your sponges clean. Before you take this step, however, you can take a break to assemble materials for the inking and subsequent procedures, since the rubbed-up stone or plate must be kept damp all during the inking and printing processes.

If you are not going to print the stone or plate immediately, prepare it for storage after the wash out and rub-up by either wrapping it in newsprint or rolling it up with black proofing ink, talcing and gumming it, and then wrapping it in newsprint for storage. If you start to print and notice that the image

seems faint, it is best to pull a few more proofs. This will help "bring up," or strengthen, the image. After proofing, always roll up the stone or plate with black ink to full strength again, then talc and gum it. Cover the image with newsprint and tape the newsprint to the back side of the stone or plate for safe storage.

PROOFING AND PRINTING A STONE OR PLATE

No matter how long you have been drawing, it is an exciting moment when your drawn image is first rolled up with black ink and then transferred to a sheet of paper. This process is known as *proofing* the image.

The basic proofing steps are: ink your image, cover it with a sheet of proofing paper (newsprint or other inexpensive paper), place another sheet of newsprint over all, put this printing sandwich through the press, pull a proof, sponge the plate or stone off, roll on more ink, and repeat until your image is up to full value and strength. Once the proofing is completed, if you are not going to edition

Figure 6.12
Photo by Mace Wenniger.

Ink spreads out across the inking slab as the roller is pushed forward over it. This printer is about to turn the roller, shifting it until he is sure that it is evenly covered with ink, ready to roll on his litho base.

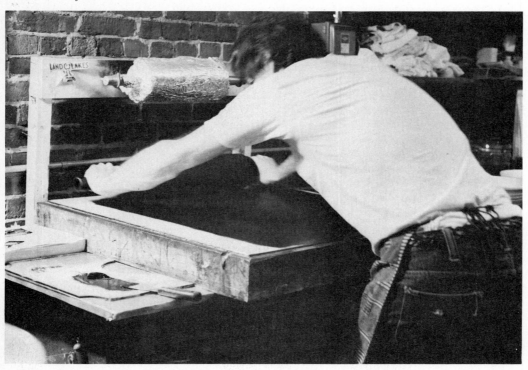

immediately, apply a thin coat of gum and let the image rest before proceeding further.

Proofing is the step prior to printing an edition of a print. When you proof, you will be seeing your image printed for the first time. As you slowly roll ink over the damp lithographic base, the ink attaches itself to the drawn areas and is repelled by the wet, nondrawn areas. You see your image emerge on the stone or plate. Paper goes over the image, then the tympan, and finally you put the stone or plate through the press and pull a trial print. This process is repeated several times as you slowly bring the image up to its drawn values.

After a few proofs are pulled, you can dampen the stone or plate with a fountain solution, which is composed of one ounce of gum and six drops of phosphoric acid. This helps stabilize the image. When the image looks as strongly defined as it was originally drawn, you can switch to a good paper and start to edition your print.

Proofing is a time of suspended judgment when you can make an aesthetic evaluation of your printed image. It is also the point at which you can determine whether or not the image will print well. Proofing is important because an image gradually attains its full range of values through repeated inking and printing. This is the time to make corrections and determine how best to ink a particular image.

The process of slowly inking an image to its full values is unique to lithography. The washed-out and rubbed-up image will only print up to its full values after several passes through the press. That is, *the "awakening" image will accept just so much ink at a time and must be slowly coaxed up to its full potential.* A lithographic image cannot be forced to accept ink, or it will coarsen and muddy up. Most printmakers plan to do about ten proofs to get their image up to full strength. These gradually darkening proofs are known as *progressive proofs.*

As your image is being worked up to full strength, you must make some decisions. You must judge exactly when the image is the way you drew it, when the values in the image are inked sufficiently but not too much. If a lithographic printer were to print your work, you would hover over his shoulder and point and exclaim, "There it is, that's exactly it!" Now you must, as your own printer, lean over your own shoulder and call it when it is exactly as you want it.

Once your proofing has proceeded to the point where you are satisfied with the image, tax your artistic judgment. Pause long enough to judge the merits and flaws of the image objectively before you go ahead and print the edition. Tack the proof on a wall and look at it carefully. Ask yourself how well you exploited the lithographic medium. Have the tusche or crayon areas started to thicken or fill in? Have the dots of crayon created passages of light and dark? If so, see the following section for counteretching techniques.

After proofing and studying your print, you can make a decision about whether to make your edition using black ink or to print in color.

A well-drawn lithograph edition printed in black and white can be beautiful and show lithography at its very best. The degree of visual appeal, however, depends on subtle variables that you must now consider. These include being sensitive to the color and texture of your paper and the color of the black ink that you choose for the printing.

Depending on the subject, the choice of a paper that is off-white, cream, gray, buff, or tan, plus a black ink containing an admixture of some reddish yellow for a brownish-tinted black or some blue-red for a cool violet black can do wonders for a lithograph. Although the subtle colors of paper and inks remain unobserved to the average viewer, most people find these softening efforts pleasing to the eye without being consciously aware of what the artist has done.

Black inks range in subtle shades from cool to warm, in finish from flat to glossy. These can be mixed to be silver blacks, sepia blacks, green blacks, blue blacks, and red blacks.

Now is the time to consider whether your lithograph should be printed in black or developed further as a single color or multicolored lithograph. By studying your proof, you can discover possibilities that did not occur to you earlier. At times a stone or plate may lend itself to highlights of color; at other times the same stone or plate can be used to print many colors by careful use of counteretch. Or again, the image can be used as the key plate or stone for a multicolor print (see Chapter Seven, Working in Color.)

Sponging the Plate or Stone before Inking

The stone or plate must be kept damp all during the printing process once the excess asphaltum or other grease-attractive substance has been washed off.

You will use two sponges throughout the printing process, along with two bowls of water. The coarse sponge lays down a coat of water over the entire plate or stone, and the finer sponge, kept well wrung out, removes any excess water and keeps the plate or stone damp. Too much water will cause the roller to slide or skid. Two water bowls are used, one for the coarse sponge, one for the finer. The second must always remain clean in order to prevent scumming. The second bowl often contains a drop of gum arabic or fountain solution added as another preventive measure against scumming.

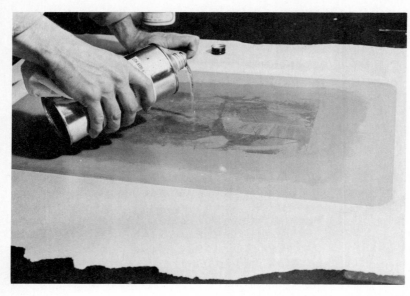

Figure 6.13a
Photo by Mace Wenniger.

Wash out: The image on the gummed plate is dissolved with turpentine. The hardened gum remains as a stencil.

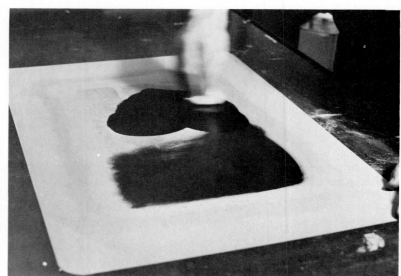

Figure 6.13b
Photo by Mace Wenniger.

Rub up: After the image is washed out, solvent-thinned black ink or asphaltum is rubbed into it, except if printing on a zinc plate, this step is skipped.

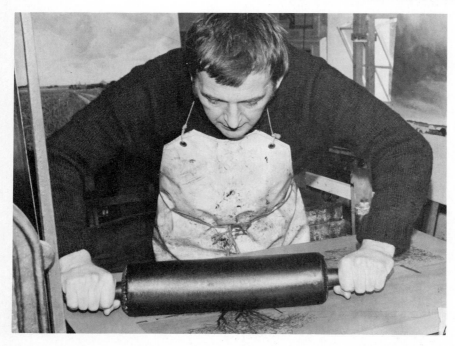

Figure 6.13c
Courtesy George Guest.
Photo courtesy Charles Robarts.

Roll up: Artist rolls black proofing ink on the image on his zinc plate, which rests on the bed of his press.

Figure 6.13d
Courtesy George Guest.
Photo courtesy Charles Robarts.

The artist arranges newsprint and blotter over printing paper and plate. This cushion softens and tightens the pressure exerted by the scraper bar passing over them.

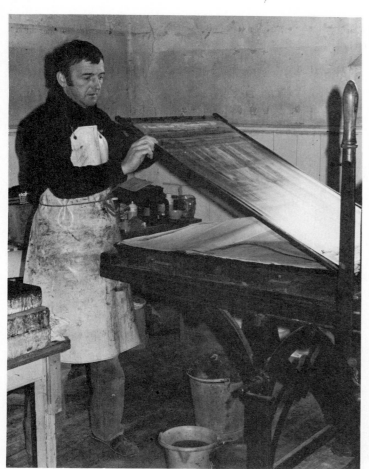

Figure 6.13e
Courtesy George Guest.
Photo courtesy Charles Robarts.

The last step in making a printing sandwich is the placement of the greased plastic tympan sheet all over. Some tympans are arranged by the printmaker in a more convenient way with the tympan automatically being lowered by a pulley arrangement as the plate goes through the press.

If a break is necessary in the midst of printing, roll up ink on the stone or plate, and cover the surface with a thin coat of gum arabic.

Inking Your Plate or Stone

Now that you have prepared your proofing ink, washed out, rubbed up, cleaned off excessive grease-attractive material, and dampened the stone or plate, you are ready to ink.

Move your inked roller across the damp stone or plate at a moderate pace. Do not stop the roller on the image or you will leave marks that will print. Roll from several sides of the image, preferably from bottom to top and side to side. The combination of different directions constitutes a *pass*. With a plate, two passes are probably sufficient for each proof, whereas three passes may be necessary on a stone. Keep track of the number of passes you use for each proof. This helps to make the inking consistent when you edition.

Be aware that images on plates are in some ways more difficult to ink than those on stones. Because the grease sits in a superficial way on the plate, compared to its penetration into the pores of a stone, special care and sensitivity must go into inking a plate. The artist must watch the work to see that delicate areas are not overloaded, and yet must take care to bring enough ink to the darker passages.

Correcting Common Printing Problems

SCUMMING

If the image is inked too heavily at one time, or with an ink that is too loose, the white areas around each grease-topped grain might fill in. This is referred to as *scumming*, or *filling in*. When that happens, some of the delicacy of the image is lost. Because a coarsened image is difficult to restore, it is important to proof slowly and carefully. Should scumming occur, however, you can try lifting some of the excess ink off by *rolling hard and fast* with your roller or by putting the plate or stone through the press several times without reinking. Then give the image a quick roll up with magnesium-tightened ink, talc and gum the stone or plate, and put it aside to rest and stabilize.

An excellent measure to correct scumming on plates is the following: Be sure the image is gummed; wash out ink with a solvent; rub in more of the solvent-thinned ink; buff this to the plate surface, roll up and print again. For plates, sponge with Pro Sol and water in a fountain solution (2 ounces of Pro Sol to 1 gallon of water) to correct scumming.

WET WASH OUT

Another solution, possible only on stone, is to remove all the ink using water and turpentine, and then reink. You must apply this wet wash out with great care, but you can do it any time, even while you are printing an edition.

Applying a Lacquer Base

You may wish to apply a lacquer base to your plate or stone after proofing. This helps stabilize the image for a large edition of prints, but it is not necessary for a small edition. Below are the steps to follow when applying a lacquer base:

1. Use soft paper toweling, wash out the etched plate with turpentine and lithotine, then isopropyl alcohol, and finally lacquer thinner to remove all the grease from the image. Each of these solvents lifts off grease in a different way. They are all used to obtain the complete grease removal necessary before adding the lacquer coating to the plate. If any grayness lifts off the plate when you clean it with the lacquer thinner, repeat the application of alcohol and lacquer thinner until your solvent rags are relatively clean after use.

2. Now apply the lacquer base. Pour a small dollop, about the size of a half dollar, on the plate and smooth it over the whole plate in a thin film with a soft cloth or cotton swab. Use rapid arm motions so the lacquer does not become tacky during the application process. Be careful not to use too much lacquer base. A very thin coat is all you need. If you apply too much, you may find it difficult to remove from nonprinting areas when you wash it off before printing.

3. Buff the lacquer film with a clean wad of cheesecloth. Then apply the grease-attractive material of your choice with a soft rag and proceed to printing steps.

EDITIONING

When you print your image on good paper as a multiple, you are making an edition. One characteristic of an edition is that the number of prints you make are limited in number; this varies from ten to fifteen for the beginner and from one to two hundred for the professional.

Another common practice among printmakers is to print all the prints in an edition exactly alike. However, I have heard it said by print curators that fifty prints in an edition of fifty can be entirely differ-

ent from each other. In fact, curatorial practice today is to search for the unique print, to encourage print-makers to print each print in an edition differently from all the others. Curators often want a personal print, a manipulated print.

As a beginner though, when you make an edition, try to make all the prints look the same. This is the traditional understanding of an edition.

If you did not store the plate or stone after you pulled your last proofs on newsprint, simply roll up your image again to commence editioning, register your editioning paper to the stone or plate, and print. If you did store the stone or plate fully inked in black after proofing, you will have to wash out and rub up the image with your editioning ink before rolling it up with editioning ink.

Editioning with Colored Inks

Should you choose to edition with a colored ink, however, you cannot proceed directly to editioning after you proof; you have to prepare by first inking the image in black ink, using proofing procedures, bringing the image gradually up to full strength, or as completely articulated as originally drawn. Then talc it, gum it, and dry it before starting the steps necessary to print it with a colored ink.

The next step is to remove the black roll-up ink from the inking slab and roller, as well as from your stone or plate. This clean up is particularly essential if you plan to use a light-colored ink because any black residue can muddy colored inks, particularly the lighter hues.

Gum the stone or plate first. Prepare your colored editioning ink, and ink the roller. The stone or plate must now be washed out through the gum stencil and rubbed up with thinned colored ink if you are editioning in color or thinned black ink if you are editioning in black ink.

Since you have washed out the stone or plate after proofing, you will have to proof the image again on proofing paper to bring the image back up to full value. You should roll up the stone or plate with the same number of passes used in proofing earlier, so you can expect the image to build up to full strength after pulling approximately the same number of proofs as before. The proof that finally shows you the image as you want it to print is called the *bon à tirer* proof.

CARE OF PRINTS
WHILE EDITIONING

As each print in the edition is pulled, it should be stacked carefully between clean sheets of news-

Figure 6.14
Photo by Mace Wenniger.

David Thomas is shown in his studio beside his clothespin arrangement made for hanging prints up to dry. Another option is a storage rack made of a tier of wooden or wire slats at one end as seen in Figure 6.1.

print or, if the edition is printed on dry paper, you can hang the prints up by two corners from clothespins strung on parallel wires or lines with paper tabs under the clothespins to protect the paper.

If your printing paper has been dampened before printing, place each print flat between sheets of newsprint and blotters. Then use large sheets of homasote boards on top of every six prints and blotters. The weight of these boards makes the prints dry flat. The newsprint should be changed daily until each print is flat and dry.

If you stop printing for a half hour or more, gum the stone or plate by using a damp sponge, and fan it dry. When you are ready to resume printing, wash off the gum and re-ink.

Closing the Stone or Plate

When you have finished printing and wish to store the plate or stone for any length of time, or even if you are going to remove the image eventually, the following steps should be followed:

1. Roll up the image with ink.
2. Talc it.
3. Gum it. (Either cover it with newsprint, and store it in this state or go through the following steps.)
4. Wash it out with lithotine or turpentine.
5. Rub it up with asphaltum, and buff it to a thin, even film.
6. Cover the stone or plate with newsprint and store it on a shelf.

It is important that the stone or plate be kept free from moisture. It is dampness that will alter or damage the image. In the case of a plate, be sure to wipe off the back when you remove it from the press to prevent oxidation.

CLEANING UP

After editioning or proofing, be sure to clean up thoroughly. The instinctive reaction after printing is to close the door behind the mess. Don't do it; it's hard-

er the next day. Clean up is a good wind-down. Here is a clean-up list to follow for workshop and printing accessories, with hints to make it easier for you.

1. First remove most of the ink from the slab by scraping, not dissolving it. Use an inexpensive paint scraper or a window scraper and lift the ink off. Then dissolve the remaining ink.
2. Spread kerosene or paint thinner over the inking slab. Over this puddle, press a sheet of newsprint. You can then roll the inked roller over the solvent-saturated newsprint to remove most of the ink on the roller while cleaning off the ink slab. Repeat the process until the slab and the roller are clean. Hang rollers up on roller rack. Finish by cleaning with dampened paper towels. Clean the putty knives and put them away.
3. Clean rubber rollers with solvent. It helps to rest roller handles on edges of trash bin and spin as you wipe off ink with solvent.
4. Scrape the nap and ink the leather roller both with and against the grain. Wrap in tin foil. Hang up on a horizontal rack.
5. Clean the grease off the leather strip of the scraper bar and off the back of the tympan. Use soft rags and solvent. Hang up the scraper bar and tympan.
6. Be sure to cover the trash can filled with solvent-soaked papers tightly. If possible, place the can outside your studio for safety reasons.
7. Wash out the cheesecloths, shake them, and spread them out flat or on a line to dry.
8. Tape ink cans shut; ink crusts easily.
9. Wash out sponges and water bowls. Dry sponges before storing so they will not sour. Put away inks, gums, asphaltum, and other materials.

Winding Down

Clean up inks and inking slab, remove solvent filled rags, open windows to ventilate, wash out gum filled cheesecloths, thoroughly wash out and wring your wetting sponges and put them somewhere to dry, be sure the bed of the press is gum- and ink-free, pick up any scraps of newsprint on the floor, turn off all electrical equipment, and shut the door on another day.

Figure 6.15
Photo by Mace Wenniger.

Rubber rollers should be cleaned immediately after inking. Metal waste can edges serve as a holder while the roller spins and solvent is slowly poured over it. The ink is wiped off with paper towels or rags. The plastic bag in the waste can catches drips and dirty towels. To prevent fires, a lid is placed on the can after the flammable material has been put in.

Figure 6.16
Photo by Mace Wenniger.

An important part of cleaning up after printing is to remove the grease from the scraper bar and also from the tympan. Use soft rags and solvent. Hang up scraper bar and tympan.

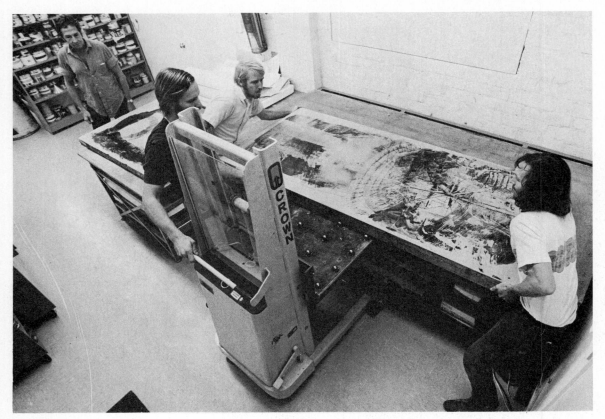

Figure 6.17
Photo courtesy Gemini G.E.L., Los Angeles, California.

Gemini G.E.L. lithographic workshop shown during the printing of Robert Rauschen-
berg's *Stoned Moon Project* (1971). Robert Rauschenberg observes his huge drawn
stone lifted onto a carrier which will transport it to the press for color printing.

SUMMARY OF PRINTING STEPS

1. Grease the tympan and scraper bar.
2. Place the scraper bar in the holding box. The *set screw* in the middle of the box is turned to hold the scraper bar in place in the box.
3. Cover the stone or plate with the tympan, but no paper, since you are just setting up the press.
4. Make chalk marks or use tape to indicate on the press bed where to start and stop the stone or plate.
5. Adjust press pressure. With the pressure handle raised, turn the pressure screw to adjust the pressure of the scraper bar against the tympan resting on the stone or plate.
6. Check the pressure again. You should feel considerable tension in the pressure handle as you push it down.
7. Prepare your ink roller.
8. Prepare color or black ink; modify it if necessary.
9. Roll out ink.
10. Wash out or dissolve processed image, using turpentine or paint thinner.
11. Rub up image with thinned black or colored ink.
12. Damp-sponge the image to remove ink from negative, non-ink-holding areas.
13. With a clean wet sponge, dampen plate or stone.
14. With ink-charged roller, ink the stone or plate.
15. If you are proofing, cover the inked stone or plate with newsprint, then blotter and tympan. If you are editioning, you will register the paper to the stone or plate, in place of the newsprint, and then cover it with blotter and tympan.

16. Position the stone or plate under the scraper bar (using chalk marks) and start the press (using the button on the electric press or the crank of a hand-operated press).

17. After you stop the press, release the pressure handle, remove the tympan and the blotter, and pull your proof or edition print. Then return the press bed to the inking position.

If you like to work with color, you can learn color lithography. You have learned ways to make, process, and print a lithograph, and have mastered a registration technique. Now you will become familiar with simplified approaches to printing with multiple colors.

Color lithography dates back to 1817 with the early attempts of Alois Senefelder, the founder of lithography, who printed a color lithograph entitled *The Fair of Bulgaris*, a print in eleven colors which was so large in scale that he used three stones drawn side by side for each color. His first color lithograph had to have thirty-three separate printings for each print!

The main inhibition in doing color lithography, then as now, was the problem of working out an easy, clear method of registration. This was resolved in 1835 by Godefroy Engelman, inventor of a rather primitive registration frame which he developed for a new process of commercial color printing called *chromolithography*. The commercialization of the process slowed down the development of color lithography as an art form. Only black and white lithographs were deemed respectable by the Salon

Working in color

until the 1890s when the impressionists revolutionized lithography by producing many color lithographs.

HISTORY OF EUROPEAN COLOR LITHOGRAPHY

During the late 1800s in France and England, artists who were thinking of printing in color worked under the following influences: the development of chromolithography; the strong admiration and emulation among French artists for the Japanese overprinted color woodblock prints; the emergence of color photography processes based on color separations; and the growth of the poster as a legitimate art form.

The greatest period for color lithography in Europe began in France during the 1890s. So many major color lithographs were made that the period has been dubbed the "color revolution." At that time the seed was planted for a renaissance of original printmaking, during which artists began to print their own work. In an exhibition of painters-print-

101

makers at the Durand-Ruel Gallery in Paris, 353 objects, mostly prints, were exhibited, and the catalogue stated, "Today almost all the printmakers are beginning to print their own studies, to vary the effects of impressions. All possess convenient presses in their studios."

By 1895 avant-garde printmaking and color lithography were synonymous. The prints of Signac and Toulouse-Lautrec, Renoir, Cézanne, Rivière, and Gauguin were celebrated in exhibitions and publications.

Among the expressionists, the most acclaimed achievements in color lithography were made by Munch, Kolliwitz, Nolde, Kirchner, Beckman, Klimt, Kokoshka, and Marc.

The drawing of the expressionist Franz Marc, *Horses in the Wood*, printed in 1908, was done with an innovative interplay of the more experimental ways that he worked on the surface of the stone. His technique exploited both the granular texture of his base and the scraping and scratching techniques possible in lithography. It reveals one of the unique qualities of color lithography that results from overprinting color layers made up of vigorous textures which let the colors underneath breathe through their broken and random surface patterns.

Printed at the same time, Gaustav Kampmann's *Evening in the Fall*, with its broad handling of flat colors, shows a connection with Japanese prints and is certainly an antecedent of the broad, flat color-field work seen in many color lithographs of today.

A parallel development during the late nineteenth and early twentieth century was the poster movement. Between 1890 and 1910 a large amount of work, some of it later known as Art Nouveau, was printed by lithographic means in unlimited editions in the United States, Holland, Germany, Scotland, Austria, Italy, and Spain. It was in Lautrec's posters that the spattered effect known as *crachis*, which is used so often in color lithography, was developed.

The great painters—Picasso, Braque, Chagall—later used color lithography as a major means of expression. Their sketches and gouaches were reproduced in color often without the artist's direct involvement, to the great alarm of collectors, who saw these lithographs as variations of chromolithography. Picasso, however, later became directly involved with the lithographic processes, and maximized the medium by working directly on stones and plates which were printed directly under his supervision. They were images that he edited and worked on continuously, producing many states before he was satisfied and permitted an edition to be printed.

Picasso's *Bull*, a lithograph in eleven progressive states, was printed between December 5, 1945,

and January 14, 1946, in Paris. The first three states involved more and more detailed depictions of a bull. The states show a gradual reduction of elements until the bull in the eleventh state was drawn with only one abstract line in a dramatic, hardly recognizable outline of a bull.

HISTORY OF AMERICAN COLOR LITHOGRAPHY

Nineteenth-century american artists printing noncommercial color lithographs often worked abroad—Whistler's lithographs were printed in England and Paris, and Cassatt's was printed in France.

Color lithographs were printed in the U.S. by Reginald Marsh, Charles Sheeler, Childe Hassam, and Stuart Davis during the early decades of the twentieth century. These involved colors printed from separate hand-drawn stones which were prepared and carefully printed as interwoven layers of colors by the artists themselves.

Of greatest importance in the development of color lithography in America was the federal funding of the graphic arts division of the Works Progress Administration of the Federal Arts Program. It began in 1935 and continued until 1939, when it was replaced by the Work Projects Administration, and then disbanded in 1943. Under Holger Cahill's direction, workshops with good equipment were set up under the direction of experienced printers like Will Barnet at the Art Students' League in New York City and made available to help lithographers process and print their work.

Supported by the federal government, many artists experienced a new freedom to experiment and grow. It is reported in the documents of the WPA that a major surge of color lithography work was printed in New York, Chicago, and San Francisco. These lithographs were created with innovative color layering techniques as well as new ways of imaging that included transfers, scrapings, and tusche spattering.

A shift in subject matter also resulted from the lithographer's new independence: nature and portraiture were replaced by social statements—people in their environments of work, home, and travel. During the past thirty years this shift in interest back and forth between nature and popular culture has continued. Lithographic images have been either intensely personal statements or advertising billboards, flags, and targets. Photographic and newspaper elements were central to new work in the 1960s. Expressionism manifested itself at the same

time and persisted through the 1970s. However, a revival of realistic work is evident in today's subject matter: still life, portraits, urban and country landscapes.

Way to the Sea by Will Barnet (Plate 5) is an example of the new social statement. Noted for his powerful compositions and unparalleled drama of color in forms and symbols, Barnet always chooses the familiar, the poignant for his subject matter and designs it sparingly, which works to increase its power. The artist drew his designs on transfer paper and then transferred the drawing onto the plates and also added some work directly to the plates. His plates were printed on a flat-bed lithograph press. The sky-and-ocean blend was hand rolled.

Today, much of the interest in printing color lithographs has stemmed from the founding of workshops where artists can spend time experimenting with and editioning their own prints. One of the workshops is the Pratt Graphic Center, where artists can do their own color prints.

During the forties and fifties it was the leadership and instruction of teachers like Ture Bengtz, at the Boston Museum School and John Muench at the Rhode Island School of Design that influenced much of the work done in color. More recently Leonard Lehrer at the University of Arizona has taken the lead in setting high standards for installing safe, comfortable student workshops from which much

good color work has issued. During the past two decades many workshops, both academic and independent, have been formed—often called *collaborative* enterprises.

As a result of this interest and support, some of the most innovative work in printmaking done today is in the realm of color lithography.

WHY DO COLOR LITHOGRAPHY?

Exploring the many aspects of plate and stone lithography in color offers unlimited challenges to today's beginning lithographer. The ability to produce a lithograph in color by taking an image through several color printings in which layers created on either stones or plates are used to complement each other is an exciting accomplishment for both the beginner and the experienced lithographer.

A concern for color is, in fact, central to all lithography. Even in black-and-white work energy is focused on creating a range of values with varying intensities (colors) in each image. The hues of the black inks available must be considered carefully, since they vary greatly from cool to warm black tones. Although this chapter deals primarily with applying different colors to the same image, some of

Figure 7.1
Courtesy Lisa Mackie. Photo by Mace Wenniger.

"Draw Down." Artist Lisa Mackie pulls the edge of the putty knife across paper surface in order to see what the ink mixture looks like when spread on the surface of the paper or when layered over another printed color.

the approaches to color lithography discussed here might also be useful to a lithographer working with black inks. For example, the additive-subtractive method of reworking an image can help you refine and redo your work.

Innovative or traditional drawings made from pencil, crayon, rubbing stick, or tusche can capitalize on the grainy quality and its effect on a color print. The grain can facilitate and emphasize the interplay of colors with each other and with the printing paper. The granular surface can enhance lights and darks working in the same image. The background paper, itself sparkling through the minutely separated grains of color, imparts a luminous glow to your print. Space and light—these are both enhanced by the grain of your lithographic base.

GETTING STARTED

In color lithography you will work with several plates and stones, many layers of color, color combinations, and the ink properties—opaque, transparent, and translucent. These various elements make color lithography more complex than black and white.

Plan Your Image

When you start to work on your first color image, be sure to recall the basic elements of working on any image: be concerned with a strong composition and a strong interplay of values, from light to medium to dark. Your composition and range of values will provide depth and structural strength to your work before you start to consider hues.

WORKING WITH COLORS

Draw Downs and Tap Outs

As you experiment with colored inks and their properties, there are two easy ways to determine what your ink mixture will look like when printed: draw downs and tap outs.

A draw down is putting a color on a scrap of paper in a thin strip in order to see how a color mix will articulate on that paper. Do a draw down by pulling or drawing the edge of a putty knife that has been dipped in the ink along the surface of your printing paper or inking slab.

A tap out is lightly touching colored ink onto paper using an ink-covered fingertip. For a tap out,

Figure 7.2
Courtesy Lisa Mackie. Photo by Mace Wenniger.

"Tap Out." Tapping light or heavy spots of ink on printing paper is a useful technique used by lithographers to test how a color will look on paper in both light and dark values.

dip the tip of your finger into the ink mixture, then tap a piece of paper in ever-increasing circles. As the ink wears off your finger, the tap out will get lighter and lighter so that the darkest hues will be towards the center. This will show you how your color mixtures work in all values. Tap outs can also be made over other tap outs and on color proofs to show color combinations that will occur as you print one color over another.

Overprinting

One of the things you will discover as you experiment with colors in lithography is that colors printed over one another produce additional colors. To help make this happen, add modifiers to your colored inks—transparent medium or transparent white ink or a mixture of alumina hydrate and heavy varnish all make colored inks more transparent. For this reason, you can produce multicolor prints with fewer plates, stones, and inks than you might initially plan. For example, a three-color print may only require two inks and two plates and stones, or a five-color print may require only three inks and three plates and stones.

Properties of Inks

Start to assemble your colored inks. You can order them from the sources in the materials list in Chapter Two. I recommend starting with your favorite colors, the ones you typically use in other color work. If, for example, you prefer to work with earth colors, order an assortment of these. Be sure to double-order white and transparent white inks (the transparent medium mentioned previously that will be added to most of your ink mixtures for overprinting color layers).

Each colored ink has its own properties. Some are extremely loose and runny, others are stiff. Some are transparent, translucent, or opaque.

TRANSPARENT, OPAQUE,
AND TRANSLUCENT INKS

Transparent Ink. Transparent ink allows the color or paper underneath it to show through and blend with overprinted color. Some inks are naturally transparent and others are semitransparent. To make ink more transparent, mix it with at least half as much transparent medium. To avoid wasting ink, begin with a scoop of transparent ink and add color to it, rather than the opposite.

Take time to make sure the ink you are mixing is sufficiently transparent. Do a draw down on printing paper. Most beginners add too much pigment to the transparent medium. I have learned to add ink from the end of a finger to a tablespoon of transparent medium. I mix it thoroughly, do a draw down to check transparency, and add more pigment gradually if necessary.

Opaque Ink. Opaque ink blocks out whatever is underneath so that you cannot see through it without using additives. Most manufactured offset inks are opaque or semiopaque.

Translucent Ink. Translucent ink is a combination of any ink, plus transparent medium, plus white (opaque) ink. It partially reveals the color underneath and adds to it as well.

If you print an opaque ink over another color, you will see the opaque top ink. However, even the color of your paper will affect opaque inks. If you print a transparent ink over another color, the color underneath it will show through the transparent ink and combine with it to make a third color. The percentage of opacity to transparency in ink will always be reflected in the amount of translucency this new combination produces.

These distinctions are important to bear in mind as you work with color if you are going to achieve the results you want. Do some experimenting to learn about color properties. To test the transparency or opacity of ink, skim some with a putty knife over a mark made with a felt tip pen or spread it out over a smear of another ink.

Tints. These are thin films of very delicate transparent or translucent colors which are printed over each other or in separate parts of an image. Tints are printed behind or over a darker toned key image.

Here is a list of basic lithographic colors which gives their transparent, translucent, and opaque qualities.

Permanent yellow:	transparent
Primrose yellow:	semiopaque
Monasteral blue:	transparent
Royal blue:	almost opaque
Monasteral green:	transparent
Emerald green:	transparent
Autumn brown:	semitransparent
Vermilion:	semitransparent
White:	semiopaque
Thalo blue:	transparent
Thalo green:	transparent
Vermilion:	transparent
Violet magenta:	semitransparent
Lemon yellow:	transparent

Preliminary Color Studies

Before actually drawing any image on the stone or plate, I recommend that you prepare a well-drawn study in color, full scale to the size of paper you plan to use, using color pencils or watercolors. Some lithographers make color separations on clear Mylar, laying in major color areas on each separation. Cautionary note: Remember that every color you use tends to multiply the possibility of throwing off a good print. Overprinting a perfectly good image that has some color in it might not work. The new color might be so strong it will kill the colors that went before, or the color registration or placement might be wrong.

It is an object lesson, therefore, to try to make the most out of the least for economy as well as discipline. If you have successfully printed two colors by blending and overprinting them to make four colors, think twice before adding a third color. But, I must add that, each new color increases the possibility for greater richness and beauty. *Try more colors* as your experience and ease with them increases.

THE COLOR WHEEL

The color wheel is useful for learning fundamental four-color lithography. It shows the three primary colors—red, yellow and blue—and the secondary colors made from mixing equal amounts of colors that are beside each other on the wheel. Complementary colors are found directly opposite each other on the color wheel and are a combination of primary and secondary colors.

OTHER COLOR GUIDES

As you become more familiar with color, you will want to explore more subtle color relationships not found on the color wheel. To experiment with the full range of color relationships, a book of color swatches such as the Pantone Matching System or the Lewis Roberts Matchmaster is invaluable.

Since the Pantone Matching System and the Lewis Roberts Matchmaster show exactly what proportion of each color is used to produce a new color, they are very useful as mixing guides.

An equally useful tool is the commercially prepared Color-Aid system, in which each of the 220 silk-screened color swatches can be pulled out and arranged next to any of the other colors. In this way the effect of one color on another can be judged. Does it drain the life out of other colors you plan to use, or does it intensify and enhance them?

Mixing Colors

Colors used straight from the container produce prints that have a commercial appearance, often suggesting the Sunday comic strips. If you wish to avoid this look, modify your inks with other colors. You will soon build up a vocabulary of your favorite color mixtures. Using mixed colors will help you produce softer and more subtle effects. Cool colors can be warmed with a touch of red or brown; warm colors can be cooled with a drop of green or blue. Neutralize colors by mixing them with their complements. Mix opaque white, a color and transparent white or transparent medium to make a pastel. It is similar to painting except the color vocabulary is slightly different. Ink colors are not like paint, but the same color rules certainly apply.

COLOR GUIDES

Color Percentages

Thinking about the strengths or percentages of the colors you plan to use, as a commercial printer does, can help you judge how much to modify your color—how much white or transparent medium you should add, or how dark you should draw your image.

EXERCISES IN COLOR LITHOGRAPHY

1. Use complementary colors next to and over each other on a print. Stipple tusche on five or six plates. These should be printed in complementary colors so the dots lie over and next to each other to create vibrancies.
2. A split complementary color scheme is a good starting point for a print. Choose two primary colors and then pick the two secondary colors on either side of the remaining primary color. For example, yellow, blue, orange, and purple create a split complementary color scheme and make a dynamic color print.
3. Experiment with overprinting colors: Yellow green printed over orange becomes dark green; red over black becomes brown; yellow over black creates a deep green.
4. In one image combine light, medium, and dark colors, all with transparent medium added. Example: Try overprinting a mixture of black and red, plus transparent medium, with a transparent blue. Then overprint parts of the image

with a transparent yellow. You may find that the colors will work better in another order.

5. Experiment by adding transparent medium to three opaque colors and overprint. This should produce a many colored print since the added transparency will allow one color to show through other colors.

6. Experiment with the order in which you can print your colors and see what results. Start, for example, with a yellow printing first and go on to print yellow over other colors.

THE MECHANICS OF COLOR LITHOGRAPHY

Before you can begin color lithography, you must master the technical procedures involved in the accurate registration of color layers. Then you will learn the way to approach the making of a color lithograph and the mechanics of color proofing and editioning.

PLATE TAPED TO PRESS BLOCK

Registration

Although most artists like to be spontaneous in their work, some careful planning will help facilitate the making of a color lithograph. To save time and many frustrations, make yourself master the technicalities of registration.

Registration methods are covered in Chapter Six, Processing and Printing; T-registration, which utilizes marks on the edge of the print paper to line up exactly with lines on the lithographic base; pinpoint registration, in which two pins are pierced through the print paper into indentations made earlier on the lithographic stone or plate; outboard rigging registration, which makes use of wooden corner pieces; right-angle registration, in which you line up the corners of the printing paper with right-angle marks drawn on stone and plate; and Mylar registration, which employs register pins attached to the press bed to hold the litho plate, a Mylar transfer sheet, and the printing papers. One of these registration methods should be practiced until it becomes natural, almost second nature to you. This mechanical part of color lithography should not inhibit your development as an artist.

MYLAR TRANSFER SHEET

Use transparent sheets of Mylar or acetate to guide your color registration. Here is one way to do it: Cover your Mylar with talc, conte crayon, or carpenter's chalk so it will absorb the ink without smearing when put through the press over an inked image. Use the T- and bar-form of registration on your first stone or plate; then lay the Mylar over the inked image, including the registration marks. Now, using a razor blade, cut through the acetate exactly where the T and bar marks are on the lithographic base, and encircle these cuts with a china marker or a magic marker so you will see them. The acetate is then put through the press, and a light but faithful print of the first image is made on it. This print is laid over each subsequent plate or stone to transfer

Figure 7.3
Photo by Mel Hunter © 1980.

B & W. Use of a quarter-inch hole punch and register pin system permits paper to be pre-punched, so that each sheet goes down on the press in precisely the same position on each pass. The original Mylar key drawing is also punched and used as a plate mounting guide, making it easy to quickly and correctly position each color plate for the next run in a multicolor edition.

both the registration marks and a nongreasy chalk image which guides you in drawing other color plates or stones.

Another way is to dust the printed Mylar with its inked image. The image is transferred from it to the lithographic bases. I use the Mylar transfer sheet to help me plan my images. With a sheet of conte crayon turned onto the stone or plate, the image also can be outlined onto the plate or stone through the Mylar and completed at a later time.

Use Mylar to take an impression of the second and subsequent color plate or stone to check it against the impressions of the first color for accurate registration and to guide your decisions in creating another plate or stone for the next color. Place your Mylar proofs over each other to help get an idea for the placement of other colors.

MULTIPLE COLOR PRINTING

Methods for Using Multiple Colors

There are two basic methods you can use to make a color lithograph:

1. Use a different stone or plate for each color.
2. Work with several colors on the same stone or plate, either consecutively or all at once.

Multiple Plates and Stones to Make a Multicolor Image

The most popular way to approach color lithography is to use a plate or stone for each color. A combination of both has been found useful because plates and stones can complement each other. Plates, for example, are often used to do broad flat color areas while stones are used for detailed drawings.

Colors are applied either side by side or by overlapping, which creates new colors. Exactly how to get started on this approach is a problem for most beginners.

TWO APPROACHES:
THE PLANNED AND THE EXPERIMENTAL

In the planned approach you start with an image in mind and then work out the colors to achieve the results you want. In the experimental approach, you develop color and images more spontaneously.

In developing multilayered color images, I have found it helpful to break down these two approaches into four strategies. I have labeled them the *key image method*, the *separated image method*, the *additive image method*, and the *additive-subtractive method*. Two of these are more planned in approach, and two are more experimental. They need not be taken as directives, and using one method does not rule out using another. A key image, for example, is often used with any of the other approaches.

This breakdown into four different methods of printing multiple colors is based on the idea of using a different stone or plate for each color or several colors, incorporating for the latter the ideas offered later in this chapter for printing several colors from one stone or plate. Make a careful study of the text following and the accompanying illustrations to learn how four lithographers approach the problem, breaking down their colored images into parts in slightly different ways. These strategies should help you decide how you want to approach your lithograph.

1. KEY IMAGE METHOD

A basic drawing, or key image, provides the foundation for further images, colors, and forms. With this method, the key image can be a completed print in itself. In contrast to the next method, it does not depend on the printing of each plate for a completed image. You add layers of ink underneath or over the key or core image to help define and refine and perfect it. Though planned, this method does allow for some experimentation with color.

This approach is the most fundamental in color lithography. Create an image which includes enough detail to read as the central image of your composition. Use restraint, and allow for undrawn areas to provide room for complementary images to be drawn on different stones and plates to carry more colors. You can print these auxiliary images in color under the key image as well as over it.

Drawing a Key Image Lithograph. Draw the key image first. Plan to print it in a dark color as the final part of a multicolor image. Start by making an image that may come last when the lithograph is printed as a dark, detailed image, imprinted over the combined color underneath. Keep this order in mind when drawing the key image to avoid making the key image so strong that it will overwhelm or muddy the various hues printed first.

Colors in a Key Image Lithograph. Using the key image is a good way to start doing color lithographs because you can approach the use of color cautiously.

The addition of one or two colors used selectively and in appropriate strengths to complement

each other and the dark color of your key image can greatly enhance a print. In this case, it helps to de-intensify your black drawing and tone down your key image color so it does not overwhelm the colors printed first.

Two Colors plus Black = Five. Be aware that the use of two colors plus a tinted black can be worked to look like multicolor prints.

Four Colors plus Black Requires Planning. When using four or more colors, be especially sensitive to the relative strengths of colors used together and what their various admixtures do to each other.

Mechanics of a Key Image Lithograph. Use a transfer sheet, or "set-off" (as explained in Chapter Three), that is, tracing paper backed with either cone chalk powder or an analine dye, to transfer your key

image to other plates as a guide. Or take proofs of your key drawing, dust with the chalk or dry powdered dye, and put them through the press again over each fresh plate so that you will have a nonpermanent but definite impression to work from on each of your color plates. Pulling proofs on transparent Mylar and using them in the same way can help you with positioning your key image on your auxiliary plates.

David Thomas's *Love Brooding* illustrates the key image method. Thomas drew the key image plate for *Love Brooding* first, planning to print it as the final plate. Using a china marking pencil, he outlined the face, robe, and arms in a light to medium value. He then added tusche to create a mottled background. Further details and colors were added by printing under (although over is also a possibility) the key image, thereby creating a richly toned final print.

SEQUENCE: "KEY IMAGE" APPROACH TO COLOR PRINTING

Figure 7.4a

The first plate provided tonal background: the negative area which would be printed around the key image printed in a metallic gold ink. The rich atmospheric effect of the gold surrounds and dramatizes the most important parts of the composition, which are contained in the white areas.

Figure 7.4b

The second plate was drawn to enrich the grainy dot pattern of the face and hair in the key image and combines with part of the background to make shadows in a new color. This plate, drawn with a china marking pencil, was printed in Polychrome offset ink with an equal amount of transparent medium added to red ink. If opaque red were used, the color would remain on top of the gold instead of merging with the gold.

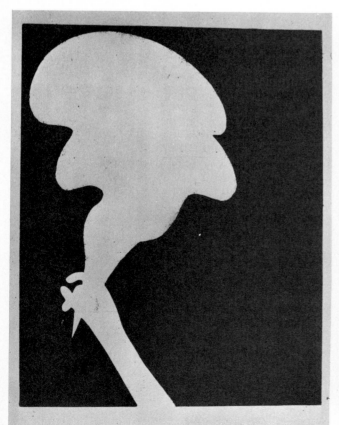

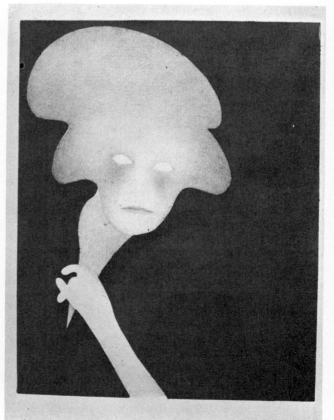

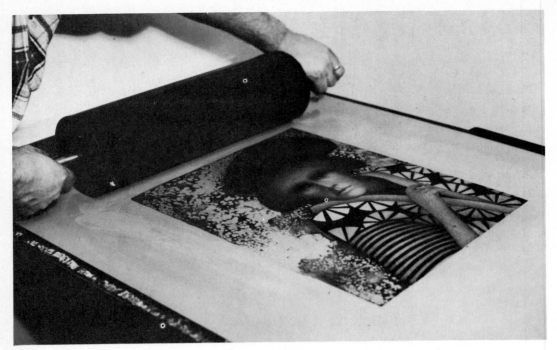

Figure 7.4c

Thomas rolled up the key plate, which he printed in black over the first two colors. After pulling a progressive print of *Love Brooding*, Thomas judged if his color plan had worked. He correctly assumed that the black would articulate the robe, pulling it out from the background. Some red, however, stood out on the face, so Thomas later added a corrective plate of blue-black to soften the facial shadows. In the last printing step, Thomas overprinted with varnish, to give the print a glossy surface. He re-used the first background plate, with a roll up of Polychrome Varnish #3-C-35. Varnishes are tricky. Be sure to wait at least two weeks after the colors are printed before using varnish as it can pull the colored inks right off the paper. Count the number of passes you make on each plate with the varnish to achieve a uniform appearance throughout the addition.

Working on plates, as Thomas did in this instance, is advantageous because you can readily draw several plates as parts of the same image, planning how they will work together. Process them, make deletions, experiment with the order in which they will be printed. After color proofing, if any plate is unsuccessful, it can easily be replaced by correcting the offending plate by counteretching it, redrawing and reprocessing it, or by making a new plate with appropriate corrections.

2. SEPARATED IMAGE METHOD

In this method a drawn image is separated or broken into its main color components, and each of these becomes the basis for a part of the image drawn separately on a plate or stone. It is printed in sequence until a final color image is contracted. Without each of these components, you would not have a complete image. The combination of the various images results in color overprinting in some parts of the final image.

When you use this method, split the image into its simplest parts, and draw a part or parts of the image on each stone or plate. After dividing the image into its parts, decide which colors to use for each part and in what order they should be printed.

This simple approach to the challenge of combining colors in one image is illustrated by John Muench, who uses the separated image method as a natural component in his work. Each part of his image is treated separately; it is drawn on and printed from a separate stone or plate.

Using tusche as his medium, John Muench prepared four stones to achieve his final print in *Winter Cove*. He used opaque, transparent, and translucent inks, carefully choosing these inks for their ability either to combine with each other or to remain separate during the overprinting of the images.

3. ADDITIVE IMAGE METHOD

This is an experimental method. You do not begin with a drawn image, but create it loosely as

SEQUENCE: "SEPARATED IMAGE"
APPROACH TO COLOR PRINTING
Sequence courtesy John Muench. Photos courtesy
Associated American Artist Gallery and John Muench.

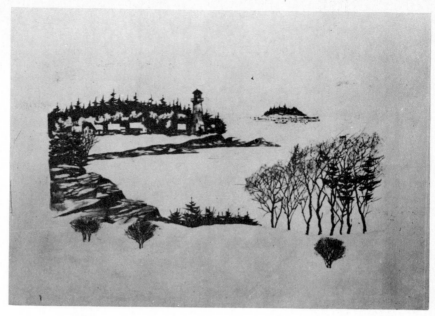

Figure 7.5a

Stone 1, shapes of stones and trees in foreground and background, printed in black cooled with a touch of green, no transparency added.

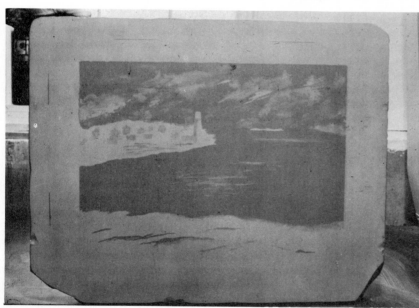

Figure 7.5b

Stone 2, sky, water, and stones on right in final image, printed in gray blue (opaque white, royal blue, dash of brown).

Figure 7.5c

Stone 3, water form overprinted in transparent blue, made of 50% transparent base and 50% stone monastral blue.

Figure 7.5d

Stone 4, a shrubbery and land formations printed with undiluted antique brown; moon printed at the same time using a *small* rubber roller with blended roll-up of red and yellow.

Figure 7.5e

Winter Cove, by John Muench, final image composed on the four stones.

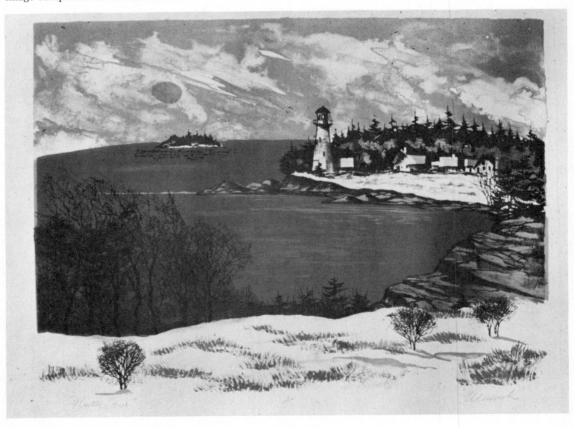

you go along by building it up, adding colors from many plates or stones which are printed consecutively.

Methusala, by Leonard Baskin, is an example of the additive method of image-making. Baskin roughs in a head by laying in random layers of tans and greens by means of marks made on several plates and stones. He finishes his image, defining the features by delineating them in blue ink.

This approach is subtly different from the separated image method, in which the image is carefully planned, because it is composed of separate parts, each of which is printed in a color on a different stone or plate. It is more similar to the key image method except that more than one plate or stone carries the details.

The additive method is more haphazard, perhaps, and certainly it is a more painterly method, with layers of colors, image definitions, and accents gradually building up the image until it is complete.

4. THE ADDITIVE-SUBTRACTIVE METHOD

The same stone or plate is repeatedly used in this approach. Parts of the initial image are subtracted as others are added, until the desired result and the new image are achieved.

The additive-subtractive method is a difficult approach to color lithography. It can only be accomplished through careful attention to technical procedures. But since you repeatedly print from the same stone or plate, this is an advantage; reinking the same litho base means that the exact same registration marks will be used and reused. The technique basic to the method is counteretching, which is discussed in Chapter Ten.

SEQUENCE: "ADDITIVE" APPROACH TO COLOR PRINTING

Sequence courtesy Mace Wenniger, Leonard Baskin, and Fox Graphics.

Figure 7.6a

Methuselah by Leonard Baskin, printed by Herbert Fox. Each of the nine colors in this subtle facial study was drawn additively by Baskin gradually overlapping forms and transparent forms in a painterly manner on different lithographic stones and plates using crayons and a tusche.

Figure 7.6b

Progressive proof of *Methuselah* with only five colors printed. Four more images gradually add colors which will articulate the image until it realizes artist's concept.

Figure 7.6c

This aluminum plate holds the fifth color for *Methuselah*. It is a large oval of transparent light green which is printed over and around the four previously printed colors. Baskin first created an oval stencil of gum; he added a lacquer base inside the oval by rubbing lacquer base over the oval in a thin layer (applied on a cotton swab). This plate was rolled up in black ink, given an etch, washed out well and rubbed up with thinned green ink before it finally was rolled up in green ink. Here a printing assistant sponges the plate during printing. Magnesium carbonate (to remove excess grease) and litho oil varnish (for easier spreading) were added to the pale green ink, which is a mixture of 80% transparent base and 20% Hanco ink.

Here is an abbreviated record of the printing steps that Mackie took to produce the image *Journey Song*. One of the reasons why her color layering works is that plenty of white paper was left around the artist's marks, so the image seems light and airy, not as heavy as some multiple overprinted color images.

The steps that Mackie went through with each color are: taking black-and-white and a color proof, then making progressive color proofs—proofs of the print as it looked as each layer of color was added to the image.

Mackie worked mainly with the three primary colors in *Journey Song* using subtle mixtures based on red, blue, and yellow to build up her images. Layering the variations of these colors worked like the layering of tones in a painting. She gradually added different tones and slightly different colors until her image worked to her satisfaction. As a new color or tone was selected for each new drawing, many colors were mixed and many trial proofs were pulled and various amounts of transparent base were added to the inks until the color layers blended together successfully.

Plate 1
Barnum and Bailey Circus Poster (early 1900s)
(Approx. 30 x 36")
Courtesy Museum of Our National Heritage, Lexington, Massachusetts; photo by John Hamilton.

This poster is a unique example of early chromolithography in America.

Plate 2
DANIEL DALLMANN
Elizabeth (1974)
(Six-color lithograph, 13 x 16″,
edition of 40)
Courtesy of Daniel Dallmann; photo courtesy Snyder Photo.

This lithograph was hand-printed by the artist
from six aluminum plates on Rives BFK paper.

Plate 3
BEN SPRUANCE
Sonia and Her Cello (ca. 1940)
(Color lithograph from six stones, 13⅜ x 19¾″)
Courtesy Lucille and John Sims.

This sensitive study of the artist's daughter
playing her cello was given to a friend of mine as
a wedding present during the 1940s. Today
such color lithographs made during the 1930s and 1940s
are esteemed by collectors.

Plate 4
MARY ANN WENNIGER
Old Friends (1976)
(Color lithograph, 24 x 28″, edition of 12)
Courtesy of the artist.

The same aluminum plate was used five times for six
colors, each time erasing most of the image,
resensitizing the plate by using a counteretch
solution, and drawing another *new* part of the image.

Plate 5 (right)
WILL BARNET
Way to the Sea (1980)
(Color lithograph and serigraph, 40 x 30″,
numbered edition of 300)
Courtesy of the artist; photo by Styria Studio, Inc.

Noted for his powerful compositions and
unparalleled drama of color, forms,
and symbols, Barnet always chooses the
familiar and poignant for his subject matter
and designs it sparingly, which works to
increase its power.

Plate 6 (below)
MICHAEL KNIGIN
*''The 26th Station on the Kisokaido,''
after Hiroshige* (1980)
(Original color lithograph, 17 x 26⅝″,
edition of 250 plus 25 artist's proofs;
16 colors on 14 plates, printed on rotary
offset by American Atelier, New York,
on Somerset paper)
Copyright © 1980 by Michael Knigin; courtesy of the artist;
photo by Malcolm Varon, New York.

An example of creating a lithograph
by the Mylar method.

Plate 7
EDWARD RUSCHA
Drops (1971)
(Color lithograph, 20 x 28″, edition of 90)
Courtesy Brooke Alexander, Inc.;
photo by Eric Pollitzer, New York.

Reversal techniques and a shift in registrat
during printing made possible the
white lines that define the drops.

Plate 8
HELEN FRANKENTHALER
Barcelona (1977)
(Color lithograph, 41 x 32″, edition of 30;
printed and published by Tyler Graphics Ltd.)
Copyright © 1977 by Helen Frankenthaler.

Plate 9
SONDRA FRECKELTON
Begonia with Quilt (1978)
(Color lithograph, 27¼ x 21½, edition of 97)
Courtesy Brooke Alexander, Inc.; photo by Eric Pollitzer, New York

An example of the new return to realism,
this piece shows the *separated method*
of making a color lithograph combined with a key image
and some layering of colors.

Figure 7.7a

Black-and-white proof shows a subtle, softly drawn image with delicate variations. Note that as each color stage of the image is drawn and processed, time is taken to proof it in black ink, a highly recommended procedure because it stabilizes the image. This first stone was printed in a warm, red-brown color, a mixture of yellow, red, orange, black and white, with a small amount of transparent base. Proofing in black showed the artist that the initial drawing was too light so she mixed the red brown instead of the pale yellow originally proposed for this first image. The color of the first stone is important because it sets the mood of the print.

SEQUENCE: SUBTRACTIVE COLOR LAYERING
Drawings courtesy Lisa Mackie. Sequence photos by Mace Wenniger.

Black-and-white proofs of the layers of color drawn sequentially on the same stone for the print *Journey Song* by Lisa Mackie. Mackie developed her idea from a photograph she had taken. She enlarged the photo and drew on it with a soft litho crayon. It was then transferred to the stone by putting it through the press, face down on the stone. Note the large amount of undrawn area, at least two-thirds, left on the stone. This permits each color image to bounce against the surface of the printing paper as well as to blend with colors on the paper.

Figure 7.7b

Mackie's second drawing on the stone is also printed in a warm red-brown color, similar to the color used in stage one, but with a small amount of white added. It prints more delicately than stage one. It completes the statement made by the first image. As the second layer of color is added to the first color on the print, it develops a richer look.

Figure 7.7c

Black-and-white proof shows the artist's intent on the second drawing is to emphasize the foreground figure even though some work was drawn on the background. The drawing is getting heavier with this stage although white areas still remain. Transparent base allows the earlier reddish-brown shades to show through the blue layer. The print now begins to include layers of colored shadows.

Figure 7.7d

Color four, a heavily drawn image, is printed in a pale tone of translucent yellow to introduce light into the print. The yellow used in this color proof was muted with white ink as well as transparent base. Mackie suggests a sensitive handling of yellow because yellow reacting with the paper creates a bouncing effect. Here straight yellow would have been too heavy, yet the yellow had to be strong enough to show through the next layers of colors. The yellow ink introduced warmth and light.

Figure 7.7e

At this point the artist intended to use a photo etching to pull the print together. This was tried, abandoned, and this next stone was drawn. This image was drawn to bring out the more prominent details of the photograph. It pulled the image together by putting a textured tone over everything. However, when the black and white proof was pulled, Mackie realized that the drawing was too dark to use in color in the print. Yet she felt her drawing was successful and should be used. She deleted part of the image so the new color would not hide the girl's form. Radical changes can be made after a proof is pulled. Mackie decided to subtract some of the black area with a deleting tool, a honing stick. After deletions, Mackie experimented to find the color for this proof. After trying dark blue, then red, she found a translucent blue composed of white and blue with a touch of green and transparent base to be successful. This stone unifies the whole image by adding a cool blue in the background space between the figures. At this point Mackie had planned that the print would be finished, but realized that she wanted to add accents to it.

Figure 7.7f

Final printing of *Journey Song*. The red-brown markings have been worked among the indigo marking which makes them almost black in spaces, thus adding punch to a print that already has good lights and shadows. The red-brown was decided upon because the warm color seemed appropriate to the dramatic mood that Mackie wanted to establish. A dark brown would have been too dominant and harder to blend with other layers of colors. As Mackie develops her print, you can observe how her colors blend in tone. This is a result of much experimentation with different color combinations.

Use of One Litho Base
for a Multicolor Print

The fine special techniques that follow are useful to color lithographers as they make it easy to print many colors for one image on one litho base. This eliminates the necessity of separating the image onto several stones or plates and, hence, some of the complications of registration.

Cautionary note: each of these techniques can become gimmicky if overused, so the beginner is urged to be sure the image suits the technique and that the technique really serves rather than dominates the image. This word of caution is added because so many beginners, once exposed, have so overused the blended roll technique that some instructors now refuse to show new students how to do it.

1. Blended roll technique—Printing several colors on an image from a graduated blend of colors arranged on a single roller.
2. Papier collé technique (also known as chine collé)—Colored paper is incorporated into the lithograph and adds a background color by being glued to the printing paper as the stone or plate passes through the press.
3. Reversal methods—The negative and positive areas of the image are both printed successively in color. First, a complete edition of the positive image is printed; then after counteretching the stone or plate, the negative areas are made ink-receptive and printed.
4. Gum block-out technique—Printing a single color or blended roll on a large flat made of an acidulated gum border in which a lacquer or asphaltum base is laid and printed.
5. Reduction technique—The same litho base is overprinted in many color layers, each one made smaller by subtracting from the base by erasing manually or chemically and then re-etching.

1. BLENDED OR RAINBOW ROLL

It is interesting to note that blended, or rainbow, effects from a single roller are not a new development in lithography. Jules Cheret, who printed posters in color during the 1870s and 1880s in Paris, usually used three stones, and the third introduced a graduated background, known as a *fond gradue,* with cool tones like blues and greens at the top half of the poster and warm tones like yellow and orange at the bottom.

Toulouse-Lautrec's work shows the influence of Cheret in his use of the same graduated color backgrounds.

The blended or rainbow roll can enhance an otherwise simple image or be part of a series of steps in a multicolor lithograph.

Method. Instead of laying down only one color on your inking slab, lay down two or more colors side by side and then roll up in a direction parallel to the bands of colors. Where two colors overlap, they will produce a blending which may result in a third-color combination of the other two or a softening of the edges of the colors.

This technique involves choosing and laying out colors that will work well when blended. Blending is done by repeatedly moving a roller from side to side very slightly as it goes back and forth over the glass inking slab. Artists often use strips of masking tape to insure that the roller will be returned to pick up the ink in exactly the same place each time.

Line up the roller with your stone or plate so that the order of the colors on the roller will correspond to their final placement on the stone or plate. Test the motion of going from the inking slab to the stone without color first, to help think out correct placement of colors. Place the colors on your inking slab so that you will not have to turn your roller there before printing.

The blended roll should be planned when your image is drawn. Used as a last resort to rescue a poor image, it turns into a crutch and usually stands out as a device used inappropriately.

2. PAPIER COLLÉ

This process is derived from the French word, *collé,* meaning glued; the action of gluing paper to your printing paper is central to the making of this type of print.

Since the use of a different type of paper is a device for introducing a background color, your most important decision is what combination of papers will be most effective. Oriental papers with subtle colors and textures have traditionally been used for papier collé images, hence the alternate name for the process *chine collé.* Kozo or Hoshi are two of my favorite papers for this because they are tough enough to take the gluing process without tearing and come in subtle tones from tan to white.

Method. The oriental paper is given a coating of a specially prepared glue. This is allowed to dry before being used in combination with a predampened print paper, whose wetness will activate the glue on the oriental paper and bond with it as the printing sandwich goes through the press. The printing procedure also attaches the glue-covered paper to the dampened paper as the inked image is printed on the glued paper.

Figure 7.8a

Color Slides. *Summer Storm* by John Muench, a two-stone lithograph in which the artist used color blends as he rolled ink on both stones in order to introduce color changes without having to create new images on separate stones or plates. The first stone printed showed the water and the sky, each a different color. Here the blended roll works well to create a hazy blending of colors at the horizon. The second stone printed images, the island in a green-black on the top half of the stone, low tide in a blue-black on the bottom of the stone over the lighter colors of the first stone.

Figure 7.8b

Layout of prepared colored inks for blended roll on the glass or stone slab. Artist uses a firm putty knife to pull thin, even strips of ink across the slab. Some artists overlap the edges of colors slightly so they will blend; others mark exactly where each ink strip stops with masking tape so the roller passage will be identical for each print. Here Muench places color side by side: on the left is a mixture of monastral blue, royal blue, black and some white; on the right is opaque white with a touch of monastral blue and chrome yellow added.

119

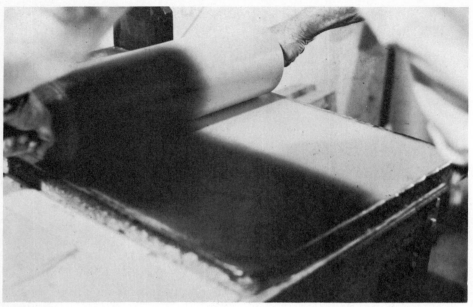

Figure 7.8c

Work the colors back and forth on the inking slab. Lift and spin the composition roller each time it is brought back to the starting edge. Check the roller for lines created by starting and stopping roller action. These should gradually disappear into an even film of ink as the roller is rotated and inked and worked with a softer and softer touch. Colors merge as the ink film on the slab and the roller becomes smoother. Artist moves the roller gradually from side to side to get a wider strip of blended color between the two other colors.

Figure 7.8d

Muench lined up the stone with his inking slab so the blend would occur just below the horizon. He maintained this effect throughout his edition of thirty prints by lining up the bottom edge of his roller each time with the bottom edge of the circular image and only rolling in one direction.

The glow of the blended colors dramatizes the imagery on the stone. This glow occurs where the dark sky and pale waters meet unexpectedly. The artist added to this impact by making the water light and sky dark instead of the reverse. The white schooner on the horizon was created by scraping away tusche in the sky area.

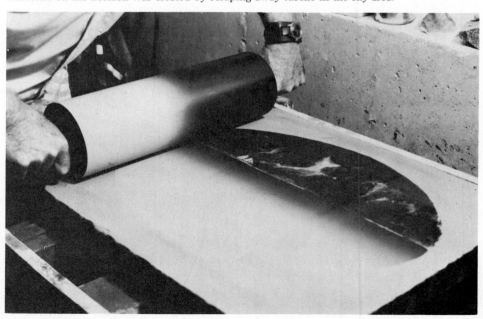

In the accompanying demonstration are papier collé prints made on small plates containing drawings from nature. I used a tan background Murillo paper—somewhat stiff and with a light texture. Over it, I printed my drawing in a muted green, on a textured, darker-tan rice paper, which was glued to the Murillo background paper during the chine collé process.

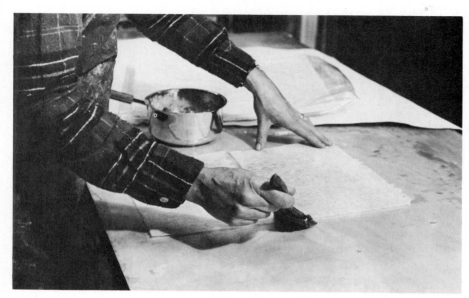

SEQUENCE: CHINE COLLÉ
Photos by Mace Wenniger.

Figure 7.9a

You can add a background color by the chine collé procedure instead of using an additional plate. Priental or any other paper is torn to the plate or image size using a heavy ruler. To facilitate the tearing, the paper was sponged with water along the edge of the ruler. This makes it easier to pull the paper away from the ruler and creates a handsome deckled edge. The thin arrowroot glue mixture is being spread on the oriental paper with a clean paint or a sponge. Work on a clean glass or plexiglass surface when spreading glue in order to hold the paper down so it won't curl up as it dries. The glue-covered paper can be dried with a hair dryer—or air dried. It is sometimes necessary to insert a table knife under the dried paper edge to release it from the glass behind it. A handy trick here is to put a small check in pencil discreetly on a corner on the glue-covered side so you will be sure to know which side has the glue on it after it is dried.

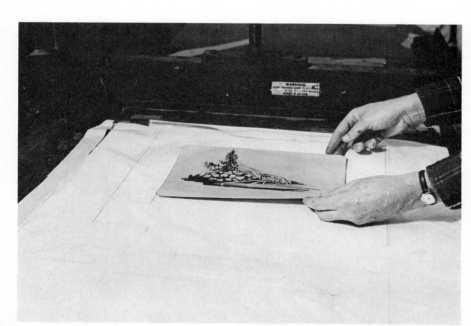

Figure 7.9b

Lines on the paper beneath a sheet of plastic guide the artist's careful placement of the plate, the glue-prepared paper, and the printing paper each time the chine collé print is made. Here the artist drops her fully inked plate within the designated lines, a simple registration method.

Figure 7.9c

Lines on the paper on the bed of the press guide the placement of the dampened printing paper. Now put the entire printing sandwich plate or stone, glue-covered paper (glue side up) and dampened backing paper through the press. If the glued paper does not attach put it through the press again. Dry your papier collé prints under a weight with a clean sheet of newsprint between each print since the collé (attachment) process can cause buckling. This will keep them stretched flat.

Figure 7.9d

Finished chine collé prints. These were made with a small plate drawn from nature when the author was on a field trip. Using a chine collé process gives this quick drawing more of a presence and makes it possible to add a background color to image by another procedure.

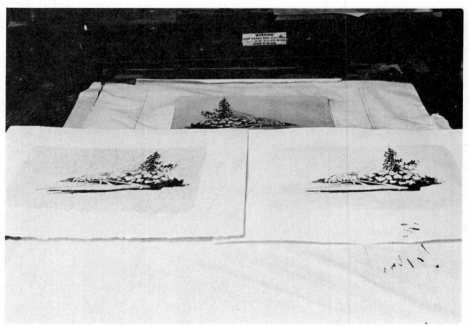

3. REVERSAL TECHNIQUES

There are several reversal techniques you can use if you want to print the negative as well as the positive parts of an image with a color. This idea is often implemented slightly out of registration, which provides a thin, dramatic line of the printing paper between the positive and negative images.

After a total edition of the positive image has been printed in a color, the stone or plate is counteretched. The transposition occurs when the negative areas are changed to positive areas. They are coated with a thin film of shellac (for a plate) or Liquitex polymer medium (for a plate), rolled up in black ink, etched, and then printed in color after the once-positive areas have been removed with a solvent on a cotton swab. Be careful not to scratch or make indentations in the shellac or polymer covered areas as you remove the ink from the first positive areas.

LIQUITEX IMAGE REVERSAL*

1. Always use Liquitex gloss medium
2. Be certain the stone or plate to be processed is in a grease base, it must not be in lacquer base.
3. Remember, any sponges and cheesecloths used in this process must be washed immediately upon the completion of each step, the polymer will dry in them very quickly. For best results cheesecloths should be put in a pan or sink of water as each is used to prevent any drying.
4. This technique works equally well for stone or plate; reversals on zinc are really not practical.
 a. Roll up image fresh, rosin and talc.
 b. If borders are to be masked, do so at this time, but as an alternate method, use contact paper.
 c. Counter-etch the image with a mild c-etch (i.e. citric).
 d. Apply a Liquitex medium thinned 25–30% with water. Apply with a small damp sponge and buff lightly to a smooth coat with cheesecloth. (Let dry 30–60 minutes until fully dried.)
 e. Repeat #d twice more. Always be careful to get a smooth polymer film.
 f. Wash out the ink with lithotine and further clean with gasoline (important) to remove all traces of grease.
 g. Check 2/clean pad and gasoline to be sure the image is completely washed out. Dry.
 h. Apply a moderate-strong etch of 12-15 d. HNd$_3$/oz. gum or 2.4 plate etch. Work the etch with a sponge or brush for 4–5 minutes. Remove and reapply the same etch a 2nd and 3rd time. A slight amount of scrubbing (lightly) with a sponge may be more effective.
 i. Buff down etch and leave for 30 min.
 j. Re-gum with pure gum arabic, buff tight.
 k. Wash out with lacquer thinner or Glaquer Solvent. Be sure all the polymer is completely removed.
 l. At this point, borders or any area to remain white should be treated with a mild etch. (Dry.)
 m. Rub up image in asphaltum on stone, or go directly to lacquer base on plates.
 *n. Wash off and roll up as in a normal first roll up.
 o. Apply rosin and talc, etch with mild etch.

In this new state, the negative areas are printable, while the initial positive drawing receives no ink and accordingly does not print. When the stone or plate is rolled up with the new color, each printing paper is registered with slight alterations on the pin-point registration so that it will print with the white paper halos mentioned earlier around all the positive inked areas. The resulting print shows a positive image surrounded by white halos within a field of another color.

To achieve the out-of-register effect, it helps to print the first positive image, including the register marks, on a sheet of Mylar or acetate. This will help you determine exactly how much off-register the second, negative, image should be printed. Move the registration mark slightly (not more than the width of a pencil line), marking it with new pin marks and crossing out the old marks with a hard pencil before proceeding with the reversal steps described.

Method. It is important to organize all necessary materials before you begin a reversal procedure.

Assemble cotton swabs, gasoline or turpentine, vaseline, a mixture of one part shellac to two parts denatured alcohol for stones or Liquitex Polymer Medium for plates, paintbrushes, medium etch mixture (12 drops nitric acid to one ounce gum), sponges, and fan. Work on a dry day so the shellac or Liquitex will quickly dry to a tacky stage, enabling positive image areas to be removed without damaging the coated negative areas which will become positive areas.

*Contributed by Russell Hamilton, Master Printer, Albuquerque, N.M.

* As in normal roll-up, if the image isn't forming well, a few newsprint proofs may help.

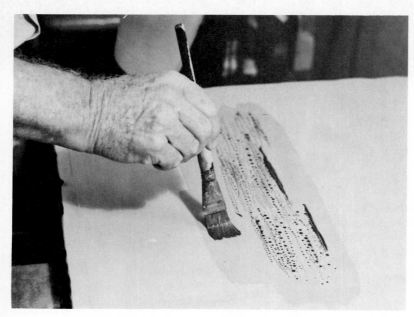

Figure 7.10a

Black-and-white photos. The positive image, rolled up with black ink, is not talced or rosined. Here the dry stone is brushed over with a counteretch solution, which sensitizes the stone so that it will take or receive the negative image created by the reversal process. The counteretch solution (here the artist used a solution of 50% water and 50% potassium sulfate) was worked over the image for three minutes. The stone was then washed with water and fan dried.

Figure 7.10b

The surrounding borders of the image to be reversed are covered with vaseline, which acts as a mask so they will not be affected by the process which follows because vaseline resists shellac. Areas within the image can be masked in this way so they will resist the formation of a negative image, too.

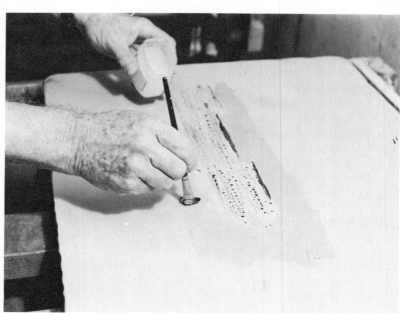

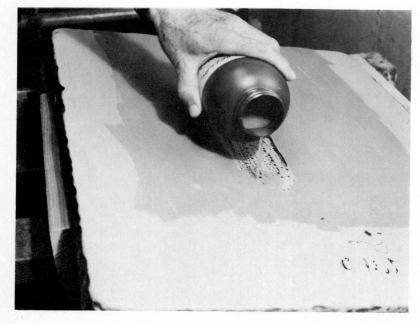

Figure 7.10c

A shellac mixture, two parts denatured alcohol to one part shellac, is gently poured over a slightly tilted stone. It adheres to all open or negative places and rests lightly on the grease-carrying dots and lines of the positive image.

GUM BLOCK-OUT TECHNIQUE

The gum block-out technique is used for background colors in multilayered color lithographs. It can be used with a rainbow roll or a single color to make "flats." This is a method in which gum arabic is drawn around an isolated area on the plate or stone that is designated for printing. This area is later coated with lacquer base, asphaltum or tusche and then rolled up with ink, etched, gummed, washed out and printed.

Method. The value and significance of this seemingly simple method cannot be stated fully. Flats carrying veils of color are indispensable in creating multicolor lithographs but they cause the easiest ink film to print poorly. Gum arabic applied with a brush or sponge is used by the artist to draw around an isolated area or areas on a litho stone or plate. After the gum has dried, the area is made printable by applying a thin layer of lacquer base or asphaltum with a sponge, rag, or cotton swab.

After the lacquer base asphaltum or tusche has dried, the next step is to roll up the isolated area in black ink, talc it, and apply a light etch over all. Let the etched plate "rest" for twenty minutes, regum and buff it, wash out the black ink, rub in your colored ink, and proceed to print it in color.

HOW TO PRINT "FLATS"

A *flat* is a background plate carrying one or more colors. A common cause of poor flats is a flat that was never properly established in the first place. Tusche and autographic ink are notorious for creating flats that never roll up completely "full." Tusche flats have a habit of looking dull and over-etched. For this reason, I recommend using a polymer/korne solution "sure-flat" for any flat on stone or plate.

1. Pre-stretch paper if you are printing an exceptionally large print or using soft paper such as German etching, or trying to print a hard edge image with no overlaps and several color runs. To pre-stretch paper, run dry paper through the press two or three times. Use printing element as the base for stretching the paper; tape newsprint on top; lay paper with registration marks lined up with those on the base on the leading end of the paper so the paper will have the same stress factor as when it is inked and printed. Put tympan over and run scraper bar across. Repeat four times.

2. Flats print smoother and thinner if you use a soft ink (i.e., add Setswell) and try to use fairly thin ink on your slab, with three or four inking passes rather than trying to pile it on.

3. Hold the tympan up as the stone goes thru to help reduce push and slur.

4. When ink is tacky or stiff, roller marks are harder to work out and more ink is needed for full inking. Tacky inks often present "orange peel problems". Thin inking is the only reliable solution.

5. Sometimes it's worth the trouble to "double drop" when printing a flat. This means to print the same run twice inking thinly each time.

6. Pressure is critical and it varies according to the ink and paper used.

7. Always be sure that the sponging is as smooth and thin as possible to reduce water streak problems.

REDUCTION PRINTING

This can be done from an inked stone, as described in the additive-subtractive process in the previous section of this chapter, or from inked plates as explained here by C. David Thomas.

Method.* This procedure can be used to create an infinite number of textures as well as solid areas of color. It allows you to reuse the same plate and registration devices while adding layers of color to your image.

The first step is to prepare your printing paper with either T-registration or pinpoint registration. There are a number of ways of creating the initial image. The beginner should make a gum block-out. *Banana 80* by C. David Thomas started with a solid rectangular gum block-out made with wide gum arabic acidulated with a few drops of Pro Sol etch. When it was dry, he rubbed in asphaltum as the printing base, and added registration marks on the plate. Once the gum block-out is made, the image should be rolled up in black ink and allowed to air dry.

For best results, all reductions should be done with black ink rolled up on your printing base. Reductions can be made through colored ink, but it will create different textures than through black ink.

REDUCTION PROCEDURE

REDUCTION FORMULA
- ½ oz. gum arabic
- ½ oz. Pro Sol # 54
- 12 drops of Image Remover 229

This mixture is applied to the inked image with a brush and allowed to sit for about one minute so that some of the image will be removed. A stronger mixture made of more Image Remover 229, or a longer time on the ink, will remove more of the image. The

*Material contributed by C. David Thomas.

wave shape and textures on *Banana 80* were created this way.

Once you have removed as much of the image as you intend, allow the plate to dry and brush on a 50% Pro Sol, 50% gum arabic mixture. Work it over the image for about five minutes. Wash it off with water and proceed to the preparatory steps for printing.

Spread plain gum arabic over the entire plate. Buff down very thin and allow to dry. Wash out the black ink with turpentine, and rub in a thin layer of colored ink thinned with solvent to replace the black ink. You are now ready to print the next color. Sponge the plate with water and roll on the next color.

Once the edition is printed, ink the image fully, gum it, wash out colored ink, rub in thinned black ink, and then roll up the image again in black ink and allow the plate to dry. At this point the inked plate can be drawn on with pencil before doing the next reduction. Reduce the image again using the reduction formula and procedure.

Remember: *The only areas of the color just printed which will show will be where you now remove the image;* all the other areas will be covered over with the next color.

Once the reduction process is complete, again etch the plate with a 50% gum arabic, 50% Pro Sol etch. This will be necessary after all reductions. Wash off the etch with water and allow the plate to dry. Return again to the preparatory steps for printing. The reduction procedure can be repeated for as many colors as you want.

PRINTING YOUR COLOR LITHOGRAPH

After becoming familiar with the properties of colored inks and the ways you can approach your multicolor print, it is time to print your first image in color. To be sure that the image comes out exactly as drawn, it is generally recommended that the stone or plate be proofed first in black ink.

Recalling the proofing steps in Chapter Six, make sure that the stone or plate has been gummed. Then wash out or remove the image with turpentine. Now gently rub up with black ink, using a cotton swab diluted with turpentine. Dry with a paper towel, and then start to sponge with a thin layer of water as you roll up the image in a black ink. Proceed through the printing steps, and repeat until the printed image appears on the paper as strongly defined as in the drawing. It might take as many as ten of these proofs until the image is as you want it. Now the image is ready for color printing.

To prepare to change from black to colored ink, again proceed through the wash out and rub up steps described in the preceding chapter.

Using the black ink, roll up your image to full intensity, talc, gum, and buff it before dissolving the black ink completely with a solvent wash out, and then rub up your litho base with a swab of your colored ink softened with solvent on a paper towel.

Guidelines for Printing in Color

Although you have become familiar with basic printing procedures by studying the printing chapter, here are special pointers which will help you print in color:

1. Before printing, use dampened felt or stocking to help you remove ink from the edges of your litho base. Use image remover on a plate, or a honing stick to remove unwanted parts of an image (see Chapter Nine.)

2. Print on dry paper if you are printing multiple colors and using registration, to eliminate the problems created by paper stretching during printing and shrinking during drying. However, as with a black-and-white print, you will have to dampen the paper if your image is not printing strongly enough to suit you. This will help bring the image up to full strength. You can also add more pigment to your color mixture.

3. Add magnesium or #8 varnish to colored inks to tighten them, as most colored inks are looser than black inks. Colored inks feel rather elastic and stretchy, instead of tacky like many black inks, so before using them you should gradually add magnesium until they are shorter and tackier. Work magnesium into your colored ink with a putty knife on your slab. This tightening of the ink is particularly important if you are putting a crayon- or pencil-drawn image into color. Flat areas of color can be printed with looser inks.

4. Use a rubber roller, not leather, for colored inks unless you have access to a smooth leather roller which is habitually used for color inks. You also can use several rollers, large and small, for a single image, when working with several colors onto one litho base. Just be sure to roll onto the various parts of the image from different sides of the stone or plate.

5. Before using colored ink, clean off your roller and glass ink slab thoroughly, particularly if black or dark-colored ink has been used previously. Use lacquer thinner as well as paint

thinner so that every vestige that might alter your color is removed.

6. Lay out your colored ink in thin strips with a clean putty knife. Start with a thin coating of ink on your roller and gradually build it up.

7. When printing "flats" (as the background plates of one or more colors is called) work with a soft ink, a mixture of Setswell and ink, rolled in a thin ink film. Establish a balance between a moderate amount of pressure and a light, thin ink roll out in order to avoid the problems of "push."

8. Add a little more ink to the slab after it looks as if the ink is beginning to be depleted. Some lithographers say this should be done after every two prints, but this depends, of course, on image variables; how much has been drawn, how large the image is. To maintain good ink consistency establish a regular pattern for scraping up some ink off the glass as well as adding fresh ink; this keeps a balance between fresh and old ink.

9. You may need to pull several prints before the print seems as strong in color as you want it. Don't force too much ink onto the image too soon. Slowly build up the color, pulling proofs until you are satisfied with the way it is printing. On the other hand, if you are having trouble getting part of the image to hold color for some reason (overetching, or whatever), you can force ink by letting the stone or plate dry partially and then rolling ink onto the troublesome areas, sponging extra ink off, then repeating the process.

10. Keep track of the number of passes it takes to get the color just the way you want it (see Printing, Chapter Six). When editioning, repeat the same number of passes for each print.

11. If the ink starts to thicken or fill in parts of the image, it is a good idea to let it rest for a few minutes with a coat of gum washed over its surface and buffed down. If the filling continues, it helps to put the image through the press several times, pulling off ink onto newsprint. If ink seems to pile up on the image in the course of printing a large edition, gum it and wash it out, dissolving the ink with turps, then start with a thin layer of color again.

On a stone or plate in extreme situations, use a wet wash out technique: apply both water and turps to the image, dissolving the image, and then immediately start to sponge and roll up with a thin layer of ink. The image now will print only as a faint echo of your previous one, but now you can redeem it by slowly adding ink and pulling proofs to bring it to a full state carefully, watching it all the time to see if it is thickening again.

12. If you have a holder for your rubber roller, put your roller in it between uses rather than let it rest on your ink, which creates a line on the roller.

13. Parts of your color layers can be partially removed by passing the freshly inked image through the press with pieces of tissue over the parts of the image that need softening. When you lift the newsprint, you lift off some color. There are various ways to do this, but my favorite is to isolate just that part of the image that would profit from being lifted and pass only that part of the image through the press, face up, with the newsprint strips visible under the typanum. This removal procedure can turn your lithographs into monoprints because different areas can be lifted on each print.

This same blocking method can be used to print part of an image over again. Cover with newsprint all the parts of the plate or stone except the part that needs reprinting. Then ink that part and put it through the press and reprint it.

14. Master printers suggest that it is a good idea to gum the image after every ten prints pulled, to help keep the image stable.

15. It is particularly important to change the printing water often because dirty water seems to promote scumming, in which negative areas carry an unwanted film of ink. Be sure to keep your workshop area clean—your slab, discarded rollers, your hands.

16. Be careful to fix start and stop marks on the bed of the press to tell you when to stop the press bed as it moves under the scraper bar.

17. Be aware that weather conditions affect printing. Avoid printing on a humid day. A cold studio will make your ink much more difficult to manipulate.

Color Trial Proof

Color proofing is tremendously important. If I had known how to handle this step with the caution I prescribe here many of my favorite drawings would have been more successful lithographs. You probably will have to search for exactly the right color that the image needs from each base holding part of your image. A plate or stone should be tried with many color variations until the appropriate color is found. This is your most sensitive step! Take proofs of dif-

ferent color combinations before you think about printing an edition. After one solution is chosen, go back and print these new color combinations in another session. Remember that different papers are as much a part of color proofing as ink colors.

My favorite way of working now is to start with a key image on my stone; after proofing it in black ink I make several chalk transfers onto half plates and from these create supplementary plates and background flats to my key image. I process and print these on Mylar first to see how all the parts work together, and after that I make any subtractions and additions to the plates, and even discard some.

When all the parts of the image work together, I devote at least a day to color proofing. I print the first plate with a light color on several different types of paper, taking into account their colors. Then I choose the solution I like and make five prints in this first color with some color modifications. The second plate is printed on those five prints with five variations of the second color, and so on. If there are five plates and stones involved, my final run involves something like twenty-five colors on those five prints.

After selecting the paper and color combination I prefer, I refine it through another printing session in the second stage of color proofing. In this I modify inks by adding a more transparent base or white ink to bring a color "up" or "down" to vary the intensity of the colors. At the end of the second proofing, I am ready to start my edition or abandon the image.

It is by far best to solve the colors and the order of printing before editioning but if you jump into your color printing, your color choices can evolve as you go. This can be especially tricky when the search is for the perfect conclusion to a multicolor print. Follow your gut reaction to how each new color works with your previous color. If there is an "Aha," pleased reaction, keep printing. If doubtful about the color, stop and evaluate. Do not force a color decision just to get your print resolved. You have put too much into it. Let it gestate.

The proof that finally measures up to the artist's plan is callen a *bon a tirer*, "good to print." At this point playing with colors is over, and the job of making editions begins.

BE FLEXIBLE

Since the printing process can be lengthy, it helps to remain as open as possible when progressing from stone to stone or plate to plate in making an image. A plan, such as a watercolor or pencil color drawing, helps the process, but final color decisions should be based on color proofs. Be ready to regroup, clean off your inking slab, and try again until your color combinations really work together.

Many artists use colored pencils, colored chalks, or semitransparent acrylics over a color proof to search for and try out new color combinations. Experiment on your proofs until you know which new colors or tones will work perfectly with those you have already printed. Persist until you get the effect you are looking for. Until a proof is pulled, it is hard to know if the chosen color will work well with the other colors on the print.

Color Printing

Prepare your colored inks with an awareness of their transparent, opaque, and translucent properties. Keep an experimental attitude as you start to mix and roll out your first color in a sequence of colors. Some of the colors may not work out as readily as you wish.

Since you have proofed your image in black ink, you must change from black to colored ink. Follow this procedure:

Apply talc to your fully inked, black image. Gum and buff-dry the stone or plate, and then remove all the black ink, using turpentine or paint thinner on a soaked rag or paper towel. When the black ink is all removed from the image, rub a solvent diluted portion of colored ink into the image. Dry this colored ink with a soft paper towel, and then apply a wet sponge to the entire plate or stone to remove extra colored ink from your base. Now your next color is ready for printing. Proof the image in color. If it is acceptable to you, print your edition then and there, while everything is going for you.

Lay out your colored ink in a strip and start to roll it out. As mentioned before, the first layers applied to your image should be thin. If the ink makes a light crackling noise and looks like a smooth film on the ink slab, it is properly prepared.

Start to roll the colored ink onto your stone or plate, go back to the ink slab for another coat of colored ink, dampen your base again, sponge the image, roll up the image in color again, and then put it through the press.

Pull the proof from the stone or plate, and look at it with a critical eye. Perhaps the color should be subdued, or, on the other hand, sharpened. If the color seems dark for the image, experiment with adding transparent medium. You can achieve other effects by using translucent and opaque inks. Do not be afraid to experiment. Some artists make as many trial proofs of different colors as they make of their final edition in an effort to find the appropriate colors for their image.

PROGRESSIVE PROOFS IN COLOR

Each time you print a new color, pull a color proof. It is important to see that color not only by

itself but also on a sheet already proofed with one or more of the preceding colors. This is called a *progressive proof*. Many lithographers keep their progressive proofs as an exact record of how their lithograph was created.

COLOR EDITIONING

Keep records of printing steps and color mixtures used to print a color edition. Artist Barbara Swan has kept a set of trial proofs and progressive proofs since

Figure 7.11

In the lithograph of *Emily Dickinson*, three separate colors, dark red, gold, and lavender, were combined in a multiple-color overprint lithograph using three different but related images.

The first stone for the image was the key image, printed first on the paper in red ink. In the artist's opinion, nothing that was later added changed the image. At this point she wanted only to strengthen the color of the eyes. The second stone was printed in a transparent golden ink. The lavender on the third stone did what she hoped—it enriched the background and the left side of the figure and deepened the intensity of Dickinson's eyes.

These images, when combined carefully using transparent and translucent modulations of colors, were subsumed to make a rich brown image full of the nuances that the artist strove for when she began her image of the poetess.

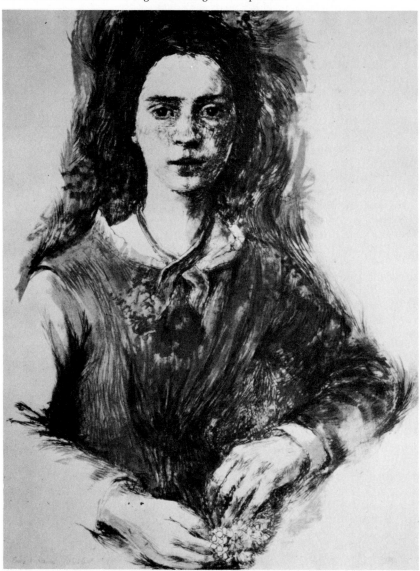

Figure 7.12

Large rubber roller used to print a large flat of color. The advantage is that the larger surface on the roller will work for a smooth ink roll up with no offset lines showing since the job is done with only one or two revolutions of the roller. Due to its hollow aluminum core, this roller is not as heavy as it looks.

1949 for her image entitled *Emily Dickinson.* Her intent was to catch the spirit of Dickinson who wrote, "My eyes are the color of sherry in left over glasses."

Besides keeping your progressive proofs, you should also keep an exact record of the color mixtures and compositions of the inks used to produce each solution, especially the formulas for the inks you use in your edition.

Once color decisions have been made, and you have confidence in what you are doing, you can proceed to the fully engrossing, intense experience of printing an edition in color.

To begin, I organize my materials and my movements so there will be an economy of gesture and steps.

I recommend having a place for your sponges and water bowls, such as the top shelf of a rolling cart positioned at the left end of the press. The bottom shelf of a discarded warming cart gives me handy storage for gum arabic, cheesecloth, and correcting tools.

As you print, return your sponge to its assigned place, perhaps on the top of a wetter sponge resting in a plastic storage box. Also, if using pinpoint registration, return pins to a cork or sponge. Keep your felt and honing stick in your apron pocket. Each discipline will prevent the many delirious searches to which I have subjected myself during printing.

Have your printing papers within arm's reach. Many lithographers have a platform covered with clean newsprint over the right hand end of the press to store their paper during editioning. Decide where your prints will be put to dry after they are printed.

PATTERN OF INKING

While printing, be thoughtful about how you are printing. How many fresh pick ups or passes of ink does it take to roll up your image the way you want it? Keep track of the number of your passes and direction from which you push your inked roller, and repeat this for each new print.

Always check for lap marks, or roller marks. Roll up to an edge or wherever the roller's edge will disappear. Watch for minute particles of dust which should be removed with a pin before printing.

Check edges of your stone or plate for excess ink daubs. Remove with dampened felt or honing stick.

CHOICES

Even when the new color is fully decided, start editioning on your worst prints first. There might be minute adjustments of color intensities that will occur to you as you print.

If a color adjustment occurs to you after you pull a few prints, try it. A uniform edition is not a necessity.

Usually, however, for sanity and economy, it is preferable to stay with a color decision and print a full edition of it.

There will be differences between the prints. George Guest puts aside the prints that he prefers, to be designated as artist's proofs, calling them "the cream of the crop."

I have a hard time finishing an entire edition and usually take a coffee break and rest before completing the last half of my edition because I want

130

these to be my best. At that point I just let it happen mindlessly with a rhythm and a routine I enjoy. If for some reason printing is discontinued when you are editioning, be sure to cover the fully inked image with gum arabic and buff it down. Cover your ink slab and ink-covered rollers tightly with saran wrap to keep the ink from drying out.

Clean Up

The hardest part of color printing is cleaning up. I have learned that it is best for me to get right at the task without procrastination.

Clean up rollers promptly after printing; colored inks become virtually permanent if left on a roller. Use phenol to remove old ink from a smooth leather or rubber roller.

Leave your image rolled up in black ink or asphaltum, not colored ink, if you want to save the image after the color printing. Colored ink is much harder to remove than black ink after it dries.

Be sure that inks in cans have been smoothed out with a putty knife, because ink with rough edges can harden to an unusable state. Spray the ink left in cans with anti-skin spray, put the tops back onto the cans, and tape with masking tape. If the labels on the ink cans are not clean and readable, mark them clearly before closing them so you can find the color you want when you work with them again.

Clean the putty knives used for mixing inks, including their handles. Store upright.

Wash out your sponges, and leave them in the sun to dry if possible. Wash the cheesecloth used for buffing gum and hang it up to dry.

Throw away all trash and ventilate the studio, and go home and relax.

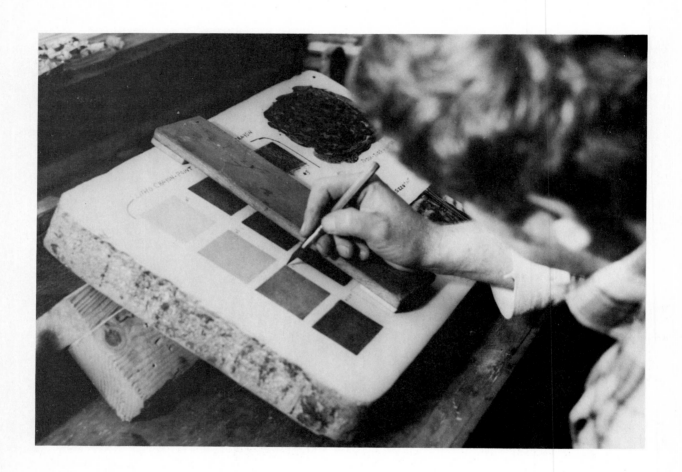

I recommend that you take time to make practice plates and stones. Although you are impatient to make lithographs at this stage, you will find it helpful to test out what you have learned thus far. Try using lithographic drawing materials. Test out etch proportions vis-à-vis your use of lithographic materials. Make some of the common errors particular to lithography. Do all this before engaging in a major creative effort.

Making trial plates and stones is a step that every beginning lithographer should not skip. It will help you eliminate the guesswork so often involved in lithography. It will make you try out lithographic drawing materials. It will help you adjust processing formulas to your imagery. It will allow you to practice lithographic processing and printing procedures and to make mistakes without creating total disasters.

Keep in mind that test stones and plates are precisely that: stones and plates on which you test materials, techniques, ideas. Remember that in and of themselves they have little artistic value. As a

CHAPTER EIGHT

Test stones
and plates

means to an end, however, stones and plates are invaluable.

PRACTICE USING
DRAWING MATERIALS

Because so much time goes into creating a lithograph, it is recommended that you, on an experimental stone or plate, start to build up a vocabulary of possible drawing effects by trying several of those discussed in Chapter Three.

Test stones and plates will enable you to experiment with a complete range of values, outlines, and textures. They will help you visually to understand and work with the effects that can be achieved with litho crayons and tusche. The beginning lithographer tends to work an image that is too light or too dark. By experimenting, you will develop a sense of confidence about lithographic possibilities which will help eliminate that timid feeling when

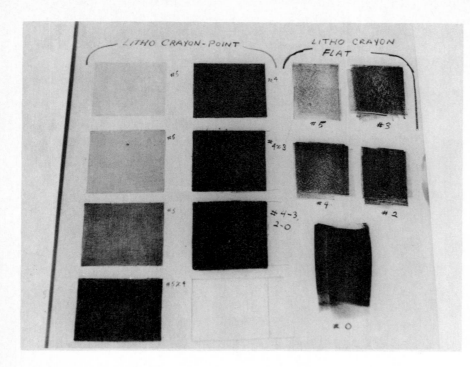

Figure 8.1
Photo by Mace Wenniger.

Allan Gardiner has used different litho crayons to produce a variety of tones on his test stone. By using the crayon point and then the flat edge of the crayon, he demonstrates the textural effects that can be obtained. Of special interest are the darker tones created by working softer crayons over harder crayon marks.

you approach your first carefully drawn image on a plate or stone.

PRACTICE PROCESSING AND PRINTING TECHNIQUES

By familiarizing yourself with the steps and materials involved in processing and proofing, you will start to master the basics of lithography.

The two variables that require most experimentation in lithography are the strength of etches and the duration of etch time. What you accomplish with various drawing materials can be either enhanced or ruined by the strength and duration of the etch you use. The right drawing materials can give you the image you conceived; the proper etch can bring forth that image when you print.

Strength of Etch

On test plates and stones, systematically test etches of varying strengths to see the effect each will have on your drawing materials. Because different etches are required for each litho base, several are presented in this chapter to illustrate the wide range of possibilities that exists. Inking and printing the test images will enable you to determine the appropriate etch and avoid a weak etch, which might fill in your image, or too strong an etch, which could start to burn out an image.

Using test plates and stones with various etches is a tremendous tool. If you want to use strange drawing materials, it is wise to test how to etch them.

Use both stronger and weaker etches on these materials to see what prints them most successfully.

This practice procedure will provide a measure of sureness when you go to process a finished drawing because you will have learned how strong an etch is appropriate for your own work.

Duration of Etch

It is important to experiment with another variable, the length of time that an etch needs to be worked onto your art work to get an image consistent with your intentions. If the etch is left on an image for too long, it might start to remove light passages. If the etch is not worked long enough, parts of the image might coarsen or lose their crisp, uniquely lithographic texture, because of a breakdown between drawn areas which is known as *filling in*.

PRACTICE DEALING WITH LITHOGRAPHIC PROBLEMS

Lithography is anything but easy. It is full of uncertainties and pitfalls. You have to go through procedures and make some of the usual mistakes before you can relax within the medium and become one with your stone or plate.

One of the things you will discover is that doing lithography raises questions and demands a lot of thoughtful time. During that time your mind will be buzzing with questions—questions about the tonal gradations and density of your drawing, questions about the strength and duration of your etch,

questions about wash out and roll up, questions about how to use litho ink and keep a consistent image. You will have many more questions than you will have answers for.

This chapter will suggest means of answering many of those questions.

The accompanying photo essays demonstrate how to make and work on test plates and stones and how to use different materials and different etches, first on plates, then on stones. You will see how three artists (one professor and two students) prepared, etched, and printed their test lithographs.

Recording Test Variables

You will notice two different methods of recording what was done. In one instance, the artist writes backward on the aluminum plate so that when the plate is printed, the writing is legible. In the other instance the artist writes left-to right on the stone or plate so that when it is printed, the writing is reversed.

TEST STONES

Working on test stones, Maine artist Allan Gardiner demonstrates the drawing and processing test steps that he teaches his new students. He suggests etches that are increased in a geometric progression as he proceeds.

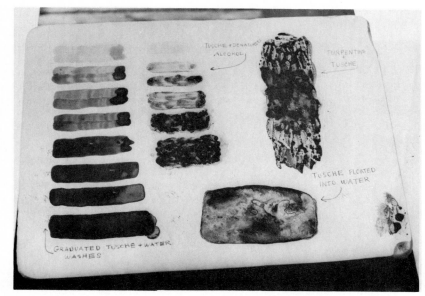

Figure 8.2a
Photo by Mace Wenniger.

Allan Gardiner used only tusche to make this test stone. This first column on the left he made graduated tusche and water washes. In the middle row, increasing amounts of tusche were brushed into denatured alcohol solution. In the bottom square tusche was floated into a pool of distilled water. Turpentine and tusche, mixed with a brush, produced the right column.

Figure 8.2b
Photo by Mace Wenniger.

Gardiner doubled the acid with each additional etch, in effect testing each of the four columns with etches of 2, 4, 8, 16, and 32 drops of nitric acid to 1 ounce of gum.

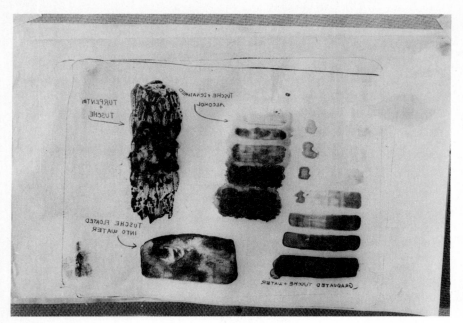

Figure 8.2c
Photo by Mace Wenniger.

The pulled proof shows that the amount of acid used in each etching step affects the way ink will be received during printing. Even a light amount of acid in the gum burned out the lightest tusche washes, which should have been coated with pure gum first. Clearly, the strength of the etch must vary according to the amount of grease being etched. For example, a thin alcohol tusche was burned by the heavy etch and left intact by a light etch. The tusche-and-turpentine wash seemed to work best with an etch strength of 16 drops of nitric acid to 1 ounce of gum. The tusche in distilled water, on the other hand, seems to have responded well to all etches, which confused Gardiner until he realized that this small area was filled with a combination of light and dark areas for which a varied etch was perfect.

Stone—with Crayons

Gardiner began his etching procedure with a gentle etch of 4 drops of nitric acid to 1 ounce of gum. He applied this to the lightest parts of his stone, and then moved his brush over slightly darker areas, continuing to add 4 drops of acid to the original solution until he had 16 drops on the darker crayon areas.

Stone—with Tusche

On his second stone, drawn with repeats of tusche work, Gardiner painted streaks of etch that progress geometrically from 2 drops of nitric acid to 1 ounce of gum arabic to 32 drops of acid to 1 ounce of gum.

Both of the above etching procedures for stone relate to the progressive etching technique taught in Chapter Five. Try the water etch, also, with etches of varying strength. Although the water etch might be more unwieldy, you might attempt it using Plasticine or modeling clay to construct mini-walls to contain and separate the water etches with their different acid contents. The point is to see what happens when different amounts of acid are used on the same type of drawing.

TEST PLATES

Aluminum—with Crayon and Tusche

Judith Tufts practiced using a variety of materials in devising this trial aluminum plate. Her intention was to familiarize herself with the greasy drawing and painting materials available to lithographers and to learn how they could best be processed before starting a long drawing project on a plate. She particularly wanted to test various tusche washes because they are considered more difficult to hold on an aluminum plate than are crayon lithographic marks.

Tufts made her test plate as follows:

Each of the first four columns contains six tusche washes: (1) tusche and distilled water, (2) tusche and turpentine, (3) tusche and isopropyl alcohol, (4) tusche and tap water, (5) spattered straight tusche, (6) gum block-out with tusche over it. By using a different etch solution for each column, she tested a combination of 24 tusche effects on her aluminum plate. The fifth column shows the different litho crayons: #1, #2, #3, #5, #3 over #5, #3 worked up to a dark value, #3 used lightly, and #3 scraped with a razor. Below the crayon effects are four examples of transferred materials.

To make the trial print useful as a decision-making guide in her work, Tufts used a #3 litho crayon to write each formula clearly but *backward* on the plate. This would print in reverse and be easily readable later.

Make a test aluminum plate similar to this one before you make a finished image on an aluminum plate. It helps to build up a vocabulary of drawing marks, and it also prevents frustration later if you can find out what lines or washes do and do not etch or print easily for you.

While processing this plate, Tufts omitted the important step of applying pure gum to her image after processing with gum arabic and Pro Sol, which almost prevented her from printing this plate. It also reinforced the important function a practice plate performs as a practical learning experience which prepares the way for proceeding later.

Figure 8.3a
Photo by Mace Wenniger.

Judith Tufts counteretched this aluminum plate before drawing on it with a variety of materials. Each of the first four columns contains six tusche washes: (1) tusche and distilled water (2) tusche and turpentine (3) tusche and isopropyl alcohol (4) tusche and tap water (5) spattered straight tusche (6) gum black out with tusche over it. By using a different etch solution for each column, she will test a combination of 24 tusche effects. The fifth column shows the different litho crayons: #1, #2, #3, #5, #3 over #5, #3 worked up to a dark value, #3 used lightly, and #3 scraped with a razor. Below the crayon effects are four examples of transferred materials. To use the printed plate as a guide later, Tufts wrote each of her formulas backwards on the plate with a #3 crayon.

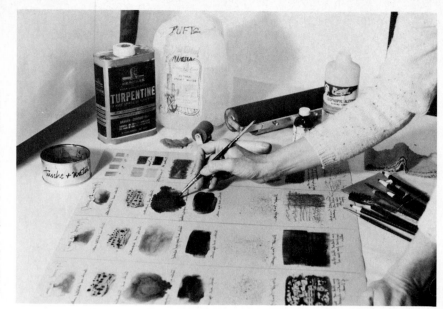

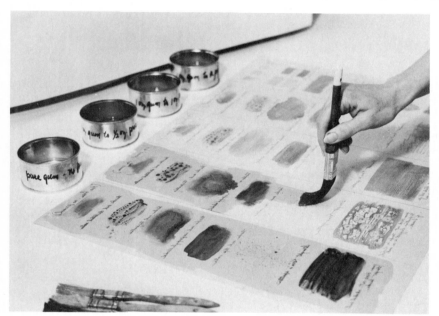

Figure 8.3b
Photo by Mace Wenniger.

Tufts first applied talc to absorb the moisture of the greasy marks and then proceeded to apply the following test etches to her plate. Each of the four first columns was given a different strength etch and worked for two minutes. In the first column, a pure gum etch; in the second, the etch being applied is composed of 1/2 ounce Pro Sol and 1 ounce gum; 2 ounces of Pro Sol to 1 ounce gum will be applied to the fourth column; the last column etched with equal Pro Sol and gum (1-to-1), the etch generally recommended for aluminum plates. Note the small cans in which a few ounces of etch are conveniently mixed.

Figure 8.3c
Photo by Mace Wenniger.

Here the etched and buffed aluminum plate is ready to be processed and printed. Prior to this, Tufts pulled the etches down to a thin film using a fine sponge, buffed the plate with cheesecloth, and let it stand for twenty minutes before she applied a thin coat of straight gum which removed the weakened etch solutions and closed off the non-grease areas from the grease areas. Now the entire surface of the plate has been buffed again with cheesecloth.

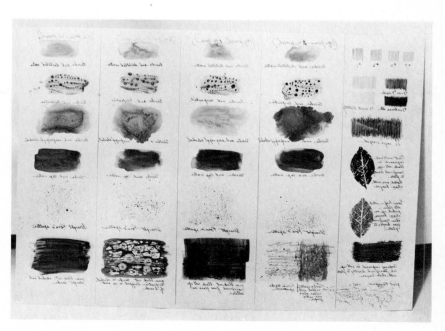

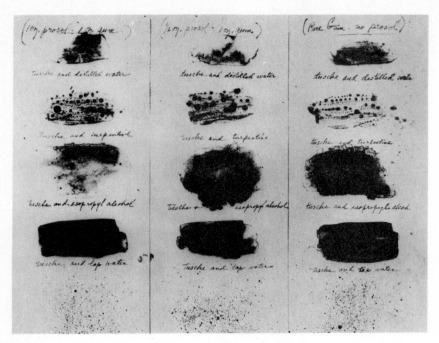

Figure 8.3d
Photo by Mace Wenniger.

Proof pulled from Tufts aluminum test plate, with the words originally drawn in reverse now readable so her proof will function as a guide to the timing of the processing of images on plates.

Zinc with Tusches and Crayons

Because of its dark, densely grained surface, the zinc plate offers interesting and different possibilities for crayon and tusche wash effects. Try making a trial zinc plate as you did with aluminum, noting the variations that occur only on zinc plates.

Student lithographer, Jan Giarruso created a trial zinc plate with three different lithographic liquids and two crayons: Charbonnel Encre Lithographique, Korn's liquid tusche, Charbonnel Encre Zincographique, and #2 and #5 crayons. She wanted to find out how these similar but different lithographic materials would print after they were processed with etches of different strengths. Note that she also recorded her materials and etch strengths in reverse on the plate because she wanted them to be readable on her final print. In this photo sequence, Giarruso is shown taking her trial plate through the wash out, rub up, and printing stages, practicing exactly how to process and print a zinc plate.

Figure 8.4
Photo by Mace Wenniger.

Washing out her zinc plate, Giarruso uses gum turpentine as a solvent because it is purer than other solvents and less likely to break down the gum stencil surrounding the tusche work on her plate. The rub-up step is eliminated when working on zinc since the oleophelic nature of this litho base retains grease residue of the image. A rub-up with asphaltum or thinned ink would make the plate hold too much ink upon printing. She will proof her zinc plate now, using a tight black ink.

Paper with Tusche and Crayon

For a quick, easy, and inexpensive exposure to amateur lithography, try a paper litho plate. You can create a test plate with systematic columns of tusche or crayon, or come up with a spontaneous drawing like the one made by Judith Tufts. The process is simple because the etch is straight from a premixed solution in a bottle. Consequently, you can experiment even when you have very little time, space, or equipment.

Figure 8.5a
Photo by Mace Wenniger.

On this paper plate, Tufts tried a number of experimental approaches. She drew with crayon and applied layers of tusche. She added soap flakes to the tusche and later brushed them off, leaving a textured surface. She put the plate into a freezer while the tusche was still moist, causing the tusche to curdle.

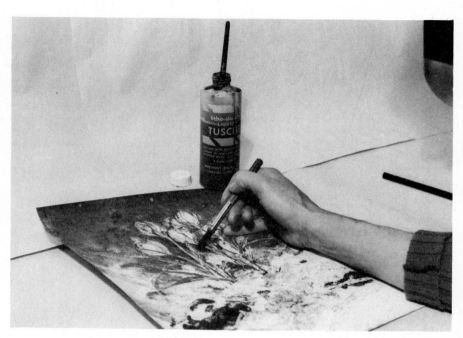

Figure 8.5b
Photo by Mace Wenniger.

Tufts uses polyurethane roller and metal inking slab provided with paper plates. The inked roller should be applied on the plate judiciously, watching out for overinking.

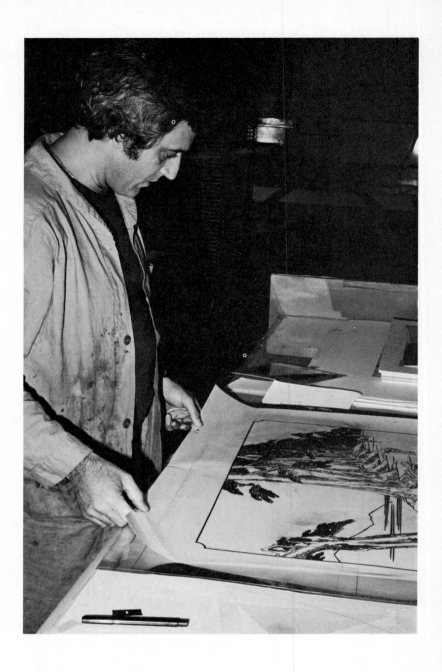

One of the most important aspects of contemporary lithography is the innovative use of transparent and translucent materials as a creative base for lithographic imagery. This chapter demonstrates how Mylar is used by lithographer Michael Knigin, professor of lithography at Pratt Institute, who recently began creating his images on sheets of translucent and transparent Mylar.* It also shows how the drawn image is transferred to a photo-sensitized aluminum positive plate for processing and printing either on a lithographic press or on an offset press.

Working on Mylar is the subject of much debate

*This chapter has been made possible by Michael Knigin.

among lithographic printmakers. Some contend that photographic technology is not art.

In response Knigin suggests:

I have been working happily and successfully on Mylar for the past few years, and while Mylar, at this point in time for me, cannot recreate the incredibly subtle and beautiful tones of a good blue-gray stone, it certainly can challenge the temperamental direct-drawn aluminum and zinc. The countless varieties of textures that can be rubbed, sprayed or drawn on its frosted surface are inexhaustible.

Corrections can easily be made using erasers and solvents. The freedom that the translucent Mylar al-

CHAPTER NINE

The Mylar method

lows for registration is unparalleled. Its lightness and flexibility enable the artist to easily transport it from location to location, and for the first time, excluding transfers, in the lithographic fine art printing process there is no mirror image. The image will print as it is drawn.

Most of all, the opportunity to re-expose the image on a positive working plate if any problems occur during proofing, printing, exposing or developing is unsurpassed.

The Mylar method is a valid way to make an original print. The artist creates the image on the Mylar rather than on a lithographic base; from there it is transferred photographically to a litho plate; if the artist's supervision is constant, and the finished print is approved and signed by him or her, then it is an original print, as defined by the Print Council of America.

ASSEMBLING MATERIALS FOR MYLAR

Because the Mylar method is different from the other procedures in this book, the materials required are different.

Figure 9.1
Photo by Michael Knigin.

Light table with a sheet of Dupont Mylar film on it and the tools used by Michael Knigin to draw using the Mylar method.

MATERIALS FOR WORKING ON MYLAR

- Dupont Mylar film
- Pencils—Stabilo #8008 & Stabilo #8046
- Lead pencils
- Graphite sticks
- Pens, brushes
- Ink—Higgens, Pelikan
 Perfex—photographer's retouch used to make solids on Mylar
 Opaque—used like ink to make solids
- ⅛″ thick sheet of Plexiglas cut larger than Mylar drawing surface
- Hole punch with a ⅜″ or ¼″ projecting stub
- ⅜″ or ¼″ register pins, depending on the size of hole punch
- Razor blades
- Sandpaper and various textured surfaces
- Staedler plastic eraser #526-50
- A.W. Faber-Castell eraser
- Light box—not necessary but helpful
- Fuji positive working plates, etch, developer, undercoating solution, image gum
- Lacquer solvents
- Lacquer C
- Webrill wipes
- Kim wipes
- Right angle
- White drawing paper
- Film—a number of ranges of soft white plastic
- Glycerin
- Cheesecloth
- Fountain solution—Imperial or Pro Sol

CREATING ON MYLAR

Artists working on Mylar have to adapt to the grained acetate surface. As with any new media, they must practice, and finally allow it to properly convey their gesture, or line.

Keep in mind that there will be no mirror image if you print on a flatbed scraper-bar press. The image will print in the same direction as it was drawn on the Mylar. Since your image will be transferred photographically; you will put the drawn side of the Mylar in contact with the emulsion side of the positive working plate, the image will be transferred in reverse to the plate and thus will print as it was drawn.

Working Procedures

Mount the Mylar on ⅛″ thick sheet of Plexiglas. Many artists find it helpful to use a working sketch drawn to scale which delineates the areas of color. They mount this sketch in position on the Plexiglas sheet.

However, it is advisable to place a white paper under your Mylar, with lines indicating the perimeters of your image and printing paper. Work directly on the Mylar, drawing your key image first, then overlaying the key with the Mylar for each color you may wish to incorporate in the final print, still using the perimeter guidelines on the white paper as a check.

Place the Plexiglas on a light box so you can see how opaque your line really is after you draw it. The opacity of the line, solid, or wash is deceiving when not held up to light. A light table is helpful for judging tones and values on the drawing.

Textures and Other Effects

With the Mylar method the artist makes a drawing on the grained surface of the translucent Mylar sheets. These Mylar sheets or films come in three textures: coarse, medium, and fine. Mylar is extremely stable; it does not expand or contract with the changes in the humidity as most tracing or printing and drawing papers do.

When magnified, the frosted textured surface is seen as an extremely fine, randomly patterned surface grain, very close in feeling to that of an extremely fine-grained lithographic stone.

The artist can use any drawing or painting material as long as it will stop light: stabilo pencil, lead pencils, pens, drawing ink, acrylic, opaques, tusche, charcoal, graphite, and markers.

A huge range of textures can be created by placing the Mylar on a textured surface and rubbing with pencils, graphite sticks, and so on. Airbrush sprays and washes can be used on Mylar with great success. Use Winsor-Newton Black gouache mixed with a small amount of red opaque for best results. Words written with a ballpoint or a pilot pen can be written as positives when working on Mylar, instead of having to write them in reverse as one does when creating driectly on a litho plate or stone.

Overlapping drawings is possible, and a double-exposure effect can be created by cutting the Mylar sheets and rearranging them with tapes.

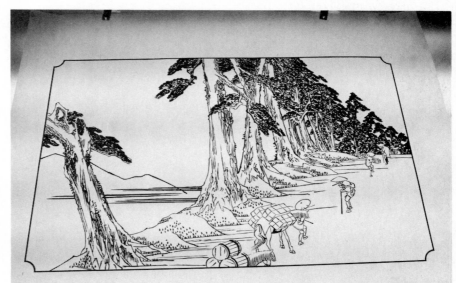

Figure 9.2
Photo by Michael Knigin.

Key drawing on Mylar using stabilo pencil 8008. Note registration pins, used on all subsequent Mylar drawings too.

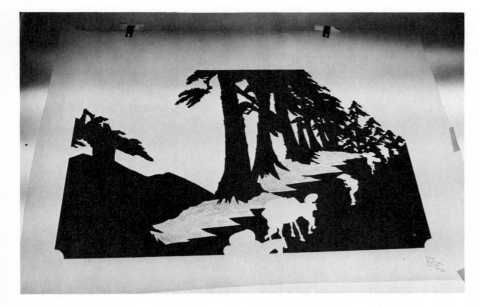

Figure 9.3
Photo by Michael Knigin.

Another Mylar plate, part of Knigin's image, was created in this way; solid areas were applied with perfex. Textures were made by rubbing a graphite stick over sandpaper. Note the registration pins used to hold each Mylar plate on both the light table and the lithography press bed.

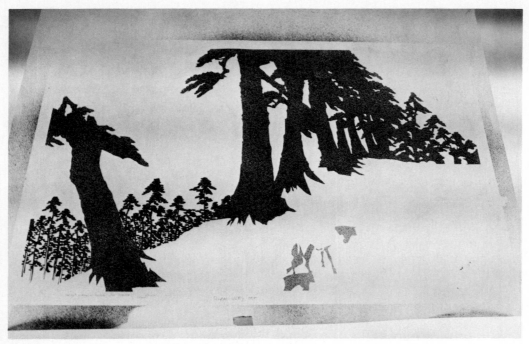

Figure 9.4
Photo by Michael Knigin.

A drawing on frosted Mylar was made by using acrylic paint and two different air brush spray textures.

Figure 9.5
Photo by Michael Knigin.

Mylar with rubbed textures and India ink air brush spray. The rubbed texture is achieved by the use of a graphite stick over the back of masonite. Again, note registration pins holding plate in position.

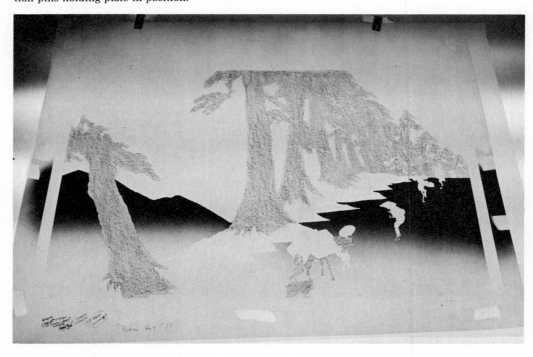

Figure 9.6
Photo by Michael Knigin.

Detail of rubbed texture and airbrush
spray on Mylar surface.

Mylar Registration

COLOR LAYERING MADE SIMPLE

Each color printing step will necessitate the use
of a separate Mylar sheet with the parts of the image
which will introduce the new color drawn on it. It is
a wise practice to label each sheet with the name of
the color to be printed.

First make a key drawing, signifying what color
will be printed; then decide how many color over-
lays it will take to complete your entire image and
prepare separate Mylar sheets cut to exactly the same
size as the key Mylar.

REGISTER PINS AND PUNCHED HOLES

Use register pins and punch holes through key
Mylar, printing plates and printing papers to prepare
registration for color overlays.

Precise registration is easy because you treat all
of your Mylar drawing sheets in exactly the same
fashion. Buy quarter-inch register pins and a hole
punch. Punch holes in the key Mylar sheet exactly
fourteen inches in from either side of the mylar.
Tape your two register pins on the Plexiglass sheet
(preferably on a light table) with the points of the
register pins perforating the Mylar key drawing.
Each succeeding Mylar sheet will be placed over the
key drawing to establish the place for the holes to be
punched. When working on each Mylar sheet, set it
down, and place the register pins through the holes
in the Mylar. These punched holes in the Mylar are
extremely important because in the next step they
will be transferred photographically to the positive
working plate.

Each of these hole marks on the plates, once
transferred, should be punched out with a quarter-
inch hole punch. The careful placement of these
marks will ensure proper registration for a multi-
colored print by later serving as register holes for
printing. The register pins will be attached to the bed
of the press and will hold plate and printing paper in
exact position during the many steps in making a
multicolor print.

REGISTRATION CROSSES

Another device that you can use to ensure exact
placement of each color is to make finely drawn regis-
tration crosses midway along the three sides where
the register pins are not used.

First draw registration crosses at the midpoint
of the three sides of the key drawing. Be sure to mark
the three registration crosses on all the succeeding
overlay Mylars when the Mylar sheets are placed
over the key drawing.

Use a center-finding ruler to ensure exact mid-
way placement of the registration crosses on the key
Mylar. Using these crosses and register pins exactly
punched, as well as register holes in all of the My-
lars, in all of the positive working plates, and
through all of your printing papers, will ensure accu-
rate registration of all colors when printing. Make
the register holes in the printing papers by using the

key Mylar as a guide. Draw the holes through the Mylar onto the printing papers and then punch holes in each sheet using a quarter-inch punch.

Plan your image placement and your paper size. For the paper, allow a one-and-a-half-inch border around your image plus two inches at one end for the registration holes which later will be torn off. Indicate your image and paper perimeters on a sheet of white paper underneath the Mylar by drawing thin lines, unless an outline is part of the image, as it is here in Knigin's image.

Tear proofing papers and edition papers to the correct size, including the extra two inches used for registration marks on the back of each. Mark this end of the paper with an "S" (for start) in pencil which will help you position each piece of paper correctly for each use.

Place Mylar over each printing paper. Punch registration holes evenly in proofing and edition papers using a quarter-inch paper punch.

Attach registration pins through registration holes in each paper to position the papers for multi-color printing.

PROCESSING MYLAR-MADE PLATES

Transferring the Image onto Positive Working Plates

Place your drawing image-side-down on the light sensitive, positive working plate, "emulsion to emulsion." For hand printing it is mandatory to use positive working plates. Recommended are the Fuji plates which must be developed with Fuji developer, Etch, and Image Gum. Fuji plates retain more water and thus do not dry out during printing.

Made close contact between Mylar and plate. This is best accomplished by putting Mylar and plate sandwich in a vacuum frame plate maker or plate burner which will ensure a perfect transfer of the drawn image with no loss of crispness of line or texture in a wash.

In a plate maker, the image is transferred to the plate. This is accomplished when the plate is ex-

posed to light and the positive image on the Mylar is transferred, or burned, as a positive onto the light-sensitive plate. The plate retains the drawing where the light is blocked on the Mylar. The plate emulsion dissolves where the light passes through the Mylar, and it hardens where the image blocks the light.

This exposure also can be made using an arc lamp or a photo floodlight to burn the image held in position by a vacuum frame or under a sheet of glass to enforce contact between film and plate. The photo lamp method is not as reliable as using a plate burning unit or an arc lamp.

Developing the Mylar-Made Image

Pour the developer over a felt scrubber (use rubber gloves), and rapidly spread it over the entire plate until all the plate emulsion coating the drawn image on the Mylar softens and rubs off. This should take from 90 to 120 seconds.

Squeegee off excess developer, and repeat the process. Wash the plate well with running water, and rinse the scrubber thoroughly. Now squeegee away excess water.

Figure 9.7
Photo by Michael Knigin.

Mauro Guiffuda, master printer at American Atelier, positioning a drawn Mylar on the presensitized "Fuji" positive working plate.

Now pour the next liquid, the etch, over a second felt scrubber onto the plate, and proceed identically as you did with the developer. Squeegee away any excess water, and dry the back of the plate.

Place the plate on a dry surface, and pour a small amount of image gum on the plate. Using a pad of Kimwipes, spread the gum over the entire plate. Buff with a pad until nearly dry. Then hand fan until it is thoroughly dry, and you can see the image, transferred to the positive working plate, ready for printing.

The plate is still light-sensitive, so if you are not ready to print, be sure to store it out of the way of light, and make sure that it doesn't get bent or creased. It is a good idea to place the plate between two sheets of corrugated cardboard.

Figure 9.8
Photo by Michael Knigin.

Developing the plate by hand wiping. Pour the developer over a felt scrubber (use rubber gloves) and rapidly spread over the entire plate until all the plate emulsion coating which was not protected from the light in the exposure unit by the drawn image on the Mylar softens and rubs off.

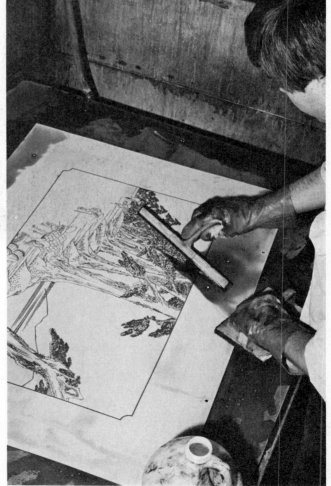

Figure 9.9
Photo by Michael Knigin.

Remove any excess developer with a squeegee. Wash the plate well with running water and rinse the scrubber thoroughly. Squeegee excess water. Pour the next liquid, the "etch," over the scrubber onto the plate and proceed exactly as you did with the developer. Remove excess etch and water. Dry the back of the plate.

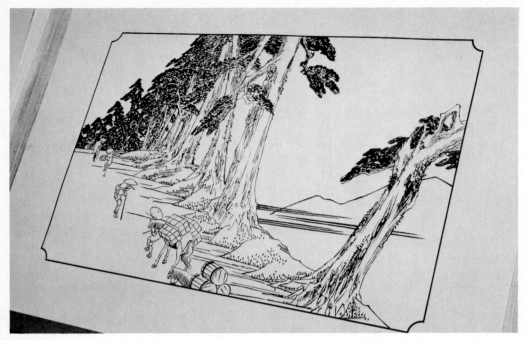

Figure 9.10
Photo by Michael Knigin.

Key image, transferred to positive work-
ing plate from which it is finally printed.

PRINTING
MYLAR-MADE PLATES

Printing from the positive plate is similar to printing
from any aluminum or zinc plate or a stone. Howev-
er, the plates are electronically grained, which
makes them much smoother and inhibits the amount
of water held between passes of ink.

When you begin to print from these plates, all
that is necessary is to wash off the gum, roll up, start
proofing with black ink, and proceed to use color
inks following the steps in Chapter Seven, Color
Lithography.

If you stop printing to eat or answer the tele-
phone, be careful to leave your plate fully inked and
protected from light with a sheet of newsprint or
cardboard. The plate is still light-sensitive, and it
will develop further with any exposure to light.

On a dry day it is sometimes necessary to add a
few more drops of glycerin to the wetting water. It is
also advisable to add approximately ½ ounce to a
gallon of fountain solution.

When you have finished printing and want to
save the plates, flood the image with water, add tur-
pentine, and wipe clean with a soft rag. Clean well,
dry, gum, and wipe down to a tight, shiny film with a
cheesecloth. Rub in asphaltum, and buff down.
Wrap in newsprint and a cardboard folder; store in a
dark place.

Printing with
Mylar Registration

Punch holes in your printing paper. Use the hole
punched in the key image on the Mylar as a guide.
Draw the holes through the Mylar on to the end of
the printing paper that has the extra two inches des-
ignated for this purpose (remember that it will be cut
off later), and punch holes in each sheet of paper
using a quarter-inch punch.

The next step is to move to the press bed where
you will set up a registration system using two or
three quarter-inch register pins attached to the press
bed. Alternatively, you can devise a bar to hold the
pins, which will hold the paper and your plate, or
just the paper if you prefer to tape your plates to the
press bed so you can make minute adjustments in
the plates' position in a multicolor printing.

To correct the position of your plates, first print
your key image on another sheet of Mylar. Place this
over each plate as a guide. A helpful device is to cut
small windows in this key proof to make sure it lines
up shapes and lines with drawn work underneath.

Corrections on Mylar

Corrections can be made easily with erasers and sol-
vents. The translucent Mylar allows more freedom to
make deletions and corrections than do aluminum
and zinc. Erasers include the Staedler Mars Plastic

148

526-50, Koh-I-Lar Drafting Film Eraser, Eberhard Faber Pink Pearl, the Pelikan PT-20, a kneaded-rubber eraser.

Larger areas of pencil and wash works can be erased by using ordinary kitchen Fantastic cleaner or alcohol and water. You can also scrape and scrub lightly; deep scrubbing will reproduce photographically.

Areas of the drawn Mylar can be cut out and patched with Scotch tape, as the edges can easily be deleted from the plate before printing.

Making Additions to Mylar-Made Plates

There are two different ways to make additions to positive working plates. The first is the easier and quicker method, but it is used only for solids. The second, used for lines and washes, is more involved and closely related to additions made on directly drawn plates.

ADDITION OF SOLIDS TO POSITIVE PLATES

Solids are not a problem to add. Follow the quick method outlined below. If there is ink on the plate, clean it thoroughly with turpentine and water. Then fan dry. If there is no ink, wash off with water, and fan dry.

1. Rub the area where you wish to add with Fuji undercoating solution for approximately 30 seconds, using a brush or Q-tip.
2. Wash well with water.
3. Dry.
4. Paint your additions in with lacquer, very thinly.
5. Etch the entire plate for approximately one minute with a sponge and Fuji Etch.
6. Wash off with water.
7. Dry.
8. Gum, and dry down tight with cheesecloth.
9. Wait five minutes.
10. Wash off with water.
11. Proceed to print.

ADDITION OF LINES AND WASHES TO POSITIVE PLATES

Additions of drawn lines or washes with lithographic materials, that is, litho crayon, pencils, and tusche.

If plate has ink on image wash off with water and turpentine. If the plate has no ink and is gummed, start with step one.

1. Wash off with water.
2. Dry.
3. Rub Fuji undercoating solution on the area or areas where you wish to add for approximately 30 seconds.
4. Wash with water.
5. Dry.
6. Draw.
7. Buff down with talcum powder.
8. Gum plate—buff down tight with cheesecloth, leaving no streaks.
9. Wash out the entire image with lacquer C solvent that is absolutely clean.
10. Pour a small puddle of lacquer C into the center of the plate, and buff it down rapidly with a Kim wipe till you achieve a tight thin layer.
11. Fan dry.
12. Allow to stand for 10 minutes.
13. Rub up image with asphaltum and black ink in a thin layer.
14. Fan dry.
15. Wash off with water and immediately roll up full.
16. Dry.
17. Etch the entire plate for 30 seconds with Fuji Etch on a sponge.
18. Wash off with water.
19. Fan dry.
20. Gum the entire plate.
21. Wipe down with cheesecloth.
22. Fan dry.
23. Wash off the gum with water, roll up, and commence printing.

SPECIAL EFFECTS

To achieve the texture of a lithographic stone on a positive plate, the Fuji developer can be used straight or diluted with water. The use of straight developer will have a tendency to burn the image very rapidly, so take care. The developer can be premixed with water to achieve a slower burning result. After burning the desired areas of the drawing, clean plate with water, fan dry, and finally etch the entire plate for approximately 30 seconds with Fuji Etch.

Since nearly every town or city has commercial offset printing facilities, and many lithographers do not own lithographic presses, the printing of lithographic images, either hand-drawn or photographic, on an offset press offers another viable alternative to a lithographic printmaker.

Use of an offset press in close collaboration with press technicians offers many important advantages: uniformity of edition, speed of printing, high fidelity to the original image, and a control of ink flow which lends itself to perfect multiples of rainbow roll and accurate registration.

Some of the limitations of offset printing for lithographers should be noted: Not every offset printer is interested in the dialogue necessary to work closely with an artist. Many printers do not want to print the small editions that would seem appropriate to a lithographer committed to the idea of printing limited editions. Prints may lack a hand-manipulated look. Paper sizes are controlled because each press has a maximum and a minimum paper size. Rainbow rolls can only be printed horizontally. The scale of the offset press makes it hard to experiment with transparent and translucent ink overlays.

Using an offset press

WORKING WITH OFFSET SHOPS

When working on a mechanized offset press, the most essential ingredient is the systematic establishment of a trust relationship between you and your offset press technicians: printers, strippers, plate-makers, camera operators. You need them. Approach them with patience and flexibility. If they start to cooperate with you, be grateful, and let the relationship mature gradually.

How an Offset Press Works

Printing images with a mechanized rotary offset press is similar to hand lithography; the image is a grease-attractive stain on a plate. However, in offset printing the artist's image is not transferred directly from aluminum plate to paper. Instead, the image is passed from an aluminum plate—with greasy image areas receptive to ink—to a rubber blanket, and from there it is "offset" or transferred mechanically onto paper which is fed under the ink-laden roller.

OFFSET PLATE IMAGE-MAKING

There are many ways to create the image on the plate, from relatively simple techniques to highly complicated processes characterized by interdependence between artist, printer, stripper, platemaker, and camera operator.

Any type of image, ranging from painterly washes to hard edge, can be made for use on an offset press. You can use traditional litho pencils, crayons, autographic inks, and tusche to draw the image on traditional ball-grained plates. You can create images using nonlithographic materials to draw with and upon: use frosted acetate, mylar, and translucent vellum as your drawing base, and choose from hard or soft lead pencils, china markers, ball point pens, or inks, acrylics, and graphite.

Photographic techniques including line shot, halftone, and color separation are available to the artist. In addition, there are possibilities in the darkroom for manipulating the negative using direct contact exposure. Also, working on developed film negatives or positive, an artist can alter his images by scraping and opaquing certain areas.

When using a positive plate as described below, drawings on translucent surfaces should be made in reverse. Because of the ease with which translucent materials can be used photographically (see Mylar method), the potential variety of images available to the artist is considerable. Drawing with the aid of a light table will help make the task easier. A material often used is masking film. With this material, artists can make solid areas or fine lines with ease. Masking film can also be used as stencils when exposing (burning) part of the image out or onto the plate.

Offset Platemaking Procedures

Three kinds of lithographic plates can be used on an offset press: ball-grain, positive, and negative. Each type has its own characteristics and processing pro-

Figure 10.1
Photo by Gail Alt.

Since this photographic image will be printed from a negative working plate on the offset press, a film negative of the image has been prepared. Working on a light table, the artist, Oriole Farb, touches up the negative with opaque, a commercial product that prevents the transmission of light and maintains equal density throughout the plate.

cedures. Aluminum ball-grain plates receive the complete range of marks usually associated with hand lithography. Negative and positive plates are both light-sensitive and usable after the image is exposed through film or acetate in a vacuum frame plate burner. After exposure, both positive and negative plates are either processed by hand or by an automatic plate processor.

The advantages of using positive and negative plates and their attendant mechanized platemaking processes are: speed in producing stable plates; ease with which plates can be remade to correct errors; fidelity to the original image drawn on a transparent or translucent material.

Although either negative or positive plates can be used by an artist with the support and guidance of a pre-press technician, use of a positive plate is recommended. Positive plates can be easily remade with an accessible automatic plate burner and plate processor. This permits manipulation of the variables of exposure time and distance from the light source until the textures and lines of your original image are faithfully recorded with a full range of values from light to dark.

POSITIVE PLATES

For a positive plate, a drawn image on transparent or translucent material such as Mylar is placed in tight contact with the plate. They are then exposed to a high intensity bright light which acts on the exposed areas so that the positive plate emulsion will soften and be washed away when it is developed, leaving only the drawn image imprinted on the plate.

To achieve clarity and the maximum range of values and tones, be sure that the drawn image on transparent or translucent material or the emulsion side of a film positive is placed in contact with the emulsion on the plate.

This means that the image might be drawn in reverse if there is a directional preference for the end product to be printed on your paper. In other words, when placed drawing-side-down on the plate, the image will be reversed as a necessary first step. To compensate for this reversal, be sure to draw your image in reverse so that it will be in the position you prefer when it is imprinted on the positive plate. Remember that it will be reversed again as it is printed on the rubber offset blanket and still again in being printed on your paper, before it returns to the direction you originally had in mind.

The initial cost of positive plates is much greater than the cost of negative plates, but the directness of image-making on a positive plate makes this plate the easiest to use and thus the most popular for the lithographer learning the photographic procedures of offset platemaking.

NEGATIVE PLATES

A negative plate requires an intermediate step between the drawn image and the imprinted plate: the image is transferred to a negative film through which it is exposed on to the negative plate.

On negative plates, images drawn on translucent or transparent materials can be photographed with a line shot onto an orthochromatic film without the use of a halftone screen, or they can be exposed on the film by the direct contact method. These film negatives are then made into plates.

When using a negative plate, place the emulsion side of the film face down on the emulsion on the plate. Make close contact between them either in a vacuum frame or under quarter-inch plate glass, and expose them to intense light either from a flood bulb or in a plate burner.

A negative working plate responds to this exposure differently than the positive plate previously described. Light passing through the transparent parts of the image on the film acts on the exposed areas, causing them to harden and become printable, rather than soften and wash away as they do on a positive plate. Thus the original image goes through the steps of being positive, then negative (on the film), then positive once again on the plate.

When using negative film which can be put emulsion-side-down on the negative plate without reversing the image, you eliminate the reversal steps demanded by positive plates.

PRINTING ON AN OFFSET PRESS

As with other forms of print-editioning the sensitivity and skill of the printer is the primary factor in producing a good print. The printer is responsible for keeping the press in top operating condition and for controlling the dampening, ink flow, registration, oscillation, and many other adjustments of the press required to print the image. You will find that a good offset press operator's advice about the printing order of the plates and color-mixing is essential and invaluable.

SUMMARY OF PROCEDURES WHEN DRAWING ON AND PRINTING POSITIVE OR NEGATIVE OFFSET PLATES

1. Make your image on a translucent or transparent base, and then either transfer it directly to a positive plate or go through the intermediate step of shooting it onto a film negative, from which it will be transferred to a negative plate.

2. When your image is drawn on a transparent or translucent material, or a film positive or a film

Figure 10.2
Photo by Gail Alt.

Printer Roberta Bannister prepares the image for printing. She wipes the plate with a wet sponge, which removes the gum coating from the ink-receptive positive areas on the plate.

negative, your work will be *stripped* in position on the *flats*, as the photographic plates are called.

3. Plates are processed by an automatic plate burner and plate processor with the help of the pre-press technician. The registration marks are transferred by being burnt on the plate, making a completely accurate registration system which will allow for precise workmanship throughout the plate work and the printing of a multicolored image.

4. When the plate is ready, the offset press operator mounts the plate, checks the positions of both plate and paper, and begins the process of ink roll up and running the press. At this point a hand-drawn and processed litho plate can be introduced. The skill, sensitivity, and experience of the printer is essential in producing a good print. In offset, the actual printing and operation of the press is rarely done by the artist.

5. Printing paper is prepared and positioned with 50 extra sheets of non-rag paper added for first steps of proofing.

6. The printer prepares the image for printing by washing the plate with water.

7. The press operator puts the artist's ink into the press. The colors can be hand-mixed by the artist prior to this step. Transparent medium and other ink modifiers can be added to the ink as it is prepared.

8. The printer adjusts the registration guides on the press. With the press's precise registration, multi-images can be printed accurately; there is also the option of deliberately printing out of register. Through finely tuned mechanisms the printer can control the amount of ink laid down during each impression. This system permits under-inking and split fountain.

9. On the press the plate can be manipulated by the artist using deletion fluid or permanent marker to modify small areas. This type of manipulation while the plate is in position on the press is unique to offset and creates a wide range of creative possibilities.

10. The printer runs the press, adjusting speed, ink oscillation, and paper distribution.

11. The artist checks first proofs; then artist and printer decide color changes and other adjustments before printing continues through the final edition.

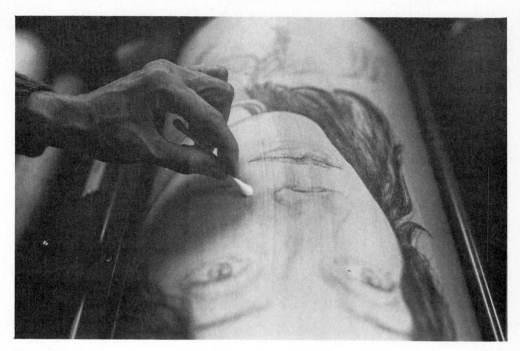

Figure 10.3
Photo by Gail Alt.

Artist modifies the image with deletion fluid, a commercial product that can completely remove all or part of an image from an aluminum plate.

Figure 10.4
Photo by Gail Alt.

The printer runs the Heidelberg offset press as the artist watches the prints drop off the press. This artist prefers to print small edition. (This was done in an edition of 35.)

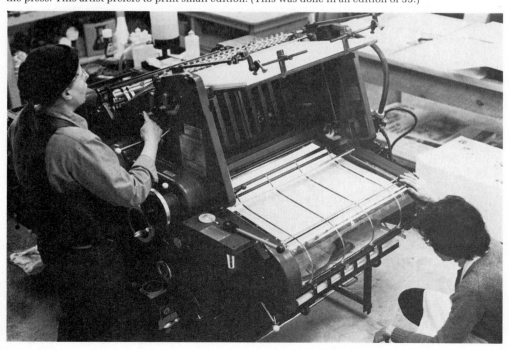

There is another chance when disaster strikes during printing and any of the following problems arise: filling, fading, scumming, push, water streaking, lap marks, flocculation, salty impressions, slur, offset, or tinting.

These problems must be corrected quickly if they occur; otherwise your image will be lost. Note: they often occur in multiple combinations which challenge the search for solutions and dictate a blend of many subtle adjustments.

For the following list of succinct solutions to common printing problems I am grateful to Russell Hamilton, director of Western Graphics, Alburquerque, New Mexico.

COMMON PRINTING PROBLEMS

Filling
(darkening image)

CAUSE
1. Overinking or use of an ink which is too soft or greasy.
2. Underetching and subsequent breakdown of the gum film.
3. Incorrect printing pressure.

SOLUTION
1. Use less ink on slab and/or fewer inking passes; ink may need to be stiffened with modifier.

CHAPTER ELEVEN

Printing problems, corrections, and additions

2. On stones, wet-wash the image (quickly hit stone with both lithotine and water to dissolve ink while keeping stone wet), and roll up in lean black ink. Rosin and talc the image, re-etch affected areas with a moderate to strong etch as necessary, wipe off etch, and buff image down with an etch of 6 drops nitric acid to 1 ounce gum. Allow 15 to 30 minutes drying time. Re-gum, wash out, and roll up in printing ink.

3. On plates follow the above wet-wash procedure, and then roll up plate with lean ink; powder with talc, re-etch with moderate to strong etch and re-gum.

Scumming (ink deposit on non-image areas)

CAUSE
1. Poorly etched or gummed element.
2. Use of too much ink, too greasy ink.
3. Dirty water with fatty particles in it.

SOLUTION
1. Re-gum and roll up with lean ink; re-etch and re-gum.
2. Use fresh ink of leaner and shorter consistency.

3. Use less ink on roller; use more passes to ink image.
4. Change water frequently.

Fading (image loss)

CAUSE
1. Underinking.
2. Heavy pressure.
3. Insufficient grease in ink.
4. Unstable image.
5. Wear.

SOLUTION
1. Use slightly more ink and slower passes, or more passes.
2. Lighten pressure.
3. Add #1 or #3 varnish to ink (be conservative).
4. The image may not be fully established, especially if it has been counteretched: roll up in soft, greasy black ink, rosin, and talc, lightly buff down under gum, and allow to sit for 24 hours or change the lacquer printing base. As a final resort, counteretch and redraw, if feasible.
5. Unless abused, an element will rarely fade because of wear in less than fifty impressions. The best thing to do in this situation is to wave good-bye or to counteretch and redraw the affected areas.

Tinting (film of ink deposited on element)

CAUSE
1. Ink problems.

SOLUTION
1. Scrape roller and ink slab.
2. Use less ink.
3. Use ink that is leaner and shorter.

Push

CAUSE
1. Paper sliding on the ink surface during printing.
 a. Soft ink.
 b. Too much ink.
 c. Paper stretch.

SOLUTION
1. Add magnesium to give ink more body.
2. Use less ink and more passes.
3. Pre-stretch paper; use push-bar. Lessened pressure often helps. Some papers are particular vil-

Figure 11.1
Photo by Mace Wenniger.

Mix a saturated solution of potassium alum and water to make stone counteretch solution.

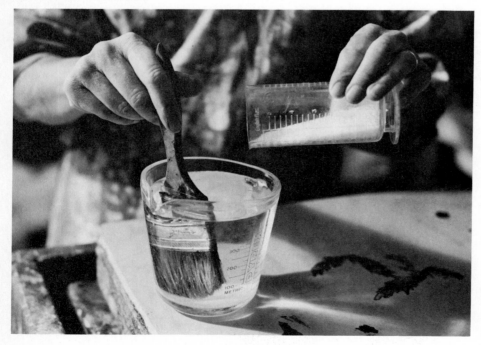

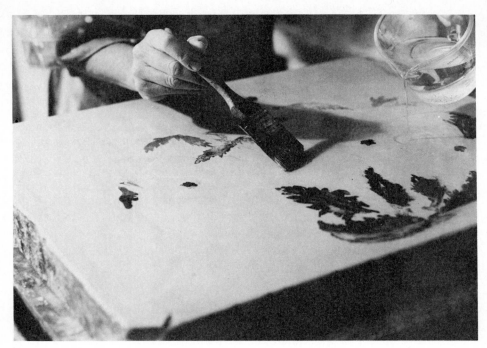

Figure 11.2
Photo by Mace Wenniger.

Apply counteretch to the dry stone directly, then work with a brush for two minutes over the part of the image needing resensitizing.

lains here; Copperplate stretches considerably (up to 1/4" per 30 ").

Water Streaking
(streaks on print)

CAUSE
1. Uneven water film during inking.
2. Uneven water film during printing.

SOLUTION
1. Use a water film as thin and smooth as possible without causing dry roll.
2. Use of glycerin in sponge-water may help (1 ounce glycerin/2 quarts water).
3. If the ink is stiff or tacky, the addition of Setswell to it may help.

Lap marks (roller marks on print)

CAUSE
1. Poor roller technique
2. Roller not matched to image.

SOLUTION
1. In color work, try to use a roller that covers the entire image in one revolution.
2. When charging the roller with ink on the slab, make the last through passes without lifting the roller from the slab. You should roll back and forth on your ink slab two or three times *without spin* to give a final even ink film on slab and roller. Roll the length of the circumference of the roller, no more or less.
3. Always be sure the ink on the slab is even before inking the element.
4. When using a leather roller or other small roller, a light touch and careful control is the only cure.

Flocculation
(ink on roller not usable
because of rubbery consistency)

CAUSE
1. Absorption of water by the ink.

SOLUTION
1. Clean slab and roller, lay out fresh ink.
2. Scrape and refresh ink as needed.

Salty Impressions
(uneven, broken light,
lifeless tones or flats)

CAUSE
1. Underinking.
2. Burnt image.
3. Pressure too light.

SOLUTION
1. Use more ink; use more passes; soften ink with varnish or Setswell (not necessarily all of these).

159

2. Try to reinforce image by pulling proofs in greasy black ink until image is full; etch lightly; proceed.

3. Increase pressure gradually.

Slur (fuzzy impression)

CAUSE
1. Paper stretch.

SOLUTION
1. Pre-stretch paper or use push bar.

Offset
(previously printed colors
imprinting on litho base)

CAUSE
1. Previous ink layers still wet.
2. Base not wet during printing.

SOLUTION
1. Allow prints to dry 18 to 24 hours between press runs.
2. Sponge the base after the final inking pass, so dampness of negative areas will retard the off-setting of previously printed impressions.

Use of Push Bar
to Avoid "Slur" or "Push"

The idea is to keep the major part of the paper away from the ink until actual printing to avoid slur or push. Build a small table or push bar arrangement made of Mylar wrapped around two strips of lathing (or yardsticks) supported by feet made of strapping tape. This table sits on the element with the four feet resting on the base, surrounding but not touching the image. The printing paper is held up by the push bar until the scraper bar pushes the push bar and reaches the next part to be printed. The goal is to keep the "trailing" end of the printing paper off the printing paper so the ink will not be moved during printing. You will quickly find this procedure requires some mastery and is usually only possible when you have a sponger to assist, because it is a two person job.

This trick can resolve many difficult problems which are usually the result of paper stretch (i.e., push, lay marks, slur). Registration does often suffer, although the whole process is much easier to work with if you are using punch registration.

PROCEDURE
1. Make footing of yardsticks under cardboard; they should be placed close to edge of stone (or

plate) and be sufficiently clear of the image to avoid smear.

2. Attach a registration tab, a piece of mat board centered on cardboard (tape or glue) and center marked, so that it extends outside Mylar several inches, and can be lined up with registration marks on stone or plate.

3. Line up the registration tab with registration mark on the leading end of the base. Be sure device is visually square with stone.

4. Locate push bar as far to end of stone as is practical.

5. Line up scraper bar and push bar direction with direction of the press in printing.

STEPS
1. After inking and final sponging, put push bar on stone and line up registration tab.

2. Without moving push bar, line up "T" of paper to stone, lay paper across bar and line up with mark on registration tab. (Be careful to do this in a smooth manner, keeping "T" in place. Put on newsprint.)

3. Keep tympan angled and not touching paper, push stone under scraper bar, engage pressure to clamp down tympan (keep holding up).

4. (This part gets tricky without a power press.) Now the sponger must hold the push bar so it slides as stone goes forward. The trick here is to be sure the paper is under the scraper bar before you grasp the push bar. Let the press pull the stone and paper away from the bar as the press cranks. If the press is hand operated, a dextrous sponger must hold both the tympan and the bar. The trailing end of the paper gradually drops onto the printing element as the push bar is moved and the tympan, newsprint, and printing paper sandwich is gradually pressed under the moving scraper bar.

Making Deletions

It is during proofing that most deletions are made on a lithographic image.

On plates, use commercial image remover (see supply list, Chapter Thirteen). Apply the image remover to those areas you want to correct. Then sponge deletion and remover off, wiping away from the image so other drawn areas are not weakened by the image remover on the sponge. Q-tips are invaluable aids in picking up small parts of the image.

On stones, use a snakestone slip or honing stick or the side of a knife to remove any unwanted areas

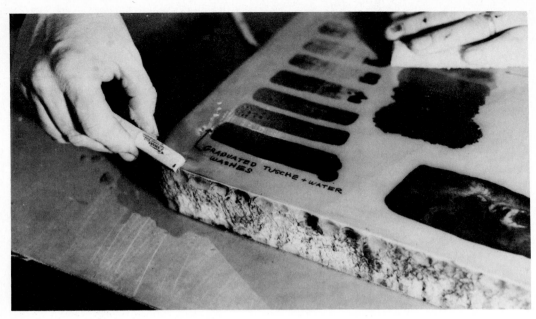

Figure 11.3
Photo by Mace Wenniger.

A honing stick is used to remove ink from the edge of a stone. It can also be used to delete passages within the image. Be sure to apply a light etch to the deleted area on the stone to make erasure permanent.

of a drawing; work gently at a dampened image, scraping or burnishing all extra marks away.

To make sure the marks stay deleted, spot etch the sites on the plate or stone before inking them again. On the plate, use a solution of 2 parts gum to 1 part Pro Sol., or use 1 part TAPEM to 1 part gum.

Making Corrections

You might find that a drawing is good except for one awkward part which must be corrected. First, use deletion procedures as described above, and then follow the counteretch procedures outlined below before adding new elements to a drawing.

COUNTERETCHING

Counteretching is the sensitizing process whereby a stone or plate is made chemically receptive to greasy drawing materials. To counteretch, use mild acid diluted in water, and work it with a brush for a few minutes on the dry lithographic base.

A distinction should be made between counteretching metal plates before drawing and counteretching an etched image on plates or stones so that new imagery can be added. Counteretching of both plates and stones after the image is etched removes the desensitizing gum film from all or selected areas on the base and renders the element or base newly sensitive to grease.

Prior to counteretching, the image is gummed, washed out, and rolled up in black ink, then talced in the case of a plate, or rosined and then talced in the case of a stone. You can use the counteretch as follows:

1. To add more marks to all or part of an image; to rework it to make it more satisfactory to you.
2. To remove parts of an image and add new material to it.
3. To reuse the same stone or plate for different colors in a color lithograph.

Counteretch Solutions

Traditionally there have been different counteretch solutions for plates and for stones but today there is a commercial counteretch available, Citric counteretch (C-etch), which works on both lithographic plates and stones. All counteretch solutions should be stored in plastic bottles with plastic lids, since they contain acid that corrodes metal bottle caps. Keep fairly large quantities of counteretch solution on hand to desensitize plates and stones. Suggested solutions are as follows:

Citric counteretch solution: use on both aluminum and zinc plates (sparingly on zinc) and on stone. Put lacquer base on image first. Apply citric C-etch with a small C-etch sponge and scrub element. Don't be shy. Your base and image are tougher than you think.

161

ALUMINUM PLATE COUNTERETCH SOLUTION
- 2 ounces hydrochloric acid
- 2 ounces phosphoric acid
- 1 gallon water

ZINC PLATE COUNTERETCH SOLUTION
- ½ ounce nitric acid
- 1 ounce potassium alum
- 2 cups water

STONE COUNTERETCH SOLUTION
- 1 cup glacial acetic acid
- 4 tablespoons potassium alum
- 1 gallon water

Counteretch Procedure

1. Before applying counteretch solution (an acid) to your image on a litho base, it is necessary to wash out your image with turps, rub it up with diluted ink, and roll it up with black ink, to protect the image during the counteretch procedure.

2. Apply talc or a combination of rosin and talc (in the case of stone) to the inked stone or plate. This allows the counteretch to work in closer to each grease-laden particle since talc absorbs the surface oil of the ink.

3. If you want to add new drawing to an image as well as to delete part of the old image, you must remove some or all of the existing image prior to counteretching. Remove the image on a plate with turpentine or lacquer thinner; remove the existing image on a stone by scraping it or using carborundum on it.

4. To counteract possible image loss during counteretching, put the remaining image into a lacquer base, first, removing image with solvent, then applying lacquer base and rolling up image again with black ink.

5. Apply the counteretch solution with a soft paintbrush, or a small, soft sponge adding more solution continually and working the counteretch for two minutes. Rinse off the solution with water, and fan the stone or plate dry immediately so oxidation does not occur.

Figure 11.4a
Photo by Mace Wenniger.

Part of the image will be removed with carborundum, leaving enough of the drawing on the stone to work into the next image. Mackie uses #240 carborundum powder to hand-grain some of the image from the stone, thus producing a rough grain that will keep the hillocks fairly distinct and ready for a #2 litho pencil. Using a finer carborundum would create a fine grain on the stone, leaving the hillocks closer together, and would necessitate use of a harder pencil for drawing.

Charcoal worked into the carborundum acts as a soft pressure, removing only parts of the image. Keep the carborundum wet while working. Watchful control is needed when removing one area while leaving traces of its position.

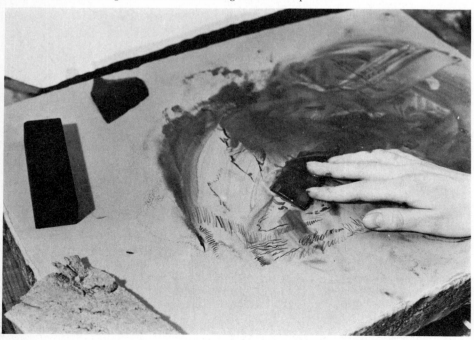

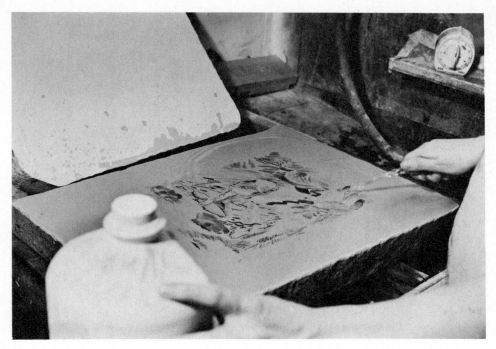

Figure 11.4b
Photo by Mace Wenniger.

Lisa Mackie floods the stone with water and then floats some of the counteretch solution of 4 tablespoons potassium alum to 1 gallon water into the water, moving it on the stone with a sponge for *two minutes*. This solution reacts with the gum arabic, which removes it from the stone, and thus resensitizes the stone. Wash the solution off, dry, and talc. Repeat the counteretch procedure, including drying, two more times with the same solution. Be sure to time each counteretching procedure, allowing a full two minutes for each application. It is necessary to dry and retalc the image each time before the counteretch is worked on the stone.

6. To be sure the plate or stone has been completely resensitized, you should counteretch three times. The plate or stone should be completely dry each time the solution is applied, because the counteretch will affect a dry surface more markedly. It is important to apply talc over the image first, before the counteretch solution is applied (or rosin then talc on stone) and buff the surface each time to make the counteretch application as effective as possible. If you want to make spot corrections, you can apply the counteretch solution to selected areas with care, let them dry, and redraw parts of the image.

7. Once you have finished counteretching, you can draw on the stone or plate as on a fresh surface. Let the stone or plate rest and dry out for at least 20 minutes first. Now draw with slightly greasier drawing materials, such as a #2 pencil or crayon, because lithographic surfaces are not as readily receptive to grease after counteretching.

8. When an image has been drawn on a counteretched stone or plate, it is easily lifted off by the etching process. A gentle etch is recommended: 2 drops of nitric acid to 1 ounce of gum for a stone, or 3 parts gum to 1 part Pro Sol for plates, or a little lighter etch than usual is a good approach.

9. Finally, put a coat of pure gum over the whole surface of the stone or plate, and buff it with cheesecloth before proceeding to the rub up, roll up, and printing processes.

Counteretch in Color Lithography

A single plate or stone can be reused repeatedly to print the various color elements of an image if some or all of the image is removed from the litho base and the surface of plate or stone is counteretched to receive more drawing. This procedure is called the additive-subtractive method. (See Chapter Seven, Working in Color.)

THE ADDITIVE-SUBTRACTIVE METHOD

Using the counteretch procedure, you can incorporate parts of the first, or key, image in succeeding images made on the same plate or stone.

In other words, new marks are integrated with the old marks left on the stone or plate—the additive process—after other marks, or parts of the image

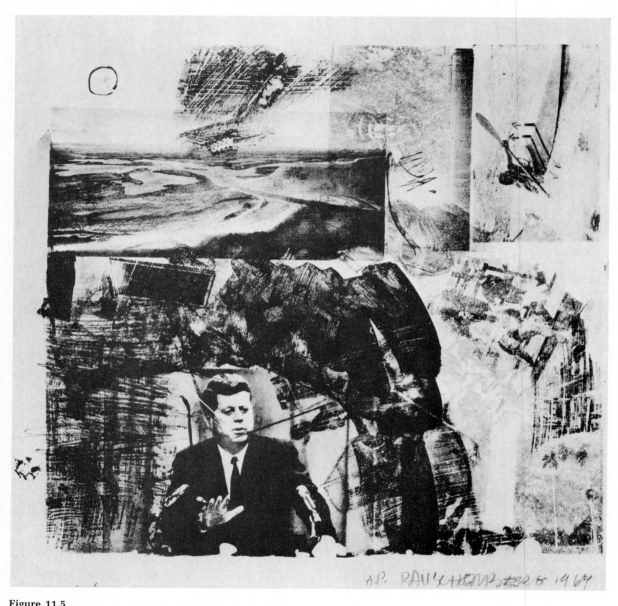

Figure 11.5
Photo by J. Burckhardt, courtesy of Brooke Alexander, Inc.

Robert Rauschenberg's *Ark* incorporates many deletions and scrapings before incorporating photographic transfer techniques.

have been eliminated—the subtractive process—honing them off the litho base. On a plate, parts of an image are simply dissolved with solvents, including lacquer thinner if a lacquer base has been used.

After counteretching what is left on the stone or plate, new marks are added, and this new imagery is processed and printed in a new color. It is the pile-up or the layering of the new marks in different colors that builds a completed image. Each color, however, must be printed in a full edition before new material can be added and printed.

To use an aluminum plate in an additive-subtractive method, follow these counteretching and deleting procedures: Print an edition in the first color; then remove part or all of the inked image with solvents; with lacquer thinner, remove lacquer base (if used), except that which is on the parts of the drawing that will be incorporated in the new image. Wash the plate with water; use a drying flag or hair dryer to dry the plate thoroughly; work counteretch solution for aluminum plates on the surface; wash off with water and dry.

If all or part of the key image is dissolved with turpentine, the ghost of the first image will remain and will serve as a guide for the new drawing. The plate is counteretched with the formula given earlier, and a new drawing is made, processed and printed. In *Old Friends*, as discussed in Chapter Seven (Additive-Subtractive Method), I used the same plate six times; each use added and subtracted more details in other colors.

If you are working on a stone and want to use the original image as the key image, the procedure is similar. Roll up in black ink, then counteretch which will reopen the stone for the addition of new marks. To remove parts of the original image, you must grain out parts of the image from the stone with carborundum. After the first graining, parts of the original image will remain. Counteretch and add marks to this and print a new color. For each successive color, roll up your new image in black ink and remove parts of it before counteretching, redrawing, and printing.

Counteretching thus can become an important part of the process for making a color lithograph. Using this method you will not have to prepare a new plate or stone or make new registration marks. This can be a relief for the artist doing a multicolor lithograph for the first time. The only limitation is that each color must be printed in a complete edition before the image can be deleted from the plate or stone and a new image can be created, processed, and printed in a new color.

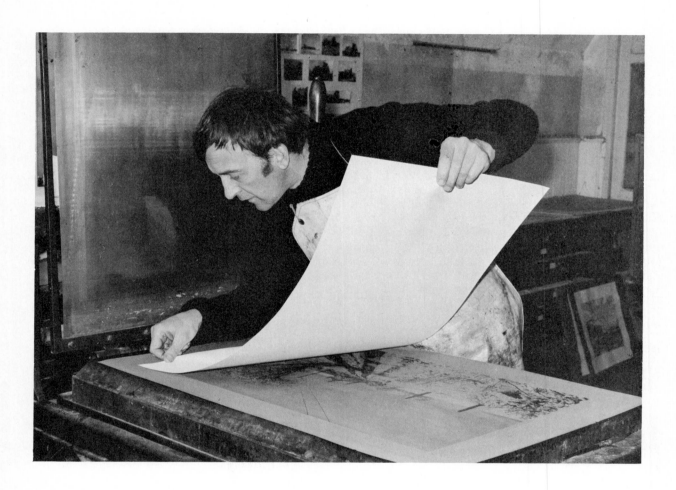

Learning to be a professional lithographer is much like learning to be a ballet dancer. It usually takes five to eight years of constant effort to achieve success. Every print, whether great or not, can teach you a lot. I caught on to the medium through my failures. They made me stop and puzzle out the technical and aesthetic aspects of the medium. What makes a good color lithograph work? Why is gum so necessary on plate or stone that an image can be lost without it? Learning the answer to these questions will help you master lithography.

So take your first lithographs seriously. Treat each print with the thought and attention it deserves; study it and learn from it; exhibit and store it carefully afterwards.

EDITIONING YOUR PRINTS

Proofing Trial Proofs

The process of initially printing an image is called *proofing*. The first prints you pull are called *trial* proofs. When you decide that one particular type of inking suits your intention, it is time to print the image in multiples, or in an edition, which can be either in black ink or in color.

The number of prints you want to make is the size of your edition, but you do not necessarily have to print all of them at the same time. You can reserve the plate or stone and print at a later date unless, of course, the image is removed from the stone.

CHAPTER TWELVE

Your finished prints

Each print is given a number in the edition such as 5/50 or 6/50. Keep track of the number of prints in an edition; if it is not completely printed, you can begin numbering again at a later date. Keep numbering records and ink formulas for each print in a ledger in your studio.

Artist Proofs

Artist proofs are outside the numbered edition, but equal to if not superior in quality to the prints in the numbered edition. From 10 to 20 percent of the edition, in excess of the edition, can be put aside as artist's proofs. These are generally the best of the run. English lithographer George Guest calls his artist proofs "the cream of the crop."

Editioning in Color

The key to lithography at this point is balancing your creative impulse with the mechanical adjustments involved in editioning.

Your first goal when editioning in color is to keep a consistency of printing throughout the edition. However, realize there will be subtle changes in the prints when you are doing hand lithography, which involve slight variations in the amount of ink, as will pressure and direction of rollers, which often cause changes from print to print.

Your second goal is economy of means. When edition printing in color, realize that a small percentage of the total edition will be lost with each new

Figure 12.1
Photo by Mace Wenniger.

Trial proofs are usually laid out in order of printing. The first proofs become gradually darker as the image accepts more ink after passage through the press.

color introduced because of incorrect color or value choices, errors in registration, or changes in the image.

If you plan to do a color lithograph, plan an edition large enough to allow for the loss of 10 percent with each new color. In other words, you might have to print one hundred prints initially to end up with an edition of fifty.

In terms of economy, this means that you must think carefully about making an edition of many colors. Begin by making color prints with only two or three colors that must be blended and adjusted in order to work with each other.

Size of Edition

If an image seems to be working out splendidly when you are pulling proofs, increase the number of the edition, so you will end up with a winner and a money earner in the end. Try to use a minimum number of colors with maximum overprinting possibilities.

SIGNING AND NUMBERING PRINTS

After editioning, when the prints are dry, they are signed and numbered in pencil by the artist. Traditionally, all the prints in an edition were made to be as consistent and identical as possible, but this philosophy is currently being disputed by artists and curators alike who now tend to value editions of dissimilar prints with a hand-manipulated look, rather than the mechanical uniformity that we emulated during the early stages of printmaking.

Edition prints are traditionally signed in the following manner:

Just under the bottom edge of the image the title of the print is written on the left, followed by the edition number in the center, and the artist's signature is signed modestly in pencil on the right with "imp." after it to signify that the artist printed the image. However, the location of the title, number and signature is at the discretion of the artist. Some even sign on the back of the print.

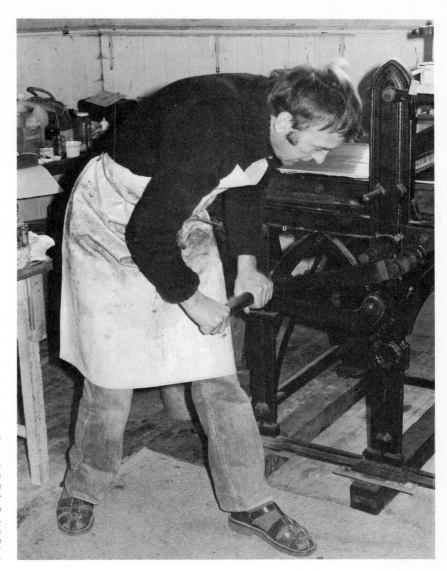

Figure 12.2
Courtesy George Guest. Photo by Charles Robarts.

George Guest pushes the hand crank on his ancient but beloved litho press. This slowly passes the press bed under the stationary scraper bar which will transfer the inked image from plate onto the printing paper. Most modern lithographic presses are operated electrically by pressing a button on the left side of the press.

The method generally used to sign prints is to spread them out on a table, count them so you have an edition number (not including the artist's proofs), and then sign accordingly 1/10, 2/10, and so on.

This edition number is expressed as a fraction, with the right hand number representing the total number of prints in the edition and the left hand number representing the place of this particular print in the total edition.

Each print will be given a number as part of an edition. Even if there are only two prints, these are not artist's proofs; they can be designated 1/2 or 2/2 or just trial proof #1 and trial proof #2 (t. p. 1, t. p. 2).

Significations of Prints

Artist's proofs are indicated as such in place of an edition number. Generally the best of the edition, they usually numbr ten to twenty percent of the total edition, but they are not taken from the edition. They are in excess of the edition. Most printmakers number artist's proofs as well as the prints in their edition. It is customary to use Roman numerals to signify them: the total number of artist's proofs on the right and the number of this particular artist's proof out of that total on the left, for example, IV/XX.

Variation proofs, or v.p.'s, are irregular but interesting prints. These should be numbered.

Bon a Tirer (B.A.T.) prints are the first perfect impressions or proofs printed by a workshop on good paper, after which the artist gives approval to print the edition using the B.A.T. as a qualitative guide.

Proofs, working proofs, state proofs, and trial proofs are all imperfect prints made while working toward the final image. These are usually numbered, such as trial proof #1 or #2.

State proof is the alteration of an editioned image to create a new related image. When printed the new image is called a "state print."

Trial proofs are pulled during proofing usually in a single color such as black. On these the artist also tries out new colors or procedures such as a blended roll, etc.

Trial proofs are inking variants usually made on the way to deciding how to print the edition.

Working proof is a proof that the artist has drawn, painted or collaged upon; it is a study proof used during printing to help make changes.

States are different editions, usually quite small, pulled from one initial image on a stone or plate, with changes made in the image from edition to edition. Prints in the first edition are marked as 1/10 State 1 and so on.

RECORD KEEPING

A record book or file of your prints should be started. Each new lithograph should be recorded, with date of printing, ink mixtures, and number of passes used. Each print should be kept track of by number, with gallery location, the dates the work was sent out and returned, and any other relevant transactions recorded clearly.

STORAGE OF PRINTS

Put your prints away tenderly. Examine each one for mistakes. Ink smears in the margins can be erased carefully with a nongreasy eraser or even with a fine sandpaper, if the printing paper is not soft. My favorite litho paper, Italia, comes apart when erased so be careful when correcting or erasing. Arches Buff, on the other hand, does stand up well under corrections. Experiment with this.

There might also be small imperfections in inking which can be corrected by adding some ink with a toothpick or pen point.

Store each print flat. Cover it with a piece of tissue or with thin transparent sheets of glassine, a paper resembling onionskin typing paper. You can construct a simple structure of vertical two-by-fours and inexpensive foam core board shelves to hold the prints.

A set of the thin flat drawers known as *map files* can be useful storage furniture for your prints. They come in sets of three or five drawers.

EXHIBITING

One thing that keeps artists working is the sense that they are reaching people, communicating. Try to get feedback from some kind of an audience as soon as you can. I suggest that you try exhibiting your lithograph in your college or community art center. The enthusiasm and curiosity of your peers will prod you to do more lithographs. If you win a prize, it belongs on your résumé, which should be available.

MARKETING

There are two ideas that I believe to be imperative if you plan to enter the marketplace with your work. To be considered professional, treat your work professionally and treat the art dealers professionally; in other words, respect your work and respect the art world. Do not treat either casually. The following are a few ideas that might help you plan your strategy.

WORK PRESENTATION/WORKING WITH GALLERIES

1. Make an appointment to see the gallery owner or a delegate. Recommended procedure: Write a letter to the gallery. Enclose a résumé or biography, a few good slides, and a stamped, self-addressed envelope so they will be returned to you. Follow up with a phone call to try to make an appointment.

2. Bring professionally presented work, that is, backed, matted, and covered with acetate (not the stiff kind that cracks in a week) or shrink-packed (the tight plastic covering that is used over record jackets).

3. Be interested in the gallery. Get to know the philosophy of the gallery and the owner's attitude toward printmakers and other artists.

4. Volunteer to help out in the gallery in some way. I have appreciated it when new artists have volunteered to do a small arrangement of their work on a wall.

5. Charge reasonable prices so your work will sell. This helps you establish your name in the marketplace. A handy way to figure out what you should charge is to realize that a master printer gets paid for every half plate printed and so much for whole plate. Double these prices at least.

6. Put a printed write-up about yourself and your work on the back of each of your prints. This will help sell each piece. It might simply give your name, address, gallery affiliations, prizes, and something about your subject matter and medium.

7. You might also consider copyrighting your work. At present just putting the copyright sight (a "c" within a circle) on your print is sufficient notice that it is copyrighted and your work is protected for a number of years with just that notice. Placement is usually next to the signature. For further information write the Library of Congress, Washington, D.C.

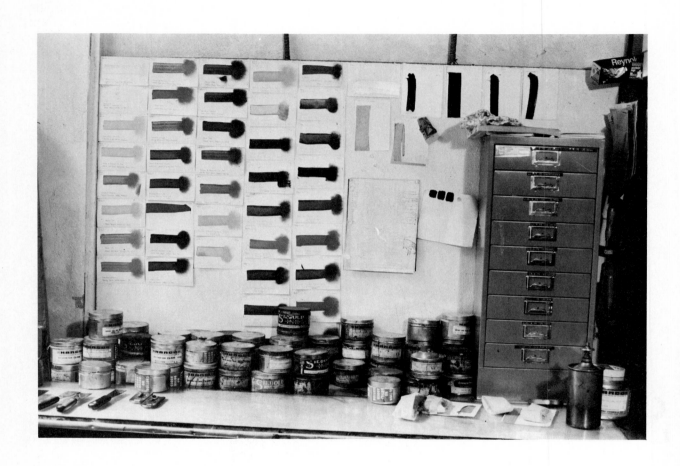

Lithographic supplies include materials which must be replaced periodically, such as lithographic drawing materials, printing papers, and processing materials, and equipment that represents a more permanent investment, such as a press, tympan, scraper bars, and rollers. The latter can be purchased either individually or jointly with other printmakers. Your lithographic base—a base of either plate or stone—is in a category of its own; it is a semi-permanent acquisition but will be considered here as a permanent purchase.

Assembling the supplies necessary to do lithography in your own studio is an area of real concern for the independent printmaker. Most of my lithographic supplies were acquired by mail order from sources listed below. This chapter begins with names of some general sources who have most lithographic supplies and will mail you the material. Then it lists the supplies you will need in every phase of making a lithograph, designating suppliers who have been found to be reliable sources for particular products. I have found that these suppliers all send orders promptly and answer questions readily. You will also learn how to set up your own lithographic workshop where you can draw, process, and print your lithographs.

CHAPTER THIRTEEN

Supply directory

GENERAL SOURCES

These art supply houses will readily send catalogues. You will be able to order some or all lithographic chemicals and materials from them:

Graphic Chemical and Ink Company
P.O. Box 27
or 728 North Yale Avenue
Villa Park, Illinois 60181

Rembrandt Graphic Arts Company, Inc.
Rosemont, New Jersey 08556

New York Central Supply Company
62 Third Avenue
New York, New York 10003

Sam Flax, Inc.
25 East 28th Street
New York, New York 10016

Daniel Smith Ink Company
111 West Nickerson Street
Seattle, Washington 98119

Roberts and Porter
26-25 123rd Street
Flushing, New York 11354

Sinclair and Valentine
14930 Marquardt Avenue
Sante Fe, California 90670

Lith Kem Corporation
4-6 Harriet Place
Lynbrook, New York 11563

Polychrome Corporation
155 Avenue of the Americas
New York, New York 10013

Charles Brand Machinery
84 East 10th Street
New York, New York 10003

Davis David
539 LaGuardia Place
New York, New York 10012

Pearl Paint
308 Canal Street
New York, New York 10013

H.A. Mitzger Inc.
157 Chambers Street
New York, New York 10007

Andrews, Nelson, and Whitehead
31-10 48th Avenue
Long Island City, New York 11101

Printmakers Machine Company
724 N. Yale
P.O. Box 71N
Villa Park, Illinois 60180
(312) 832-4888

Crestwood Paper Company
Division of Willman Paper Company
315 Hudson Street
New York, New York 10013
(212) 989-2700

PERMANENT LITHOGRAPHIC EQUIPMENT

A lithographic workshop must include the following permanent equipment: tables, a storage area, a sink arrangement, a lithographic etching or offset press, scraper bars, tympan, and a printing roller.

WORKSHOP EQUIPMENT

Processing and printing lithographs involves working on a flat table with good light and adequate ventilation, within reach of water, near a press, with someplace to lay out or hang up finished prints.

TABLES AND STOOLS

You will need strong tables with firm support and a comfortable working height. Plate glass or plexiglass placed on a portable box or a countertop will work well as an ink rolling slab. Reserve a separate piece of glass or a lithographic stone for mixing inks.

Figure 13.1
Drawing by Mace Wenniger.

Schematic drawing of an ideal lithographic workshop.

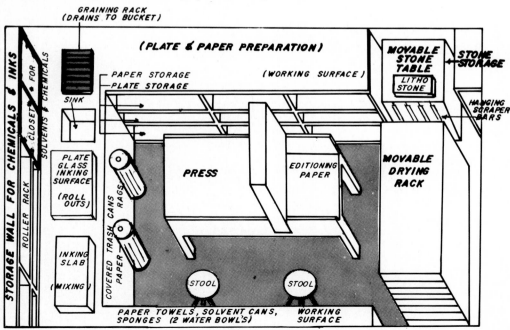

STORAGE

You will also need an arrangement for storing stones and plates. Drawers or narrow shelves to store both prints in progress and finished prints are also mandatory. Shelves or plywood sheeting lying on revolving dowels provide a good method of storing paper.

SINK

A sink arrangement is important for graining, counter-etching, and washing away chemicals and carborundum, even if the water is transported in buckets. An installed sink can be utilized as a graining sink by building a shelf of slats or rungs in an open design above the basin.

PRESSES

Lithographic Press. The lithographic press, which can be used with either plate or stone, is a fairly simple structure composed of a bed or horizontal surface made of steel or benelux mounted on a movable roller beneath the bed.

A tympan made of one-eighth-inch thick plastic, G10 epoxy, or pressed board covers the press bed. A manually or electrically operated roller sends the press bed back and forth under the scraper bar, which scrapes along the well-greased tympan and slowly presses down on the tympan, blotter, printing paper, and inked plate or stone. In this fashion the image is transferred from the inked plate or stone onto the printing paper.

Above the press bed, and holding the scraper bar, is the horizontal metal bridge built to hold the press together as a unit and to hold the central screw mechanism that moves the scraper bar up and down over the printing sandwich on the press bed. There is also a press handle on the side of the press, which, when pulled down, puts the scraper bar into tight contact with the tympan on the press bed below.

Convertible Press. The convertible press is a combination etching and lithographic press, which permits you to use either a plate or stone. It has a bridge made with two release screws that enables it to be switched from carrying an etching roller to holding a lithographic scraper. This press, which I have worked with for some time, opens new possibilities to the printmaker who enjoys working in several mediums and learning how to combine them effectively.

Flat Bed Direct Transfer Presses. These can be purchased from printing houses, where they often are stored away as obsolete equipment. They are usually inexpensive to purchase and easy to convert into lithographic presses.

Offset Presses. Available in most small town print shops, these can be used by lithographers working on an aluminum plate. On this press, the lithographic plate is attached to the press bed. After the image is inked, it is offset onto the rubber-covered roller from which it prints onto the printing paper. One advantage of this press is that the image on the plate does not need to be reversed. Since it

Figure 13.2
Photo by Mace Wenniger.

This is a lithographic press. A manually or electrically operated roller under the press bed sends the press bed back and forth under the scraper bar, which scrapes along on the well-greased tympan, the plastic sheet which covers the printing sandwich, as a plate or stone and printing paper is called, and slowly presses down on the tympan, blotter, printing paper, and lithographic base. As a result, the image is transferred from inked plate or stone onto the printing paper. Note parts of the press: Above the press bed, and holding the scraper bar, is the horizontal metal bridge built to hold the press together as a unit and hold the central screw mechanism that moves the scraper bar up and down over the printing sandwich on the press bed. There is also a press handle on the side of the press which, when pulled down, puts the scraper bar into tight contact with the tympan on the press bed below.

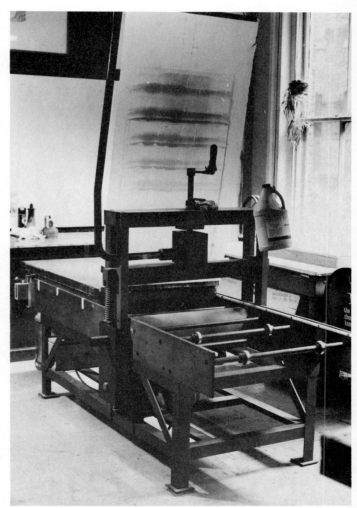

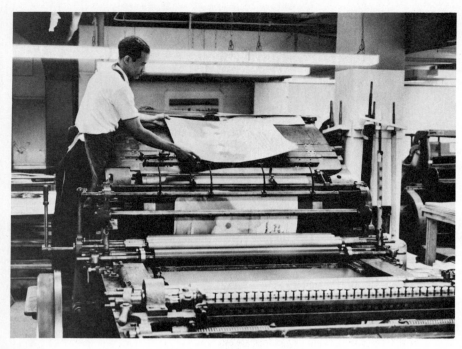

Figure 13.3 label appears at right below the image.

Figure 13.3

goes through an intermediate step before it prints, it can be drawn as it will be printed. The disadvantage is that a skilled press operator must work the press for you.

Etching Press. Etching presses can also be used but do not produce optimum results. This press has a roller that slowly revolves over a felt blanket covering the printing sandwich of printing paper, inked plate, and horizontal press bed. This press will print a well-inked lithographic image.

PRESS EQUIPMENT

Scraper Bar. This is a rectangular block of wood, Teflon, or benelux, beveled to a narrow edge on the bottom. It is covered with a narrow leather or Teflon strip, which is covered with grease or vaseline during printing. The grease must be cleaned off the scraper bar after each printing session; otherwise grit and dust accumulate on the scraper between use. Such grit often creates mysterious lines and indenta-

Figure 13.4a
Photo by Mace Wenniger.

Maintenance of the scraper bar: Lubricating grease must be spread on the leather or Teflon scraping strip before printing.

Figure 13.4b
Photo by Mace Wenniger.

When the leather strip on the scraper bar starts to stretch, tighten it by removing it, drilling a new hole, pulling it against the bar with pliers, and refastening it to the bar with a screw.

Figure 13.4c

Recommended way to store scraper bars: Attach screws on ends of scraper bars to facilitate hanging storage; the leather strip on the edge of the bar must have tympan grease removed after each use to prevent any indentations on future printed images made by any clinging dirt particles pressing into the tympan surface.

tions on the tympan during printing. The size of the stone or plate determines the size of the scraper bar to be used, so a number of scraper bars are required. The scraper bar should be slightly smaller than the stone or plate but wider than the image.

Tympan. This is the stiff sheet placed between the scraper bar G-10 epoxy and the printing paper. It is usually made of thin plastic, pressed board, or Mylar and must be soft enough to bend, since it not only facilitates the movement of the scraper bar but cushions its action.

Sheet of Rubber, Plastic or Battleship Linoleum. A flat sheet, cut to the size of the press bed, acts as a cushion for the pressure of the press upon the stone or plate during printing. If you do not have a horizontal storage place for the linoleum sheet, I recommend gluing it to a masonite backing board, as the linoleum sheet will crack and deteriorate quickly if stored vertically. Phenolic resin slab, two inches thick, cut to press bed size, absorbs pressure. Use with both plate and stone. (Takach-Garfield Press has an absorbent pressure-receiving layer between the steel facing and the metal bed.)

177

Figure 13.5
Photo by Mace Wenniger.

This is a tympan, a flat, one-eight-inch plastic or pressed board sheet which covers the press bed during printing. Notice the pulley arrangement which facilitates its operation. The tympan is attached to the bed of the press by means of piano hinges.

Grinding Stone and Levigator. A grinding stone and levigator (a circular grinder with an eight-inch rotating head) are used with sand or carborundum and water for cleaning and graining a stone lithographic base.

Press Sources

Charles Brand Press
Charles Brand Machinery Company
84 East 10th Street
New York, New York 10003
(212) 473-3661

All steel heavy duty press. Steel bed heavyweight presses sized (maximum sheet size), from 20″ × 38″ to 36″ × 52″ and priced from $4,740 to $8,629. Hand-operated only with gear ratio of twenty to one which makes it easy to operate. Button clutch to engage and disengage bed drive. Press handle on right side.

Takach-Garfield Press Company, Inc.
3207 Morningside, N.E.
Albuquerque, New Mexico 87110

Hardwood laminated press bed, sizes 26″ × 48″, 34″ × 60″, or 40″ × 72″, 188 wall steel tubing construction, fixed bed stops, hand or electrically driven. Prices from $4,250 to $6,850.

Rembrandt Graphic Arts Company, Inc.

Lithographic Pelican Press. Table- or bench-mounted, hand-operated press with steel bed covered with ⅛″ battle-ship linoleum, medium size, 22″ × 36″. Scraper bar lowers to bed of the press, which facilitates printing litho plates without raising them on a stone. Steel bases available. Price approximately $1,750.

Lithographic Elephant Press. Strong floor model press, 26″ × 50″ or 30″ × 50″ hand-operated steel beds covered with ¼″ or ⅛″ battleship linoleum—prices from $3,300 to $3,850.

Wapplo Press
8412 Heg Drive
Bloomington, Minnesota
Attn: Donald Benson
(612) 881-0982

Hardwood (maple) laminated cross bolted press bed made for no warpage, sealed, covered with acid resistant, non-skid neoprene plastic. Manual or motorized, 26″ × 36″ to 40″ × 60″. Priced from $3,800 to $7,200. Hydraulic presses also available.

Charles Wright
Grand Junction, Michigan 49056

Wright Combination Press. Hand-operated or motorized press with benelex bed can be converted to intaglio press by taking scraper bar out of horizontal casing and replacing it with steel roller. Priced from $1,800.

Suppliers of Press Beds and Slabs

Benelex Press Bed. A pressed Masonite product. A dense lignum resin cellulose laminate that

Figure 13.6
Photo by Mace Wenniger.

The graining procedure takes place in a graining sink built as pictured with metal piping or wooden slats across wooden or soapstone tub, which permits free turning and draining of stones and plates during graining and etching procedures. Be sure to create a separate draining facility under your graining sink in order to dispose of used carborundum; a six-inch pipe hanging over a bucket works adequately.

Figure 13.7

Metal storage cabinet for stones and plates: Rollers on the shelves make it easy to pull out each stone or plate, which should be stored flat or on its sides in slats. A wooden storage cabinet with deep wooden shelves will also work. Note how a grained litho stone is stored covered with a tight lid made of fitted newsprint.

offers high strength to mechanical applications. The usual size is 48″ × 72″. Available from ¼ to 2″ thick.

SUPPLIER
Masonite Corporation
Laurel, Mississippi 39440

Phenolic Slab for Press Bed. Advantage is that it does not warp. Three types of phenolic are available, glass, paper, or fabric base. Order G-10 epoxy-glass based phenolic in sheet form, 2″ thick. Order both benelex and phenolic from:

Insul Fab Plastics, Inc.
69 Grove Street
Watertown, Massachusetts 02172
(617) 923-9800

Linoleum Slab for Press Bed. Battleship linoleum acts as a pressure absorber. I glued a large sheet of battleship linoleum to a sheet of ¼″ Masonite to prevent cracking when stored after use.

Tympans

MYLAR SUPPLIERS
Takach-Garfield Press Company, Inc.
3207 Morningside, N.E.
Albuquerque, New Mexico 87110

Commercial Plastic and Supply Corporation
630 Broadway
New York, New York 10012

G-10 EPOXY SUPPLIER
Insul Fab Plastics, Inc.
69 Grove Street
Watertown, Massachusetts 02172
(617) 923-9800

Polypropylene. Type M tympan system consists of a roller attached to the scraper box, a sheet of polypropylene, a counterweight, and pulleys. The greased polypropylene sheet is attached to the end of the bed and is stretched under the scraper bar. It then passes over the roller and is pulled up out of the way by a rope passing over the pulleys and fastened to the counterweight. Sells for around $150.

SUPPLIER
Rembrandt Graphic Arts Company, Inc.
(See General Suppliers.)

Plastic. Cut out of film positives. Standard size 24″ × 36″, but larger sizes available. Shipped rolled.

SUPPLIER
Graphic Chemical and Ink Company
(See General Suppliers.)

Printing Rollers

The printing rollers used for lithography are made of leather, hard rubber, or fibrous rubber.

LEATHER ROLLERS
Grained leather rollers are used for printing with black ink. They are generally 3″ to 4″ thick and 12″ to 20″ long. They are made of tanned calfskin that has been stretched, nap side out, over a felt inner sleeve rolled around a wooden core.

The nap on the leather roller is important and must be kept open throughout the roller's life.

The advantage of leather rollers is that the soft nap of leather (like suede shoes) allows the ink to be pushed into the ground surface of the stone or plate and plucks excess ink out on the return motion, which prevents filling or thickening of the image. A smooth hard roller touches only the surface of the grain, sometimes giving a starved look to the image, especially in crayon drawings. To preserve this nap, the ink must be scraped off, and the nap must be brushed up after each use.

A leather roller is made of natural material and should be cleaned and maintained only with organic products that will feed it and preserve it.

A new grained leather roller must be broken in before use to bring up the nap and to remove any excess nap which might come off during inking. Leather rollers can be ordered broken in from Graphic Chemical Company for a minimal charge, but you can condition one yourself, using the following procedure:

CONDITIONING OF A LEATHER ROLLER
1. Sand roller with fine sandpaper until extra nap is removed.
2. Cover the new roller with mutton tallow (Graphic Chemical Company), which acts as a waterproof barrier, feeds the leather, and prevents it from becoming water-sodden and therefore incapable of picking up ink properly. Warm the tallow; rub it into the roller.
3. Roll in #00 varnish for five minutes for several days or until saturated. In between treatments store the roller in waxed paper and foil.
4. Scrape against the grain with a long, flexible spatula. To do this, determine the direction in which the nap lies; this is called the grain of the leather. Using a dull table knife, scrape the leather until you discover which way raises the nap. This is called *scraping against the grain* and is done on a new roller to remove loose nap.
5. Roll in #8 varnish to remove extra nap. Repeat for several days.
6. Scrape the roller.

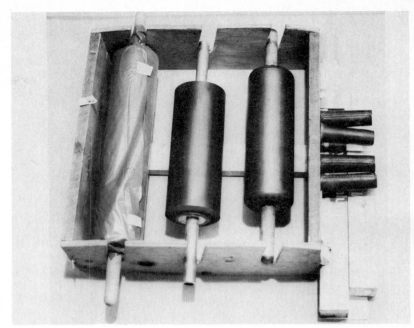

Figure 13.8
Photo by Mace Wenniger.

Storage arrangement for leather and rubber rollers. They should always be kept in a special rack or a "cradle" to prevent distortion of their surfaces.

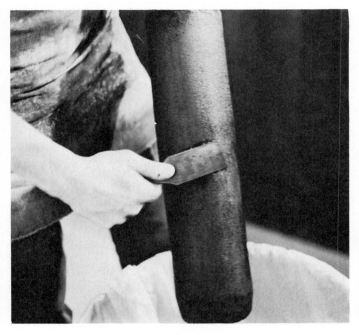

Figure 13.9
Photo by Mace Wenniger.

Care of leather roller: After each use, roll the roller on a slab until all excess ink is removed, then repeatedly scrape against nap as pictured, cleaning scraper in between strokes. Finish by scraping with nap.

7. Roll in black roll up ink daily until the roller is in normal condition. Scrape in both directions on all sides to remove excess nap and bring up the residual nap to a velvety appearance. Daily scraping of the roller is done by first scraping against the grain on all sides of the roller in order to remove the nap. Finish by scraping with the grain so that the nap lies flat and smooth. Mark the handles of the roller to indicate which way is against the grain. The roller is now ready for use in printing and proofing. Wrap it for storage in waxed paper covered with tin foil.

Storage of Leather Rollers. For long storage, scrape the roller, coat it with tallow or vaseline, and wrap it as described above. To get it ready for use again, remove the tallow with solvent and suede brush, scraping in both directions.

Reconditioning Leather Rollers. Remove hardened ink on rollers with paint remover and alcohol and recondition it with tallow. Phenol or carbolic acid can also be used to remove hardened paint on a leather roller.

After a leather roller is in use, it is important to maintain the nap by scraping it after each printing

session. It also is important to roll up in black ink and scrape a new leather roller daily.

Be careful to avoid scraping over the seam of the leather, because repeated scraping of the seam makes it stand out, which creates a line when printing.

KU ROLLERS

Made with an aluminum core and a 40 durometer fibrous rubber covering, these are used for printing with colored inks. Their advantage is that they act like leather rollers in that they push ink into the grained surface of the litho base, but they can be cleaned completely like a rubber roller between inkings. They are the same size as leather rollers and are sold by Graphic Chemical Company and Rembrandt Graphic Arts under the name of KU rollers.

LARGE RUBBER ROLLERS

Standard rubber rollers come 12″ to 18″, with a 4½″ diameter, and in 20, 30, or 40 durometer. Rubber rollers are used for printing with colored inks. They can be obtained in larger diameters than leather and simulated-leather rollers. Use of the large rollers makes it possible to print large plates without having

roller marks show on the inked surface. Graphic Chemical makes rubber rollers. Clean rubber rollers with turpentine or mineral spirits.

SMALL RUBBER ROLLERS

Rubber inking brayers in assorted sizes—1½″, 2 ½″, 4″, 6″ (with 1″ diameters)—are useful when working in different colors on separate areas of a color lithograph.

Roller Suppliers

Leather rollers can be ordered in sizes from 12 inches to 20 inches or longer. Rubber rollers are available in a variety of sizes from 1 to 24 inches. They range in price from $35 for a used rubber roller to $390.

LEATHER ROLLER SUPPLIERS
Graphic Chemical and Ink Company

Rembrandt Graphic Arts

Roberts and Porter Chemical Company
26-25 123rd Street
Flushing, New York 11354

Figure 13.10

Leather roller and rubber rollers large and small, enough for starting to print your own work. Pictured are inks to start with: two black inks (roll up and editioning inks) and a half-dozen colored inks that can be mixed to make additional colors. Note the can full of inexpensive putty knives, used to mix inks, and the can of tympan grease with its own putty knife spreader.

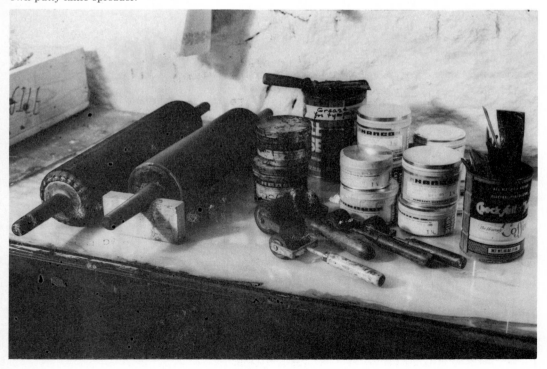

RUBBER ROLLER SUPPLIERS
Rembrandt Graphic Arts

Graphic Chemical and Ink Company

Takach-Garfield Press Company, Inc.
3207 Morningside, N.E.
Albuquerque, New Mexico 87110

Sam Flax, Inc.

Charles Brand Machinery

Samuel Bingham Company
835 Fremont Avenue
San Leandro, California 94577
or
201 North Wells Street
Chicago, Illinois 60606

They will re-cover rubber rollers if you bring in the metal core.

Dick Blick, Inc.
P.O. Box 1267
Galesburg, Illinois 61401

Daniel Smith Company, Inc.

Brayers in sizes ranging from 1¾″ × 3¼″ to 1¾″ × 8″.

Roller Accessories. Also available are leather grips and cuffs to attach to the handle of all rollers to protect the printer's hands from the turn of the wooden handle.

SUPPLIERS
Graphic Chemical and Ink Company

New York Central Supply

LITHOGRAPHIC BASES

The lithographic print can be created on any of four bases: stone, aluminum plate, zinc plate, and paper plate. Each of these possesses a unique surface, and each has its own advantages and disadvantages. Often a combination of stone and plates is used to do color lithography.

Lithographic Stones

Most lithographic stones still come from Bavaria. They can be purchased, however, through U.S. com-

Figure 13.11
Photo by Mace Wenniger.

Lithographic stone shown as purchased by the author with a map dated 1909 etched on its surface, which she printed in an edition over background color plates. It took a lengthy graining session to completely remove this image from this stone.

panies. These limestone blocks can also be found in old printing firms, where they often sit with images of maps and posters from the early 1900s still etched on their surfaces. They were plentiful at that time because they were used as ballast on boats from Europe.

Lithographic stones are approximately 97% calcium carbonate and 2% silica, plus other substances such as iron oxides. It is the satiny, granular, and porous surface of the stone that is its most valuable characteristic. The hardness or softness of the stone surface is important because the stone quality affects how the etch on the image should be formulated by the artist and prompts him or her to gauge the reaction time of the etch to the stone as well as to the image.

Lithographic stones are available in many colors which vary with the hardness. The highest quality stones are in the gray range. Dark gray, blue gray, and medium gray stones have hard surfaces which will hold finely drawn images through long editions. Light gray stones are a little softer and less dense. The tonal variations of the lithographic drawings on light gray stones usually do not coarsen or weaken during the processing steps. Yellow stones are softer because they have more calcium carbonate content: they vary from pale yellows to whites and pale tans. These allow excellent adhesion of grease and wax from drawing materials and printing ink. Because of their softness, though, the grease can spread too easily, and nuances of image can thicken and fill in with grease. Yellow stones tend to coarsen when reworked or corrected (see Counteretch, Chapter Four).

Lithographic stones need to be 3 or 4 inches thick to be useful to you for lithography and can be purchased new or used. Thin stones are often used as bases on which to roll up black ink. Remember that the color of the stone determines the price as well as the size—the yellower the stone, the less expensive, but grey stones generally produce more delicately drawn lithographs. Since these stones were commercial vehicles for printing not so long ago in America, you can sometimes locate one through the grapevine or by asking about this in a printmaking workshop in your city. Another possible source is a leather factory (they used stones to pound leather).

SUPPLIER
Rembrandt Graphic Arts Company, Inc.

Limited selection of used stones with images on them in small sizes (new stones—yellow and gray, many sizes). 6″ × 8″ yellow, approx. $47.00, gray approx. $75.00. 24″ × 36″ approx. $720.00 yellow, gray stone $1,330.00. 20″ × 26″ yellow, approx. $315.00, gray stone $655.00). Graphic Chemical and Ink Company imports yellow stones and

used stones (with images still on them). Prices vary with the grade.

Lithographic Plates

Lithographic plates, made of aluminum, zinc, or paper, are viable alternatives to stones, each type of plate having particular merits. Aluminum and zinc plates are made of nonporous metals grained to form a subtle surface like that of a lithographic stone.

ALUMINUM PLATES

The aluminum plate is the most commonly used lithographic plate in the United States and has many advantages. It is lightweight, inexpensive, and of a neutral light gray color. The aluminum plates that are recommended for hand lithography are ball-grained deep etched and medium to coarse in texture. Offset plates are coated with silicate and have a smoother surface than plates used for hand lithography. Smoother grained plates are used for photolithography techniques. Aluminum plates are hydrophilic, which means that they are particularly receptive to water and repel grease easily. They can be drawn on with little plate preparation; they only need counteretching if marked or stained.

Thin aluminum plates generally are used in America today. They are made without the silicote coating found on offset plates and are medium ball-grained deep etched. They are available at the cost of $.80 for a 9″ × 12″ size or $4.00 to $6.00 for a 25½ × 36″ size, depending on the supplier. Precision Lithograining Company in Holyoke Massachusetts will supply larger plates and regrain zinc plates upon special request.

ALUMINUM PLATE SUPPLIERS
Precision Lithograining Company
Florence, Massachusetts 01060

Ask for deep etched ballgrained. They sell two sizes of plates: 8″ × 25½″ and 25½″ × 36.

Rembrandt Graphic Arts Company, Inc.

They sell coarse grained and extra coarse grained plates.

New York Central Supply Company

Daniel Smith Company

ZINC PLATES

Zinc plates are popular in Europe and are easy to obtain there. They are expensive to buy in America, although they are available. They have a more prominent grain than aluminum plates. Zinc plates are oleophilic, which means they are more receptive to grease than to water, in contrast to aluminum's

hydrophilic quality. For this reason these plates are exciting to use with tusche, the liquified grease lithographic drawing material.

On zinc plates, because of their coarse grain, it is possible to produce an amazing variety of subtle crayoned gradations and textural variations as well as broad tonal fields with the rich, smooth look of the tusche.

ZINC PLATE SUPPLIERS
Rembrandt Graphic Arts Company, Inc.

Harold M. Pitman Company
515 Secaucus Road
Secaucus, New Jersey 07094

Precision Lithograining Company
Florence, Massachusetts 01060

PAPER PLATES

Paper plates are thin white boards with a slick, coated, specially treated surface. If there are no other lithographic supplies available, you can learn about lithography by using paper plates. Paper plates are inexpensive, can be ordered by mail, and can be printed without a press. However, they have definite limitations in size and as a drawing and printing

surface. With paper plates you can only approximate the richness and the subtleties of the lithographic print.

Children exploring lithography for the first time can easily and inexpensively learn how to print a lithograph using a paper plate because processing steps are simple and all of the necessary printing and processing materials are included in the purchase.

PAPER PLATE SUPPLIER
Anthony Ensink & Company
400 West Madison Street
Chicago, Illinois 60606

Kits available including chemicals, brayers inks, and special drawing materials used in paper plate lithography.

EXPENDABLE LITHOGRAPHIC SUPPLIES

Inks

As a lithographic printmaker, you will use special inks when you print. These inks come in a can and are thicker in appearance than inks used in other printmaking mediums.

Figure 13.12
Photo by Mace Wenniger.

Inking slab and printing materials: sponges, water basin, paper towels, solvent in a safety can, cheesecloth wads with gum arabic nearby, putty knives, magnesium carbonate, ink (on slab), and roller.

Lithographic inks used for hand lithography consist of pigments held in a varnish base that provides the fatty or greasy quality necessary for the ink to adhere to the grease-attractive lithographic dots and to repel the water used during the lithographic printing process.

Lithographic inks can be purchased from the sources listed at the end of this section or from offset printers, but be careful to buy inks without a drying agent, or unless you are using an offset press.

The qualities you should become aware of in your inks are viscosity, tack, and length.

Viscosity, or Ink Flow. Whether your ink flows smoothly or resists flow is a critical factor in lithography. Inks of low viscosity flow too easily and cannot be controlled during inking. Inks of high viscosity may not transfer from the litho base to the paper. Each ink has a viscosity determined by its own composition. Temperature also affects ink flow; warm temperatures lower the viscosity, and cold temperatures increase it.

Ink viscosity is changed by adding modifiers. Inks with low viscosity need thicker varnishes (7 or 8) or magnesium carbonate to reduce their flow. Inks with high viscosity (or too much magnesium) need thinner varnishes to increase their flow. However, since varnishes add grease to inks, it is recommended that adding Sinclair & Valentine #470 reducing oil adjusts viscosity without adding grease. This oil evaporates as you roll and print. Hand-drawn positive plates print best with ink stiffened with body gum, #8 varnish.

Tack, or Stickiness. Ink must be sticky to cling to the grease-laden dots, and it must be greasy enough to be printable on the printing paper. Tack is tested by pulling a putty knife against an ink smear and watching to see if it crackles and how it breaks. As you move the flat knife over the ink, notice where the ink breaks. Is it close to your slab or away from it? If it breaks crisply into ⅛″ peaks, it will print well for you.

Too much tack means that the ink is so tight it will pluck the paper fibers as it prints. Adding some Settswell compound and ink modifier, discussed later in this chapter, will reduce the tack on your ink. Some tack is necessary to keep the ink printing crisply and prevent scumming or filling in in negative areas. Ink can lose the necessary tack, especially if it becomes waterlogged during printing. If this happens, clean off the slab and roller and begin again.

Length. Length affects the distribution of the ink on the inking slab and on the print. Too long an ink will cause each printing dot to fill in. Many colored inks too long to be used without modification with another additive will sometimes work for broad, flat color areas. Length is tested by lifting the ink with a flat putty knife to observe how it drips. If ink is too long, it can be made shorter by adding magnesium carbonate or #8 varnish.

Filling in is one of the major problems in lithography. This occurs when the ink-laden dots or particles thicken and come closer together, causing the image to coarsen. It can be controlled by 1) the expertise with which the inking is done (further explained in Chapter Six, and 2) by the quality of your ink, as discussed above which determines how it handles during the process of inking and printing your lithograph.

Colored Inks

Since this book focuses on color lithography, I want to familiarize you with the various types and brands of colored inks available to lithographers.

Colored lithographic inks are made especially without dryers for hand-inked lithography, not for offset lithography. They are used for color proofing and editioning only; they are not used for proofing images and rolling up images for storing. Colored inks are made from linseed oil varnish mixed with finely ground pigments. They are thinner than most black inks, less tacky, and thus much lower in viscosity. The properties most important to note in each colored ink are hue, transparency, translucency, and opacity: hue = color; transparency = amount of light that can pass through the color; translucency = light plus white in a color; opacity = the light-repelling quality of a color.

There are dozens of shades of colored inks available for hand lithography, and they can be ordered from sources listed at the end of this section. Each company's inks possess slightly different properties. Since I work with transparent overlays of color, I particularly enjoy the transparent properties of the Sinclair & Valentine inks. I have found the following colors useful to start with: ultramarine blue, thalo blue, thalo green, monstral blue, lemon yellow, primrose yellow, vermilion, violet, magenta, opaque white, transparent white, and brown.

OFFSET INKS

Colored inks can also be purchased from any offset firm near you. Offset inks are made to be used on an offset press which lays down a thinner layer of ink than the artist who hand rolls ink onto his stone or plate.

The hand printer should order offset inks without the drying agent because the dryer will make the ink dry on your inking slab and roller in a short time. However, if you are doing an edition in color, a drop of dryer can be added to your colored lithographic inks to make the ink dry more quickly than the usual twenty-four hours so you can print the next color

without *offset* problems, as the transfer of an earlier lay of ink is called.

BLACK INK

Black Roll Up Ink. This is the most important ink you will use, so be sure to get acquainted with the different roll up inks and their uses and qualities.

Black roll up inks are made with a high viscosity. This low-flow quality creates a crispness that prevents an ink buildup during the critical proofing stage when the image is given the initial covering with ink. Even when prints are to be editioned in color, the first ink used in printing should be a black roll up ink since this helps prevent the image from coarsening. Also, when an image is given a second etch to make sure the grease dots remain permanent, the image is always worked over with black roll up ink, not colored ink.

Some roll up inks are quite stiff while others are less stiff, easier to manipulate, and greasier. Since the proofing stage is the most critical stage in the life of an image, it is important to try to judge which of the proofing inks best suits your image as it is drawn.

The inks below are often mixed with each other to furnish the most desirable qualities each possesses.

Sinclair & Valentine's Rolling Up Black (crisp, nongreasy); Charbonnel's Noir Monter (short, soft, greasy, useful for images needing fatty ink); Graphic Chemical and Ink Company's Senefelder Crayon Black (stiffest, shortest, tackiest black ink, often mixed with other roll up black inks and useful for images with delicate tonal variations) and Rolling Up Black (crisp, moderately viscous).

Black Editioning Inks. These are usually softer inks used for printing multiples in editions. They are characterized by low viscosity and less tack. Their softness helps the ink to penetrate the printing paper. The most popular types are: Graphic Chemical's Printing Ink, Charbonnel's Noir Velour Bronzes (soft, short, velvety, cool), and Sinclair & Valentine's Stone Neutral Black (a warm black, easy to use).

Black transfer inks. These are used for taking impressions on transfer paper and then making a clearly transferred impression from the paper onto another plate or stone. To accomplish this transfer job, the ink must be firm, with a high viscosity, and greasier than roll up inks. My recommendation is Charbonnel's Re Transfer Ink.

Ink Modifiers

Some inks can be used directly from the can. In many situations, however, inks may need small amounts of modifiers in order to change their printing qualities.

Transparent Medium and Transparent White. These ink additives can be purchased in cans from lithographic ink companies. Add transparent medium to your color to make your ink more transparent. To achieve a truly transparent effect, however, start by laying out a small mound of transparent medium on your mixing slab, to which you gradually add small amounts of colored inks until the desired quality is achieved.

Transparent white is added to colored ink to achieve a translucent effect. This additive is composed of transparent medium as well as white pigment. Mix as described above for transparent medium.

Varnishes. These are ink additives made from linseed oil that make the ink greasier while allowing it to remain stiff. In fine crayon work, a drop of light varnish (00,0,1,2,3) will thin the ink. The heavier varnishes (6,7,8) give more body to the ink and increase the tack.

Varnishes are made by boiling linseed oil and are graded from #0000 (thin) to #10 (extremely stiff and viscous). Your lithographic workshop should carry one-pound cans of #0, #5, and #8 varnishes. You may have to add two grades of varnish to an ink to make it work properly. For instance, #0 added to the ink will thin it but reduce its tack too much; it may be necessary to adjust the tack by adding small amounts of #5 or #8 varnish.

Magnesium Carbonate. This additive increases the body of the ink. It is often worked into colored lithographic inks prior to inking. In order to shorten the inks and increase their tackiness, it is necessary to shorten the ink's breaking point when it is rolled out on a slab or rolled over an image. This step is known as *bulking* the ink, and it is necessary because the etched image loses definition if inks are so greasy that too much ink is laid on each dot as the roller goes over the image during printing.

Setswell Reducing Compound. This is a wax compound that reduces tackiness and the shine that occurs when inks are printed over each other. Adding a small amount of Setswell compound to colored inks when mixing them will help you print large, flat areas of color because Setswell makes inks spread out over a large area. It lightens the ink and also helps colored lithographic inks cover evenly.

Dryers. Cobalt and manganese dryers are additives which will speed up the drying of inks. They also prevent offsets (inky deposits from a previously inked image picked up by the rubber roller and de-

posited on the succeeding image) when you are printing multicolor lithographs.

Extenders. Alumina hydrate mixed with litho varnish makes an excellent transparent extender for colored litho inks.

Flash Oil. An excellent reducer of lithographic inks for stones. It reduces ink without increasing greasiness. This oil gradually evaporates so there is no danger of contaminating the printing paper. Sinclair & Valentine's #470 reducing oil is recommended.

Anti-skin Spray. This spray anti-oxident is used to stop ink from hardening on your mixing slab during editioning. It also can be sprayed over a mound of leftover ink to preserve the ink for later use.

Ink Suppliers

There are many national sources of lithographic inks as well as local sources like printing companies. Because some inks are more transparent or more translucent than others, experience often dictates preferences.

BLACK INKS
Every proofing and editioning ink is a different color black and has a different consistency of tackiness.

SUPPLIERS
Hanco Inks (Handschy Chemical Company)
528 North Fulton Street
Indianapolis, Indiana 46200

Charbonnel
3 Quai de Montebello Court
Rue de L'Hotel Colbert
Paris, 75005
France

Graphic Chemical and Ink Company

Daniel Smith Ink Company

AUTOGRAPHIC INK
Autographic ink (Charbonnel's Zincographic ink) needs a very light etch.

COLORED INKS

Editioning inks. Some are more transparent or opaque than others. Some are luminous, some are relatively dull. Be sure to try out lots of brands of inks before you make a big investment. Most inks come from specialized ink companies and have to be ordered by mail from them.

SUPPLIERS
Rembrandt Graphic Arts
(Charbonnel and Hanco Inks)

Graphic Chemical Company

Daniel Smith Ink Company

Sam Flax
(carries Charbonnel inks)

New York Central Supply

Sinclair & Valentine

Charbonnel

Siebold Ink Company
150 Varic Street
New York, New York 10013

Hanco Inks

Lorilleux Lefranc—Export Department
161 Rue de la Republique
Puteaux, Seine 92800
France

INK MODIFIERS
Transparent mediums, varnishes, reducing oils, anti-skin spray, body gum, dryers, magnesium, Setswell compound.

SUPPLIERS
Rembrandt Graphic Arts

Graphic Chemical and Ink Company

Daniel Smith Ink Company

Sinclair & Valentine

DRAWING MATERIALS

The lithographer uses lithographic pencils, crayons, and tusche to create an image on the stone or plate. These materials are made from greasy substances and an emulsifying agent that allows dilution with water and solvents. Black pigment has been added to all of them so that the artist is able to see the image as it is being drawn. Other materials, such as gum arabic, and other resists or block out stencils as well as scraping tools can be used for special effects.

Pencils and Crayons

Lithographic pencils are pointed instruments about seven inches long, made from a combination of greasy materials, pigment, wax, soap, and shellac. To lengthen the point, the artist can unravel paper from the point; however, it breaks easily if too much is

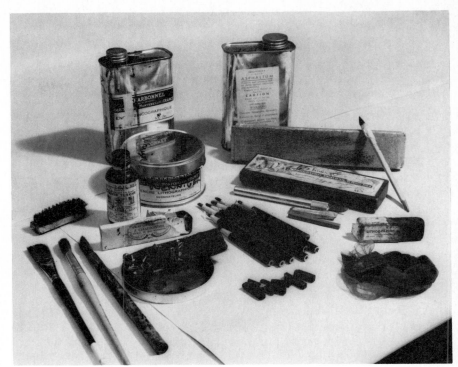

Figure 13.13
Photo by Mace Wenniger.

Basic drawing materials: lithographic pencils and crayons to draw the image; X-acto knife and sandpaper block to sharpen pencils and crayons; asphaltum to replace grease on image after dissolving the drawing materials through the gum stencil of the etch; asphaltum and zincographic inks used as washes; brushes to apply tusche and other solutions; rubbing stick and chamois or stocking to make atmospheric tones.

uncovered. A sandpaper pad or razor blade also is used to keep a long, carefully rounded point on the pencil.

Lithographic crayons, or chalks, are about two inches long and a quarter of an inch square. Both tips and sides of lithographic crayons can be used. For broad strokes, break them, and use them on the edge or the flat side of the long bar. The lithographic crayon can also be used with a sharp point, which, because the crayon is soft, is best made by cutting the point toward the crayon, rather than away from the crayon as might be expected. Use a sharp knife or razor blade to taper a point gently.

The amount of shellac present determines the hardness of pencils and crayons, which are numbered accordingly, from #00, soft and greasy, to #5, hard. Charbonnel crayons and pencils from France, however, are numbered in reverse order—#5, soft, to #0, hard.

The classic method of lithographic drawing is to start with a hard crayon or pencil and gradually build darker tones with softer ones.

Tusches

Tusche is a grease-laden solution used in lithography in a liquid form. It is made of wax, soap, and pigment with shellac. It is water-soluble and can be combined with water (water tusche) or solvents such as litholine, turpentine, or lacquer thinner (solvent tusche).

Tusche may be purchased in bar form (flat and paper wrapped), in can form, or in liquid form. All forms of tusche can be used with a brush and water and/or solvents to create dark, medium, and light washes. Liquid tusche is useful for making solid tones as well as watery washes. Tusche and liquid tusche are the most readily available and are less expensive than canned tusche, but the results are so unpredictable that it is worth the extra effort and cost to obtain canned tusche.

Canned tusche is used directly from the can. Simply mix with a brush and water or solvent until it reaches the diluted state desired.

Test different tusche products to find your favorite. Because Europeans use tusche extensively in their work, their tusche products seem to produce the most interesting washes, which dry with semicircular line patterns and delicately toned puddles, and produce the crisp edges so often praised in lithography.

ZINCOGRAPHIC INK AND AUTOGRAPHIC INK

These compounds are actually the same product from two different suppliers, and they are also classified as tusches. They are used for making one hundred percent black tones or lines in a drawing.

Suppliers of Lithographic Drawing Materials

Any greasy substance even lipstick and shoe polish will leave an impression that can be printed if processed on a lithographic stone or plate. However, for a standard lithographic image, you need to pur-

chase some of the materials listed: lithographic pencils, crayons, rubbing sticks, liquid tusche, canned tusche, stick tusche.

DRAWING MATERIALS
- Korn's lithographic pencils and crayons, #1 to #5 (#1 soft, #5 hard)
- Korn's liquid tusche and stick tusche
- Korn's lithographic rubbing sticks, soft, medium, and dark
- Korn's authographic ink
 Suppliers
 Wm. Korn, Inc.
 Graphic Chemical and Ink Company
 Sam Flax, Inc.
 New York Central Supply Company
 Daniel Smith Ink Company
- Charbonnel Encre Lithographique. (Excellent paste tusche in a can. Purchase two cans, one for water washes and the other for solvent tusches.)
- Charbonnel lithographic pencils, #1 to #5 (#1 hard to #5 soft)
- Charbonnel lithographic crayons #1 to #5 (hard to soft)
 Suppliers
 Charbonnel Company/4 Quai D'Orsay/Paris/ France
 New York Central Supply Company
 Rembrandt Graphic Arts Company, Inc.
 Sam Flax, Inc.

Additional Drawing Tools

Additional drawing materials include: Brushes, ranging in use and size from fine sable brushes to one- or two-inch indoor house paintbrushes; an exacto knife and sandpaper block to sharpen pencils and crayons and to scrape away parts of a drawing for white highlighting effects, a chamois cloth to use with a rubbing crayon to create areas of tone; asphaltum, which is used to replace grease on an image after the original tusche or crayon has been removed in the processing step prior to printing; and gum arabic which can be painted on the base to act as a negative shape or a resist and over which tusche, crayon, or asphaltum can be laid.

Ancillary Drawing Supplies. Brushes, X-acto knife, sandpaper block, airbrush, chamois cloth, red opaque, Griffold Knife #112, square blade (recommended to sharpen lithographic pencils and crayons).

SUPPLIERS
Rembrandt Graphic Art

Daniel Smith Ink Company

Image Correcting Materials. Scotch hones (stone erasures in stick form) and snake slips (pumice in stick form) are abrasive materials that remove parts of an image from a stone.

A crayon or pencil of medium hardness, #3, is recommended for the beginner who might become confused by an array of pencils and crayons. Work with a light touch with the #3 crayon and gradually work up the darker tones of the image by increasing your arm pressure. Use the hardest pencils alone, #4 and #5, to produce a delicate image with softest nuances of tones.

China or glass marking pencils (Engl, Royal Sovereign Chinagraph) also work well for fine drawings on a litho base.

Rubbing crayons are bars three times thicker than the ordinary lithographic crayon. They come in three grades, hard, medium, and soft, and are used to obtain soft atmospheric effects when rubbed with a cloth onto the plate or stone.

SUPPLIERS
Rembrandt Graphic Arts Company, Inc.

Graphic Chemical and Ink Company

New York Central Supply Company

Daniel Smith Ink Company

Trichlorethylene Fluid. This is a solvent used to dissolve some or all of a drawn image from a lithographic plate. The area on which it was used is reusable.

SUPPLIER
Roberts and Porter Chemical Company

Pro Sol Image Remover. This chemical is used to remove parts of the image from the plate after it has been printed and proofed. The area on which it was used is not reusable for another drawing or part of a drawing.

SUPPLIER
Polychrome Corporation
155 Avenue of the Americas
New York, New York 10013

PROCESSING MATERIALS

Processing materials, including certain chemicals and solutions, play a vital role in lithography. I shall reiterate the processing steps here to be sure that you

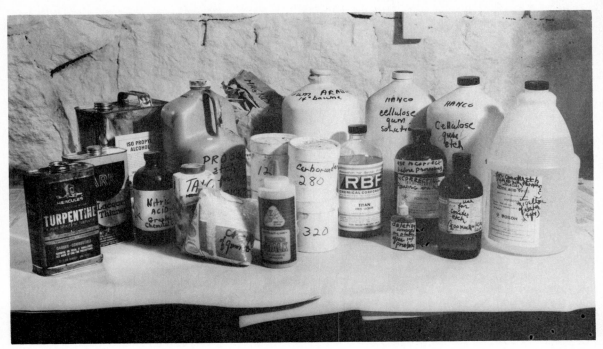

Figure 13.14

Lithographic chemicals and processing materials from left to right; solvents: turpentine, lacquer thinner, ispropyl alcohol, nitric and phosphoric acids and Pro Sol to etch image on stones and plates; talc to absorb excess grease; rosin to isolate each grease-laden grain (use on stones only); crystals of gum arabic; when mixed with gum arabic, cellulose gum solution and cellulose gum etch; vinyl lacquer to prepare plates for printing large editions; marking chalk to make duplicate plates; correction materials: trichlorethylene to erase drawn material before plate is etched, polychrome deletion solution to erase marks from processed plates; magnesium, rear, in bag, to stiffen inks.

can understand how these materials are used. Complete instructions with formulas for processing and procedures are found in Chapters Four and Five.

The basic materials for processing plates and stones are: nitric acid, phosphoric acid, tannic acid, glacial acetic acid, citric acid, distilled water, rosin, talc, gum arabic, cellulose gum, Pro Sol, turpentine, lacquer thinner, vinyl lacquer, ispropyl alcohol, polychrome image remover, cellulose etch, hydrogum, triclorethylene, and magnesium carbonate.

The processing procedures can be broken down into three steps: (1) sensitizing, (2) desensitizing, and (3) resensitizing.

To *sensitize* the plate or stone is to prepare it for drawing by removing any protective covering, oxidation, or unwanted grease marks, including old drawings or finger marks. Plates are sensitized chemically; stones are sensitized by grinding with carborundum powder.

To *desensitize* the plate or stone is to prepare the image on it for printing. This is called the *etch* step. In the etch step the drawing is massaged by a diluted mixture of gum arabic and acid. The acid works on the grease of the drawing, which enables the drawing to become a permanent stain on the stone or plate. The gum works on the negative areas making them nonreceptive to grease.

To *resensitize* the plate or stone after the image is etched or after printing, the protective gum film is removed with an acid-and-water solution. This reopens the plate or stone so that it is capable of absorbing more grease marks. *Counteretching* is the term used by lithographers to describe the resensitizing step.

Materials Used in Sensitizing, Desensitizing, and Resensitizing

CARBORUNDUM POWDER

An abrasive made from silicon carbide, sand, and carbon, rubbing with lithographic carborundum brings out the soft grain of the limestone and prepares it to receive a new image. Carborundum comes in different densities or grains. The coarser densities (lower numbered) are used to grain off old images, while the progressively finer (higher numbered) densities refine the surface.

Carborundum is used to remove a discarded image or part of an image from the stone and to regrain the surface of the stone in preparation for a new drawing. The carborundum grits are packaged in cans of one to one hundred pounds. The lower the

number assigned to a can of carborundum, the coarser the grit. From coarse to fine, they are numbered 50, 100, 120, 150, 180, 200, and 220. Letter codes F, FF, FFF, designate fineness with FFF the most refined or fine carborundum available.

ROSIN AND TALC

Rosin and talc are powders that do specific tasks when applied to the grease image on the stone or plate. Rosin, used mostly on stones, but sometimes on plates, is dusted on before the talc to isolate each grease-laden particle, enabling the gum arabic (used in the etching process) to separate non-grease areas from the greasy drawn image. It also acts as an acid resistant to protect the greasy image from the corrosive action of the acid used in the etch. Talc adsorbs extra grease on the image and coats the image so the gum arabic will adhere to the greasy drawing in an even film. Otherwise, the gum and the drawing would resist each other because gum is water-based material and the drawing is grease.

GUM ARABIC

Gum arabic is the key to lithography, for it is the main ingredient used to etch stones and plates.

Gum arabic is initially a pebbly material, which is dissolved in water to form a syrupy solution that coats the base with a thin, tightly bonded film during the etch process and stays on the negative parts of the image during the printing of a lithograph, acting as a grease-repellent but water-attractive stencil.

No other substance has been discovered that so effectively desensitizes the image on plates and stones. Gum arabic is hydroscopic, that is, it attracts water. It is made from acacia trees that grow in desert areas in North Africa and retain what little moisture there is. The gum from the trees has water-attractive properties which makes it help keep nondrawn areas on litho bases ink-free.

What happens when the gum and acid mixture is applied to a greasy image on a plate or stone is this: The acid acts as a catalyst for the gum arabic, which is thus enabled to fill the pores of the stone to adsorb. The calcium, potassium and magnesium salts in the gum unite with the calcium and other minerals in the stone. This results in the gum forming an extremely tough film which acts as a stencil around each grease-laden dot drawn and allows the dot to remain undisturbed during printing.

The gum arabic acts as a stencil around each dot because it is insoluble in solvents and grease resistant. It keeps the drawing intact even when the drawn image is dissolved with solvents and the printing ink is applied all over. Although it may not appear so, if correctly applied, the gum arabic forms such a tough protective stencil (dissolved only in

water) that no solvent or grease can penetrate between the original grease-laden dots on the drawing.

When you ink your lithograph, passing an ink-laden roller over the lithographic base while keeping it damp by sponging it, the water on your sponge is attracted to the water-soluble gum arabic and with the gum surrounds each greasy dot, thus keeping the grease-attractive dots separate, while the greasy ink roller passes over them and deposits ink on each minute dot. The amount of ink each grease-laden hillock or dot takes in is determined by the strength and depth of the gum stencil surrounding it as much as by the quality of the drawn dot.

ACIDS

Glacial acetic acid, citric acid, Pro Sol, nitric acid, and phosphoric acid are used to sensitize, desensitize, and resensitize lithographic plates and stones.

Acids are used in combination with water or gum arabic to desensitize and resensitize lithographic plates or stones. All acids should be stored in a specially designed metal acid cabinet whose construction and open shelves will prevent the collection of fumes. Acids should be used only in well-vented areas in the litho workshop.

Glacial Acetic Acid. Dilute solutions of acetic acid and water are commonly used to sensitize the surface of lithographic stones and metal plates to receive images made of greasy materials. A mixed stock solution of counteretch for stones and plates (one part acetic acid to ten parts water) should be kept prepared in a plastic bottle.

Citric Acid. A far less corrosive acid than acetic acid, it maintains the integrity of the drawn image with sensitivity.

Pro Sol Solution. This is a mixture of zinc nitrate, ammonium dichromate, and phosphoric acid. Pro Sol is a commercial etch solution prepared by Polychrome Corporation for use in combination with gum arabic to desensitize or etch a grease-drawn image on a plate.

Hanco Tannic Acid Plate Etch M5214. Used in metal plate lithography, this etch is a nonchromated etch in a gum arabic base. It is gentle on delicate work.

Nitric Acid. The best concentration of nitric acid is 69% C.P., chemically pure. In solutions of water nitric acid chemically prepares stones and plates for images to be drawn, when gum arabic desensitizes the stone or plate surface to resist the ap-

Figure 13.15
Photo by Mace Wenniger.

Stone etching materials assembled: gum arabic brushes, nitric acid, measuring cup.
Use Pro Sol solution instead of nitric acid for etching (processing) plates.

plication of any more grease. Apply to stone or plate with acid-resistant brush or well-saturated sponge or cotton swab.

Nitric acid is a highly corrosive chemical which must be kept in glass or plastic capped bottles. It should be stored in a special out-of-the-way place. For daily use the acid should be dispensed from a 4 ounce laboratory drop bottle. Be careful in mixing nitric acid with water. It is extremely important to add the acid to the water; a severe burn will occur if the acid is poured first and water is added to it. Avoid inhalation of nitric acid. If some touches your skin, immediately wash it with cold running water and apply household baking soda.

Phosphoric acid. Phosphoric acid (85%, syrupy) is mixed with gum arabic in desensitizing etches for stone, aluminum, and zinc plates. It reacts less violently than nitric acid, and thus is especially useful for making milder etches for preserving delicate drawings. Purchase phosphoric acid in pint quantities and apply from a lab drop bottle with gum arabic, using a brush, sponge, or cotton swab.

Other Processing Materials

Chemicals include: Vinyl lacquer base, which is used on a washed out aluminum or zinc plate as a further aid in making the image permanent; acids and gum used to desensitize images; trichlorethy-

lene and polychrome image remover, used to delete misdrawn areas on metal plates; solvents such as lacquer thinner and isopropyl alcohol for plate processing; turpentine or lithotine for dissolving all drawn images through the gum seal on stones or plates; all-purpose paint thinner for cleaning up ink. Images on plates are sometimes prepared for printing with an extra lacquer base coating not used on images on stone. After the gum etches are applied and dried, the image is thoroughly removed with a solvent, and a commercial lacquer base finish is applied and buffed lightly before the printing steps are started.

Suppliers of Chemicals and Related Supplies

Finding and securing the necessary chemicals is a big issue for the beginning lithographer. I have found that most suppliers of lithographic materials do sell and ship the chemicals. Other firms such as Polychrome Corporation will ship C.O.D. via United Parcel Service. Also, check local chemical and laboratory supply companies. See General Suppliers for addresses not listed.

CHEMICALS
- Hydrochloric acid
- Phosphoric acid, 85%, syrupy
- Nitric acid, 69% C.P.

- Glacial acetic acid, 99%
- Citric acid
- Lith Kem ko Lacquer C
- Pro Sol #54
- Hanco tannic acid plate etch
- Hanco tannic acid powder
- Gum Arabic: liquid and crystals
- Cellulose gum solution
- Cellulose gum etch

SUPPLIERS
Rembrandt

David Smith

ACID DROP BOTTLE SUPPLIERS
Laboratory supply companies

Lab Supply and Health Company
Canton, Massachusetts

Paper

There is a special compulsiveness that afflicts lithographers; one becomes a "paper freak," always searching for the perfect paper to enhance that special image. Paper as a substratum of a lithograph is tremendously important to you as a lithographer. A good image deserves to be printed on a beautiful, long-lasting surface. And nuances of paper color and texture affect an image whether it be black and white or color.

Early printmakers in this country often ignored their paper surfaces, with the result that the aesthetic integration of paper and image was lacking, and due to the careless choices of nonrag papers as well as mat, many early prints have started to deteriorate. Now you are urged to research seriously what papers are best for you to print on, for both artististic and curatorial reasons.

New papers are constantly being developed by paper companies both here and abroad, in many shades of white and cream and in many subtle colors: tans, browns, grays, muted greens. Major paper companies encourage printmakers to make known their wishes and needs regarding colors.

Papers are imported from different parts of Europe and Asia. Be aware that paper prices reflect the economies of their sources. Italia, made in Italy, is a favorite paper of mine for printing color lithographs; it has a cool smooth white surface and is relatively inexpensive compared to paper from other European countries.

Familiarize yourself with variations in paper size, weight, texture, and content. The rag content of paper should be carefully researched; color and surface qualities should be analyzed and studied as you plan each print. Keep careful notes on the papers you use and like. Combine forces with another printmaker on paper purchases because you can obtain a significant discount on paper bought in lots of five hundred or even one hundred sheets. An order of five hundred sheets can be broken down into lots of fifty sheets of several kinds of paper, which allows room for experimentation and developing a special look to your prints.

Paper may be made completely of torn rags, 100% rag, or of wood or vegetable fiber or of a combination rag and wood or vegetable fiber. In general, the higher the rag content the tougher and more durable the paper, and the less apt the paper is to decompose or yellow with age.

It is good to appreciate just how paper is made. First, the torn rags and fibers are combined with water and made into a water pulp. Then the pulp is formed into paper either by hand or in a machine or in a mold. Hand-made, mold-made, and machine-made paper are all commercially available.

Most lithographers prefer mold-made papers, in which the mold is shaken mechanically to release the water to form the paper, or hand-made papers in which the mold is shaken and pressed by hand to release the water. Most commercial paper products are machine-made and not of interest to lithographers.

Because of their smooth surfaces, subtle color choices, and high rag content, many lithographers print on the following mold-made papers: Arches, Rives, and Italia.

New papers are being developed all the time. Examples are Rives Newsprint (a gray paper) and Arches brown (paper-bag color). Although you will develop a predilection for certain papers, you will enjoy experimenting with different papers.

Most paper has two quite different surfaces on back and front: the smooth, or felt side, where the just-formed paper has been turned onto a felt sheet for drying and the rough, or wire side, the side that pressed on a wire mold during forming. It is the artist's intent that determines which side of the paper is to be used. The smooth side can be discovered in two ways: (1) by finding the watermark, which is an embossed trademark with the maker's name that reads correctly on the smooth side, or (2) by looking for the deckle, or serrated, outer edge, which slopes downward on the smooth side.

HANDMADE PAPER

Today there is much interest in printing on hand-made papers, either those produced in quantity by small companies or that made by the artist himself. As a lithographic printing base, hand-made paper is especially beautiful because of its subtle variations in shape, texture, and color.

However, using hand-made papers creates many problems; it sometimes is difficult to pick up subtleties; it sometimes leaves textures in flat areas. One major problem with hand-made paper is its questionable ability to accept ink.

I recommend a visit to an art supply store owned by someone who shows a passion for papers and has an eclectic collection amassed from all over the globe. You should also write for samples to the hand-made paper companies in the list following or work directly with individual papermakers.

Another alternative is to make your own paper out of plant materials—paper pulp or recycled papers, your rejected prints or paper scraps. Making hand-made paper from recycled paper involves the following steps:

1. Grind torn bits of paper into a watery pulp in a blender.
2. Float the pulp, using a ratio of 2% pulpy mass to 98% water, in a deep, water-filled plastic tub or vat.
3. Make a paper mold out of aluminum, copper, or plastic mesh screening glued on a commercially made wooden frame. Cover edges with aluminum duct tape.

4. Make a deckle, another wooden frame which fits inside the paper mold. Cover it with duct tape as well.
5. Dip the mold and deckle, screen side up, held firmly together, deep into the vat. Push them in an arc from the near side to the far side of the vat and lift. Pick up a thin layer of paper pulp on the upper screened surface of the mold. This layer is the sheet of paper.
6. Turn the mold with its attached paper layer, face side down, on a piece of dampened felt. Press mold into the felt. Sponge water from the backside of the screen, releasing water from the sponge into a nearby bucket.
7. Lift the mold, one side at a time, carefully depositing the hand-made paper on the felt to dry. Repeat.
8. The sheets of paper on their felts are stacked together, and water is pressed from them with a weight like a screwdown book binding press or board held under pressure by a car jack.
9. Paper is then removed from the felts and gently applied with a large, dry, soft-bristle paint brush to a vertical sheet of glass or Plexiglas where it will dry smoothly. To dry it more roughly, remove it from the felts, stack it, and let it dry under a weight.

Figure 13.16a
Courtesy Beverly Plummer, Photo by John Plummer, Jr.

Beverly Plummer, papermaker, dips mold and deckle held firmly together into the watery pulp made from chopped leaves and other gelatinous materials.

Figure 13.16b

Plummer lifts the mold one side at a time, depositing the handmade paper on the felt or sheet square, in order to dry. Cover with felts and weights.

IMPORTED PAPERS

- J. Green Waterleaf (English etching). Cool white, 100% rag, size 23¼″ × 31¼″, pH 6.3, mold-made, hot-pressed. This paper does not erase well and stretches slightly in printing.
- Basingwerk. Light, medium, and heavy. Lightweight, cream-colored paper with some gloss. Inexpensive, good for proofs and black-and-white prints. 45% wood pulp.
- Italia. White, heavy hard paper with smooth surface, in sizes 14″ × 20½″, 20″ × 28″, and 28″ × 40″. Recommended for transparent layering. Cannot be erased. 66% rag, pH 5.4, mold-made.
- Arches Cover. Available in white and buff, in sizes 22″ × 31″ and 29″ × 41″. A smooth, beautiful sheet with a handsome finish.
- Copperplate deluxe. Slightly yellowish cast bleaches to white in time. It requires heavy inking and dries slowly. Erases well and stretches slightly in printing. 75% rag, 29½ × 42¼″ or 21¾″ × 30″, pH 5.0, mold-made.
- Arches Cover, French. Buff and white, 100% rag, pH 5.0, size 22″ × 30″. Buff fades to white; white Arches darkens; A heavy paper requiring soft ink and high pressure, good for multicolor printing. Erases well.
- Rives BFK. Lightweight, white, with an even, smooth texture. In sizes 22″ × 30″ and 29″ ×

41″. 100% rag, pH 5.4, quite stable to light, erases well, stretches during printing.
- Strathmore. A strong, white paper with even texture. Heavy-weight. 100% rag.
- Inomachi nacre (Japanese). White or natural colored, 100% fiber, 17½″ × 22½″ (22″ × 30″, 29″ × 41″ can be special ordered), pH 5.4. Translucent vellum-like quality which can add rare beauty to an image. Nacre takes color beautifully, but it is difficult to overprint because irregularity of paper causes registration difficulty.

PAPER SUPPLIERS
Andrews, Nelson, and Whitehead
31-10 48th Avenue
Long Island City, New York 11101

They will develop new papers upon request from printmakers.

New York Central Supply Company

The owner, Steve Steinberg, will discuss papers at length, in person or by telephone, and will send samples.

DOMESTIC PAPERS
Crestwood Paper Company
Division of Willman Paper Company
315 Hudson Street
New York, New York 10013
(212) 989-2700

Figure 13.17

European papermaker air dries (over a line) sheets of heavily textured hand-made paper, which will be sold with an indentation of the line. There are other ways to dry handmade papers: between felts or sheets as described in Fig. 13.16b, or mounted flat on boards.

HANDMADE PAPERS (H.M.P., Twin Rocker, Shannon, Sheepstor, and Stonehenge) as well as Japanese papers.
New York Central Supply Company

The Paper Mill
800 Traction Avenue
Los Angeles, California 90013
(213) 687-7248

JAPANESE PAPERS
Yasutomo & Company
24 California Street, Department AA-4
San Francisco, California 94111
Write for catalogue and samples

ANCILLARY PAPERS
- Newsprint, to use as slip sheets during printing.
- Transfer paper, (Charbonnel and domestic brands) for drawing image and transferring it to a lithographic base.
- Blotters, for drying printing papers; variety of sizes and quality available.
- Glassine, thin, slick sheets to go between prints for storage, to protect and separate them; comes in rolls and sheets.

SUPPLIERS
Rembrandt Graphic Arts

Daniel Smith Ink Company

REGISTERING SUPPLIES
- Etching needles (for pin point registration). Supplier: Graphic Chemical and Ink Company
- Register pins with quarter-inch register knobs.
- Fiber alignment tabs with quarter-inch holes. Supplier: Milton Bergman Company, Fort Lee, New Jersey 07024
- Paper punch, quarter-inch. Available at stationery stores.

PHOTOGRAPHIC SUPPLIES

CHEMICALS AND ORTHO FILM
Polychrome Corporation

Rembrandt Graphic Arts

Daniel Smith Ink Company

Associated Photo and Lithograph Supply Company
25 Park Place
New York, New York
Graphic arts supply, film, paper.

Dayco Printing Products, Dayco Corporation
Richboynton Road
Dover, New Jersey

197

Lithographic blankets and rollers. Color separators, dividers, press attachments.

> Lith Kem Corporation
> 45 Harriet Place
> Lynbrook, New York

Chemicals, offset plates.

> Amalgamated Graining and Chemical Corporation
> 57 69 58th Maspeths
> Long Island, New York

Complete graphic arts supply.

> Metzger, H. A., Inc.
> 157 Chambers Street
> New York, New York

Chemicals, plates, and registration tools.

> Polychrome Corporation
> 155 Avenue of the Americas
> New York, New York

> Rapid Roller Corporation, Inc.
> Fadem Road and Diamond Road
> Springfield, New Jersey

Blankets, rollers, mercury lithography.

> Siebold, J. H. and G. B. Inc.
> 150 Varick Street
> New York, New York

Ink

> Sinclair & Valentine Printing Inks
> Secaucus Road
> Secaucus, New Jersey

Ink

> Ulano Companies
> 210 East 86th Street
> New York, New York

Masking films.

> Varn Products Company
> 175 State Highway 208
> Oakland, New Jersey

Chemicals, solvents.

> MAT AND GLASS CUTTING EQUIPMENT
> (including multiangle cutters)
> C & H Manufacturing Company
> 5755 Gallant Drive
> Jackson, Miss. 30206

MARKETING SUPPLIES

> MAILING TUBES
> (for mailing prints to galleries)
> New York Central Supply Company

- Flat file drawers to store printing paper and finished lithographs:

> Daniel Smith Ink Company

> Sam Flax, Inc.

> New York Central Supply Company
> Five drawers, gray, sand colors.

> Kole Flat Files
> Dept. 79A
> Box 520152
> Miami, Florida 33152

> Charrette Corporation
> 31 Olympia Avenue
> Woburn, Massachusetts 01801

- Shrink Wrap Machine

> Rembrandt Graphic Arts Company, Inc.

- Foam Core Board

> Charrette Corporation

MISCELLANEOUS MATERIALS

Your lithography workshop must also contain a number of household items which are essential for measuring, cutting, cleaning, hanging work, and so on. These include measuring cups, masking tape, paper towels, scissors, old rags, which you probably already have around the house. You will also need the miscellaneous supplies listed below, which can be purchased locally in hardware, art, and photo shops:

- Carborundum (#80, #120, #180, #220–340 coarse to finer grade) to remove image from stone and to prepare stone surface for redrawing.
- Snake slips, scotch hones to make erasures from image on stone.
- Two water pans. These can be open shallow pans, preferably enamel or plastic so they won't rust. They must be wide enough to hold a large sponge.
- Newsprint to slip-sheet prints during editioning; also to back prints as they go through press. For cleanliness, use smooth newsprint to cover press bed when printing. Purchase either in a large pad from an art store or as an end roll from newspaper printers.
- Sanguine conte crayons to mark margins on litho base or to transfer images.
- Drawing pencils (2H, H) to make registration marks on stones, plates, and to trace images onto litho bases.

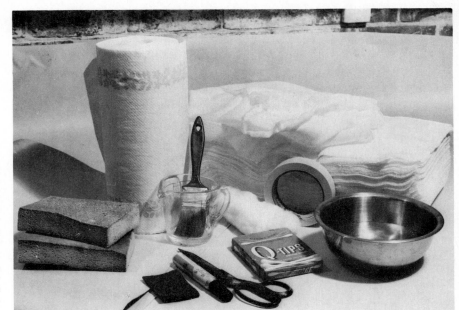

Figure 13.18
Photo by Mace Wenniger.

Miscellaneous small equipment: measuring cup and brush to measure etches and apply to plate or stone; enamel or stainless steel pans to hold water for printing; cheesecloth to wipe down gum solutions, scissors to cut plate with, lacquer base; sponges for printing; paper towels, Q-tips, and felt squares as aids in printing; magic marker and masking tape to mark stops on press bed for printing; paper towels to aid printing and clean-up.

Figure 13.19
Photo by Sigmund Abeles. Courtesy Sigmund Abeles.

This lithograph by Sigmund Abeles is a fitting lithograph for closing this book.

- Long demin work aprons to cover clothes.
- Etching needle. A slim wooden stick with a needle fixed in one end. Used to register your prints when printing in color.
- Push pins (#5 aluminum) or thumb tacks to hang up work in progress.
- Two covered metal trash cans to store solvent-permeated rags.
- Rubber gloves to protect hands from chemicals, acids, and solvents.
- Two sponges. Use flat, rectangular, densely textured sponges to apply water to litho base during printing.
- Bubble level to keep on hand to test the flatness of the surface of the stone as you grind it. Also used to level the stone when an artist is using a tusche wash technique so the wash does not puddle or drift.
- Drying rack to store prints for drying flat. Stack prints with newsprint in between in stacks of 5 to 10 to dry them most evenly.
- Metal straightedge ruler to check evenness of the level of the stone when preparing it by grinding. Also used to tear paper for printing.
- Two metal files, 10″ to 12″ long (one rough, one smooth) to file edge of a stone when preparing it as a printing surface.
- Wooden clothes pins to create drying line for freshly inked prints. Drill small holes in closed (top) end of each in order to string clothesline.
- Cheesecloth (#500 to #900 densely woven) to buff gum arabic solutions over image on surface of plate or stone.
- Tympan grease. An automotive lubricating grease or mutton tallow to spread on surface of tympan and bottom of scrape bar before printing. Store in lidded coffee cans.
- Solvent dispenser cans

- Files and rulers. Heavy steel ruler for testing levelness of the stone and for tearing paper before printing. Metal file for smoothing edges of the stone.
- Push pins

SUPPLIERS
Sam Flax, Inc.

Charrette Corporation
31 Olympia Avenue
Weburn, Massachusetts 01801

- Cheesecloth, fine grade (#900), to buff etch on litho base

SUPPLIERS
Sperry Chism, Inc.

Graphic Chemical and Ink Company

- Shop apron

SUPPLIER
Dick Blick
P.O. Box 1267
Galesburg, Illinois 61401

- Lithographic needles in wooden handles, flat #1 to #8
- Powdered rosin, talc, to dust image before processing
- Horizontal printing bar on litho press
- Scraper bar, benelux or hardwood, specify length
- Scraper bar, leather, 1½″ wide and $^{11}/_{64}$″ thick

Graphic Chemical and Ink Company

Daniel Green Ink Company

Appendix

HEALTH HAZARDS

A responsible presentation of lithographic materials cannot conclude without serious consideration of the health hazards involved in using and handling these materials. You can engage in printing with potentially harmful materials without endangering your health only if you know what you are dealing with and what precautions to take.

The very nature of lithographic printmaking involves the use of a variety of chemicals. Any material can be used in a litho workshop, provided controls are also used to minimize the toxic exposure of the lithographic printmaker. The controls offered in the following tables have been determined through investigation of the chemicals used, the hazards involved in their use, and the environmental and personal precautions which must be taken in using them.

This table was adapted from a manual for printmakers entitled *Health and Safety in Printmaking* published in 1978 by the Occupational Health and Safety Division of the Canadian Labour Department (available by writing Oxbridge Place, 9820-106 Street, Edmonton, Alberta T5k-2J6). In this manual the Canadian government has set time limits for exposure to airborne chemicals in working environments for periods of eight hours per day. They also recommend special precautions for chemicals that might act on the skin or be absorbed into the body through the skin by direct physical contact rather than by inhalation.

HEALTH HAZARDS

Name	Chemical Composition	Hazard	Precaution
Acetic acid	Acetic acid	Primary skin irritant. Concentrated liquid causes severe burns; the vapor is highly irritating to mucous membranes.	Avoid skin and eye contact; wear the appropriate gloves; use eye protection. If vapor concentration is high, a respirator or local exhaust ventilation should be used.
Hydrochloric acid (muriatic acid)	Hydrochloric acid	Primary skin irritant; solution causes severe burns. Emits hydrogen chloride fumes.	Wear appropriate gloves, and use eye protection. For extensive use, local exhaust ventilation is necessary.
Nitric acid (aqua fortis azotic acid)	Nitric acid	Highly corrosive. Will produce severe burns to the skin and eyes. Vapor is also corrosive to the skin, the mucous membranes of the eyes, nose, and upper respiratory tract, and to dental enamel.	Wear appropriate gloves. Use eye protection. With concentrated solutions, local exhaust ventilation should be used.
Phosphoric acid	Phosphoric acid	Concentrated solutions are skin irritants.	Wear appropriate gloves and use eye protection, especially when handling concentrated solutions. Use in a well ventilated area.
Alumina hydrate	Aluminum hydroxide	Nuisance dust only.	If operation is dusty, use a dust mask.
	Magnesium carbonate	Nuisance dust only.	If operation is dusty, use a dust mask.
Red oxide	Iron oxide	Nuisance dust. Long or intense exposure may cause a benign pneumoconiosis.	If operation generates excessive dust, wear a dust mask.
Rosin	Mainly abietic anhydide	May be an allergen.	If operation generates excessive dust, wear a dust mask.
Talc (French chalk)	Hydrated magnesium silicate	No short term toxic effects. Chronic inhalation may lead to benign pneumoconiosis.	Use certified asbestos-free talc, which is available as a high or cosmetic grade of talc.
Eezy Kote Diazo Powder (part A)	p-diazodiphenyl amine plus p-formaldehyde recovered as zinc chloride salt	Toxicity unknown.	Handle with care. Avoid breathing dust. Wear a dust mask if large quantities are used.
Eezy Kote Emulsified PN Developer	Gum arabic solution, epoxy resins, aliphatic ketone, ester alcohol solvents, organic acids, inorganic acids	Can cause allergic-type reactions. The solvents are narcotic and skin irritants.	Avoid prolonged use without adequate ventilation. Avoid eye contact. Wear the appropriate gloves or barrier cream.

(continued)

Name	Chemical Composition	Hazard	Precaution
Gum Arabic (arabin, calcium gumate, gum acacia, gum mimosa, African gum)	Natural substance. No exact chemical composition, contains calcium salts of arabic acid	As a powder is a sensitizer, can cause allergic reaction. Can cause asthma-like symptoms.	Wear a respirator when dusts or mists are formed with gum arabic.
Victory etch	Water, gum arabic, nitric acid, bitumen	Nitric acid is an irritant to eyes and skin.	Avoid eye and skin contact.
Hanco cellulose gum solution	Water, cellulose gum, phosphoric acid, trace phenol	Very low toxicity by all normal routes.	If splashed in the eyes, rinse thoroughly with water.
Hanco cellulose gum etch (acidified)	Water, cellulose gum, magnesium salts, phosphoric acid	Very low toxicity by all normal routes. 1% phosphoric acid could be irritating.	If splashed in the eyes, rinse thoroughly with water.
Lacquer C vinyl base lacquer	Aromatic hydrocarbon ketone, resin.	Ketone is highly irritating to the mucous membranes of the eyes, nose and upper respiratory tract; it is also a narcotic.	Use only under well ventilated conditions.
Pro Sol Fountain Solution	Zinc nitrate, ammonium, dichromate, phosphoric acid	Corrosive to skin tissue. Can cause dermatitis.	Avoid skin contact. Wear appropriate gloves or barrier cream.
Sodium dichromate	Sodium dichromate	Powerful oxidizing agent; dust or concentrated solutions on the skin can lead to deep-penetrating, slow healing ulcers.	The appropriate gloves and eye protection are necessary.

SAFETY EQUIPMENT SUPPLIERS

Check your local yellow pages for other safety equipment suppliers.

GLOVES AND RESPIRATORS
Magid Glove Manufacturing Company, Inc.
2060 North Kolmar Avenue
Chicago, Illinois 60639

Dunn Products
37 South Sangamon Street
Chicago, Illinois 60607
(312) 666-5800

RESPIRATORS AND OTHER SAFETY EQUIPMENT
American Optical
Safety Products Division
Southbridge, Massachusetts 01550

Respirator Selection Chart

Norton Company
Safety Products Division
2000 Plainfield Pike
Cranston, Rhode Island 02920
(401) 943-4400

Advertises a respirator for the smaller face

Dunn Products
37 South Sangamon Street
Chicago, Illinois 60607
(312) 666-5800

SAFETY CANS & STORAGE EQUIPMENT
Eagle Manufacturing Company
Wellsburg, West Virginia 26070

GOGGLES
Watchmoket Optical Company, Inc.
232 West Exchange Street
Providence, Rhode Island 02903

PROTECTIVE HAND CREAMS
- Kerodex
- Dow Corning Protective Hand Cream
- SBS

A SELECTED SUPPLY AND EQUIPMENT LIST FOR PAPERMAKING

WOVEN WIRE CLOTH, MOLDS AND DECKLES, FELTS
Estey Wire Works
134 West Central Blvd.
Palisades Park, New Jersey 07650

Brass wire cloth (a good all-around mesh is 40″ × 40″ & a. .01″ diameter)

Lee McDonald
523 Medford Street
Charlestown, Massachusetts 02129

Bronze-wire backing for laid screen, 50 mesh, heat shrinking polyester mesh for molds, 40 mesh brass wire, woven surface.

WATER SOLUBLE DYES
Pylam Products, Inc.
1001 Stewart Avenue
Garden City, New York 11530

BEATER, PULPERS, PULPS
Twinrocker
RR #2
Brookston, Indiana 47923

The Howard Clark Hollander Beater, cotton linters, rag half stuffs (also sizing source).

Craftool
1421 West 240th Street
Harbor City, California 90710

Laboratory beaters and pulp mills in several sizes, felts, pulps

Carriage House HMP
8 Evans Road
Brookline, Massachusetts 02146

(Elaine Koretsky) Carries bleached manila hemp, Indian hemp, cotton linters. Minimum order 10 lbs. Shipping extra. Assortment of pulps available.

Lee Scott McDonald (address above) is a generous source of information about improvising papermaking equipment: molds, light tables, heaters. He sells felts, lighting mixers, pulps and makes molds to order. Catalogue sent upon request.

Bibliography

HEALTH HAZARDS MANUAL FOR ARTISTS, McCANN, MICHAEL, PH.D., Foundation for the Community of Artists, 1975.

MANUAL OF LITHOGRAPHY, VICARY, RICHARD, Charles Scribner's Sons.

PRINTMAKING, HISTORY AND PROCESS, SAFF, DONALD and SACILOTTO, DELI, Holt, Rinehart and Winston, 1978.

PRINTMAKING, MAXWELL, WILLIAM, Prentice-Hall, 1977

THE COLOR REVOLUTION, COLOR LITHOGRAPHY IN FRANCE 1890–1900 CATE, PHILLIP DENNIS and HITCHINGS, SINCLAIR, Rutgers University and Boston Public Library, 1978.

THE COMPLETE PRINTMAKER, ROSS, JOHN and ROMANO, CLARE, The Free Press, 1972.

THE LITHOGRAPHY OF STOW WENGENROTH, STUCKEY, RONALD and JOAN, Boston Public Library and Barre Publishers, 1974.

THE TAMARIND BOOK OF LITHOGRAPHY: Art and Techniques, ANTREASIAN, GARO Z. and ADAMS, CLINTON, Harry W. Abrams, 1976.

THE TECHNIQUE OF FINE ART LITHOGRAPHY, KNIGIN, MICHAEL and ZIMILES, MURRAY, Van Nostrand Reinhold Company, 1970.

Index